Mimbres Pottery

Ancient Art of the American Southwest

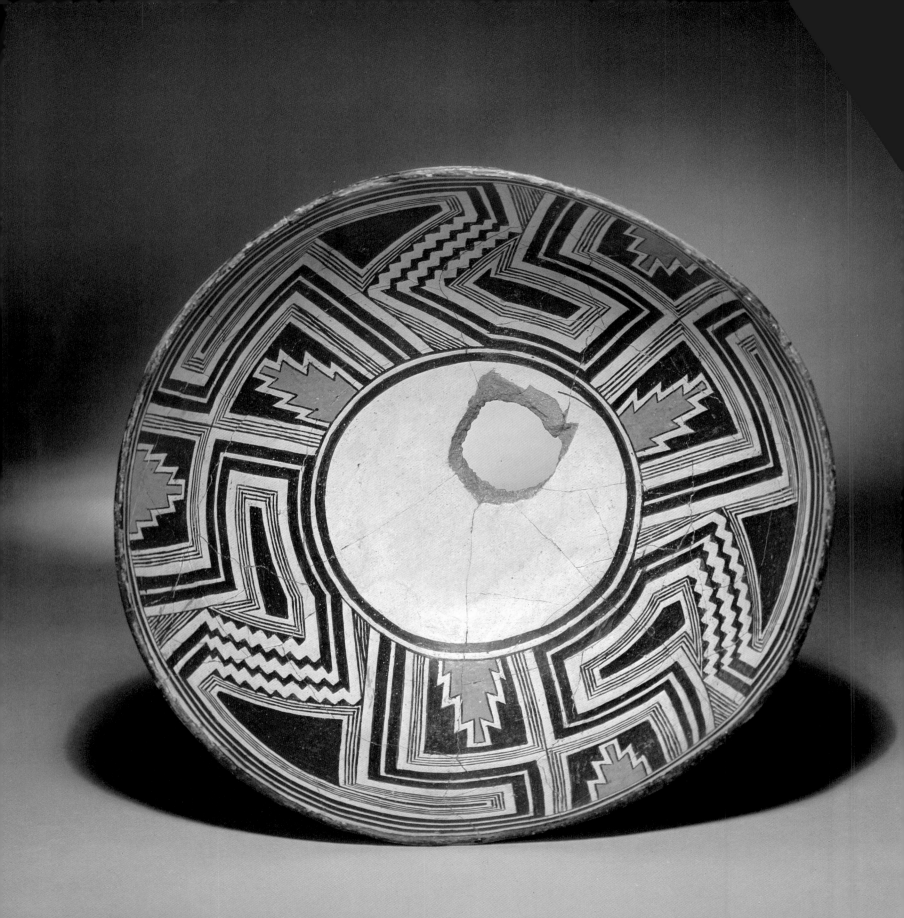

Mimbres Pottery

Ancient Art of the American Southwest

Essays by **J. J. Brody** **Catherine J. Scott** **Steven A. LeBlanc**

Introduction by **Tony Berlant**

Published by Hudson Hills Press, New York

in Association with The American Federation of Arts

This book has been published in conjunction with the exhibition, *Mimbres Pottery: Ancient Art of the American Southwest*, which was organized by The American Federation of Arts. The exhibition and publication have been made possible by grants from the National Endowment for the Arts, the National Endowment for the Humanities, and The Mabel Pew Myrin Trust.

AFA Exhibition #81-1 Circulated: January, 1984–October, 1985

Published in the United States by Hudson Hills Press, Inc., Suite 301, 220 Fifth Avenue, New York, NY 10001.
Distributed in the United States by Viking Penguin Inc.
Distributed in the United Kingdom, Eire, Europe, Israel, the Middle East, and South Africa by Phaidon Press Limited.
Distributed in Australia, New Zealand, Papua New Guinea, and Fiji by Australia and New Zealand Book Co. Pty. Limited.

Editor and Publisher: Paul Anbinder
Copy-editor: Irene Gordon
Designer: Joseph Bourke Del Valle
Composition: U.S. Lithograph Inc.
Manufactured in Japan by Toppan Printing Company

Library of Congress Cataloging in Publication Data

Brody, J. J.
 Mimbres pottery.

 Bibliography: p.
 Includes index.
 1. Mogollon culture—Addresses, essays, lectures.
2. Indians of North America—New Mexico—Pottery—
Addresses, essays, lectures. 3. Indians of North
America—New Mexico—Art—Addresses, essays, lectures.
4. New Mexico—Antiquities—Addresses, essays, lectures.
I. LeBlanc, Steven A. II. Scott, Catherine J.,
1950– . III. Title.
E99.M76B765 1983 738.3'7 83-10812

ISBN 0-933920-46-6

Frontispiece:
Colorplate 1.
Bowl. Style III, Mimbres Polychrome.
H. 4½ in. (11.5 cm), diam. 12 in. (30.5 cm).
Moderate restoration. Private collection

Contents

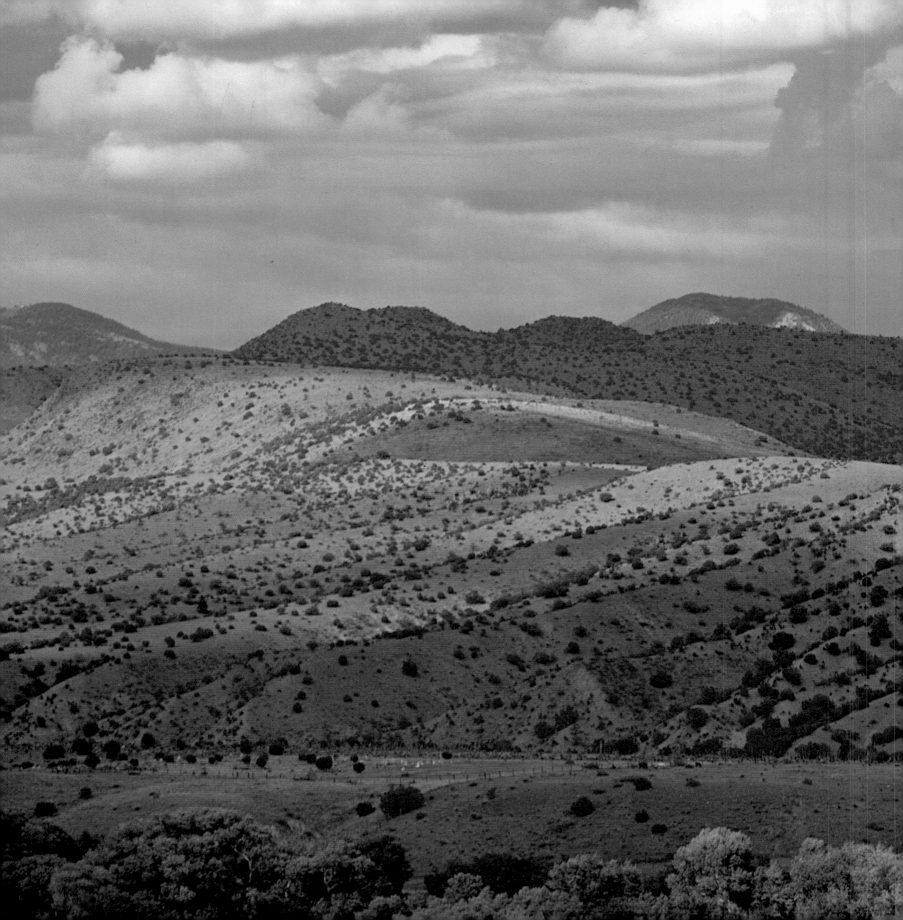

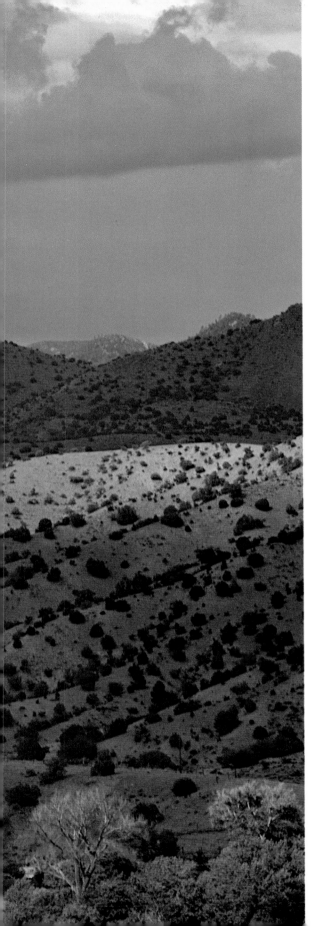

Foreword

For many years now Mimbres painted pottery has attracted the keen interest of certain scholars, artists, and collectors, who have found in both the figurative and geometric styles a kinship with current aesthetics. This first comprehensive exhibition at last introduces this superb Native American art to a much larger audience than it has so far enjoyed.

The initial planning for this exhibition and publication began more than four years ago when the project was first proposed to The American Federation of Arts by the artist Tony Berlant, who has had a strong interest in the material for some time. In 1976 he was instrumental in establishing the Mimbres Foundation, which took on the tasks of preventing the further desecration of the sites and of preserving and documenting the pottery. The initial documentation of some three thousand photographs was carried out by the late Katherine C. White, a collector and a trustee of both the Mimbres Foundation and the AFA.

Many have contributed to the realization of this project, as the following expression of appreciation will attest. First and foremost, the AFA is particularly indebted to J. J. Brody, Director of the Maxwell Museum of Anthropology, Albuquerque, and Steven A. LeBlanc, Director of the Mimbres Foundation and Research Curator, Maxwell Museum of Anthropology, University of New Mexico, Albuquerque, who have contributed essays to this catalogue; Tony Berlant, author of the introduction, whose other involvement has been cited above; Douglas Newton, Chairman, Department of Primitive Art, The Metropolitan Museum of Art; and Allen Wardwell, Director of the Asia House Gallery. Each of these five has brought a particular expertise and point of view to the project and to the process of selecting the approximately 125 pots that are included in the exhibition from a total of over six thousand reviewed. Thanks are also due Catherine J. Scott, Research Curator at the Maxwell Museum of Anthropology, for contributing her essay on the evolution of Mimbres pottery.

Others to be thanked include Ramus Suina of Cochiti Pueblo, for serving as a consultant on the catalogue; Martin Etter and Phyllis Freeman for preliminary and Irene Gordon for final editing of the publication; Catherine Sease, for the careful conservation of many pots; Dan Budnik, for his specially commissioned photographs of the Mimbres Valley; and Barbara and Justin Kerr and Hillel Burger, for their photography of the majority of the objects reproduced in the catalogue.

Members of the AFA staff also deserve credit for their important contributions: first, Susanna D'Alton, who guided the development of both the exhibition and publication with patience and finesse; Jane Tai, Associate Director, for her important overall

7

planning and supervision; James Stave, for his contribution in carrying the project to completion; Amy McEwen, for diligently working out the itinerary for the exhibition; Konrad Kuchel, for negotiating the many loans; Carol O'Biso, Merrill Mason, and Susan MacGill for their careful handling of the complex registrarial work; Sandra Gilbert, for the publicity arrangements of the national tour; Mary Ann Monet, Fran Falkin, Sandra Jamison, and Teri Roiger of the Exhibition Department, for the numerous and diverse skills they contributed.

To the thirty-two institutional and individual lenders, we extend our gratitude for their generous willingness to part with their works for the long tour. Special thanks are due the Peabody Museum of Archaeology and Ethnology, Harvard University.

Finally, the generous grants from the National Endowment for the Arts, the National Endowment for the Humanities, and the Mabel Pew Myrin Trust are acknowledged with special appreciation. Without their support, this project could not have been realized.

Wilder Green
Director
The American Federation of Arts

Preceding pages:
Colorplate 2.
The first terrace and hills rising above the vegetation of the Mimbres. Terraces just above the river were favored locations for villages. The hills above provided wild-plant and animal resources. (©1982, Dan Budnik)

Preface and Acknowledgments

This book has been written to accompany the traveling exhibition of paintings on pottery made by the ancient southwestern Native American culture we call the Mimbres and to present to a wider public a visual record of these remarkable works. The Mimbres painting tradition, which flourished for about one hundred fifty years, ended about eight hundred years ago and disappeared from human knowledge until late in the last century.

For many years after its rediscovery, Mimbres painting attracted little attention except among southwestern prehistorians. Some examples of the art entered public and private collections during the last half century, and a few have been included in virtually all major exhibitions of American Indian art organized since 1932. Nonetheless, exhibitions of Mimbres paintings outside university and anthropology museums have been rare, and this may well be the first one directed toward a public that is unfamiliar with ancient Southwest Indian art. Our intent, in both the exhibition and the book, has been to provide this new audience with the conceptual and historical contexts that make possible an informed interpretation of this exotic art.

We do not know what the Mimbres people called themselves. The name we give them is the Spanish word for *willows* and refers to the trees that grow along the lovely stream in southwestern New Mexico that was the center of Mimbres territory. The Mimbres were one of many isolated farming groups of the ancient Southwest and their art, for all of its unique qualities, belongs to a much larger tradition shared by many peoples. The nature of Mimbres art and the similarities between the art and culture of the Mimbres and that of their neighbors provide the focus of this book.

An essential aspect of Mimbres painting, and one that is found nowhere else in its time and place, is its representational character. About one quarter of existing Mimbres paintings—almost two thousand examples—carry images of animals, humans, and objects which are often shown in narrative interaction. Because of the pictorial nature of Mimbres art we know more about the content and quality of the intellectual life of these people than about any of their contemporary neighbors.

The Mimbres paintings that exist in modern collections have been recovered by excavation from long-abandoned village sites. Not surprisingly, the best collections are housed in a dozen anthropology, archaeology, regional, and Native American art museums. Most of these collections were assembled before World War II, either as the direct result of field research done by academic institutions, or as acquisitions by universities of collections assembled by amateur archaeologists. While most of these institutions maintain modest exhibitions of Mimbres art, a great number of

examples in major collections are inaccessible to the public.

Until the last decade publications about Mimbres art consisted of technical monographs, brief references in general anthropological texts, or slim exhibition catalogues or checklists. More recently the literature has been enriched by a major summary of Mimbres archaeology by Steven A. LeBlanc and a history of Mimbres painting by J. J. Brody.[1] In addition, the last decade has seen the publication of two pictorial compendiums by O. T. Snodgrass[2] and more than a dozen technical volumes, scholarly articles, and exhibition catalogues with discussions that have provided much new information.

Interpretation begins by identifying subject matter, a procedure in the case of these paintings that is often difficult or impossible. Yet, from 1914, when J. Walter Fewkes first published on Mimbres paintings, to the present, the urge to understand these images has continued and has fostered many interpretations. Among the most rewarding of these are essays by the artist Fred Kabotie, a monograph by the folklorist Pat Carr, and a study by the ethnologist Lois Vermilya Weslowski, all of which have been used in discussions of specific paintings in this catalogue.[3] Kabotie's is a frankly subjective interpretation by an active member of the Hopi tribe and a participant in its culture. He tells us what some of the Mimbreños' paintings might have meant to them had they been Hopis. Carr uses the imagery of Mimbres paintings and the recorded oral literature of southwestern Native Americans in an attempt to recover the patterns and forms of an otherwise lost ancient mythology. She is more concerned with defining the outline and understanding the character of the lost myth cycle of the Mimbreños than with discovering the "real" meaning of any one painting. Weslowski's study depended on interpretations of Mimbres paintings offered by a group of Hopi consultants. A prime objective was to define the outlines and develop a methodology for a more comprehensive study of Mimbres iconography that would identify the cultural and perceptual variables.

The impetus for this recent body of work has come from a number of sources. Much has been sponsored by the Mimbres Foundation, a private nonprofit organization established to promote archaeological research on the Mimbres culture and to support the preservation of Mimbres sites. The Maxwell Museum of the University of New Mexico, Albuquerque, is the permanent repository for materials and documents collected by the Mimbres Foundation. The museum houses a photographic archive of Mimbres paintings that now includes approximately seven thousand examples.

During the last fifteen years, as Native American art has impinged on the consciousness of the art world, Mimbres paintings have become highly valued collector's items. This new awareness of Mimbres art has had some unhappy consequences. As Mimbres paintings increased in value, objects that were once eagerly sought but only occasionally sold by local collectors became high-priced commodities. Professional pothunters found it profitable to loot Mimbres sites,

sometimes systematically strip-mining them with earthmoving equipment. Such methods inevitably destroyed many more painted vessels than were recovered, and obliterated valuable information that had remained buried for centuries.

The painted pots that have been recovered through the vandalism of pothunters survive without documentation. As a consequence, we are deprived of a good part of their human as well as their scientific value. Objects that we encounter devoid of context tell us less than we would like to know about the Mimbres past. Instead, we inform the objects, interpreting them through their resemblances to things we happen to know. The pots thus become rather like "readymade" art objects, invested with whatever meanings their new viewers wish to give them.

We are well aware that this exhibition may serve to prime an already active market and thus stimulate additional destruction of Mimbres sites, but market demand for Mimbres art has been growing without the benefit of a major exhibition. It is our belief that the preservation of Mimbres sites, so that they may ultimately be scientifically investigated, depends above all upon the education of everyone—especially private collectors—to the destructive consequences of uncontrolled excavations. The more we can learn about the Mimbres, the more meaningful their art will become, and the closer we will draw to their humanity. By a curious paradox, the more precise our understanding of the differences between their lives and our own, the less alien they seem.

The selection of Mimbres bowls in the exhibition and publication was accomplished by using the Mimbres archive at the Maxwell Museum, which has benefited from the support of Katherine C. White, the Mimbres Foundation, and a grant from the National Endowment for the Arts. Marian Rodee and Krisztina Kosse were very helpful in making this body of information available to us. Allen Wardwell and Douglas Newton provided invaluable service in the selection of pieces for the exhibition. We are grateful to Ramus Suina for consulting with us on our essays, and we would also like to thank Martin Etter, Phyllis Freeman, and Irene Gordon for their editorial work on the manuscript, Betsy James for providing diagrams, and Lois V. Weslowski for the initial work on the modern interpretive study. The generosity of all the institutions and individuals who have loaned their objects must not go unrecognized. Neither the exhibition nor the publication would have been possible without the considerable effort of the staff of The American Federation of Arts and especially Susanna D'Alton.

This project is, ultimately, the result of the initial vision of Tony Berlant and his persevering efforts to further our understanding of the Mimbres people and their art.

J. J. Brody
Steven A. LeBlanc

Notes
1. LeBlanc, 1983; Brody, 1977.
2. Snodgrass, 1973, 1975.
3. Kabotie, 1949, 1982; Carr, 1979; Weslowski, 1979 (unpublished).

The degree to which each pot has been restored is stated in its caption. If restoration is not mentioned, none has been done.

Light restoration indicates a minor amount of filling and in-painting of cracks.

Moderate restoration indicates the pot has been broken into at least two pieces and readhered with the cracks filled and in-painted.

Heavy restoration indicates that the pot has been broken into many pieces and readhered. All cracks and large missing areas have been filled and in-painted.

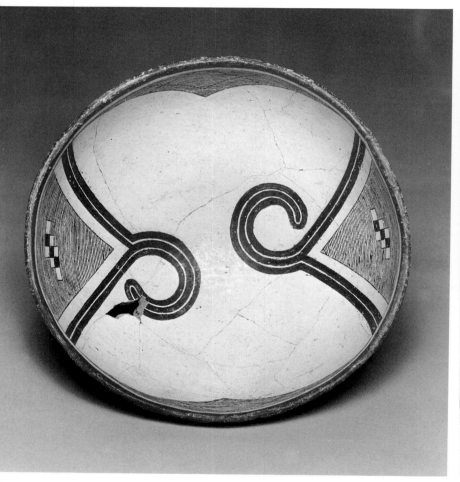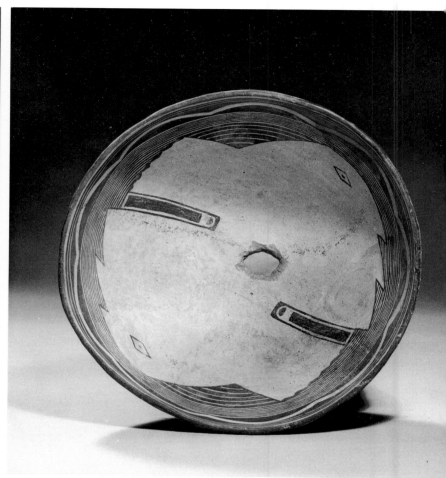

Mimbres Painting:
An Artist's Perspective

House trailers are parked by the river, fences stretch across the hillsides, and cars roll by on the two-lane blacktop road which now bisects the valley in southwestern New Mexico where the peaceable Mimbres once lived. The entire Mimbres culture vanished nearly one thousand years ago, leaving behind little in the way of architecture but an incredibly rich legacy painted on the inside of simple clay bowls.

Mimbres villages are now only barely discernible mounds scattered with shards of pottery. Excavation of a site is a slow, systematic process: a collapsed roof, then stone and adobe walls, and finally a dirt floor emerge, exposing an ancient house. Directly beneath the floor, which is still cluttered with implements of daily life, reposes a burial. A skeleton lies curled in the fetal position, its head carefully covered with a clay bowl. Finally, the bowl is turned over, revealing a painted interior unseen for nearly a millennium.

When I first saw these little-known relics, they spoke to me as a timeless message from a distant and unknown people. They were known only to local ranchers and a handful of archaeologists, but their message seemed universal. Mimbres bowls were affirming that the human spirit is immortal.

The interpretation of Mimbres archaeological finds will always be a matter of speculation, perhaps telling as much about contemporary values as about the Mimbres culture itself. But we can be confident about the attitudes toward life that we find expressed in these intricately decorated bowls. The Mimbres took intense delight in portraying themselves warmly integrated with the rabbits, antelope, sunflowers— even bugs—of their landscape.

This remarkable people created paintings on pottery for six hundred years (A.D. 550—A.D. 1150) with almost no incidents of warfare. In contrast, Europe during the same period was a world wrenched by strife and dominated by severe religious imagery. The central symbol was the judging Christ, and the most vivid scenes were those that portrayed the agonies awaiting the damned in Hell. In the Southwest, meanwhile, the Mimbres were painting images reflecting a world viewed as something of an amiable cosmic circus.

The center of the Mimbres world was the forty-six-mile-long Mimbres Valley. From the valley floor, the horizon is broken by the irregular lines of the flanking hills. Clouds fill the sky in ever-changing patterns which cast moving shadows on the land;

Opposite left:
Figure 1.
Bowl. Style III, Mimbres Classic Black-on-white.
H. 4⅛ in. (10.5 cm), diam. 9½ in. (24.4 cm).
Light restoration. Mr. and Mrs. Edward Kitchen, Santa Monica, Calif.

Opposite right:
Figure 2.
Bowl. Stylized human faces. Style III, Mimbres Classic Black-on-white.
H. 5 in. (12.7 cm), diam. 9½ in. (24.4 cm).
Moderate restoration. Mr. and Mrs. Benjamin B. Johnson, Santa Monica, Calif.

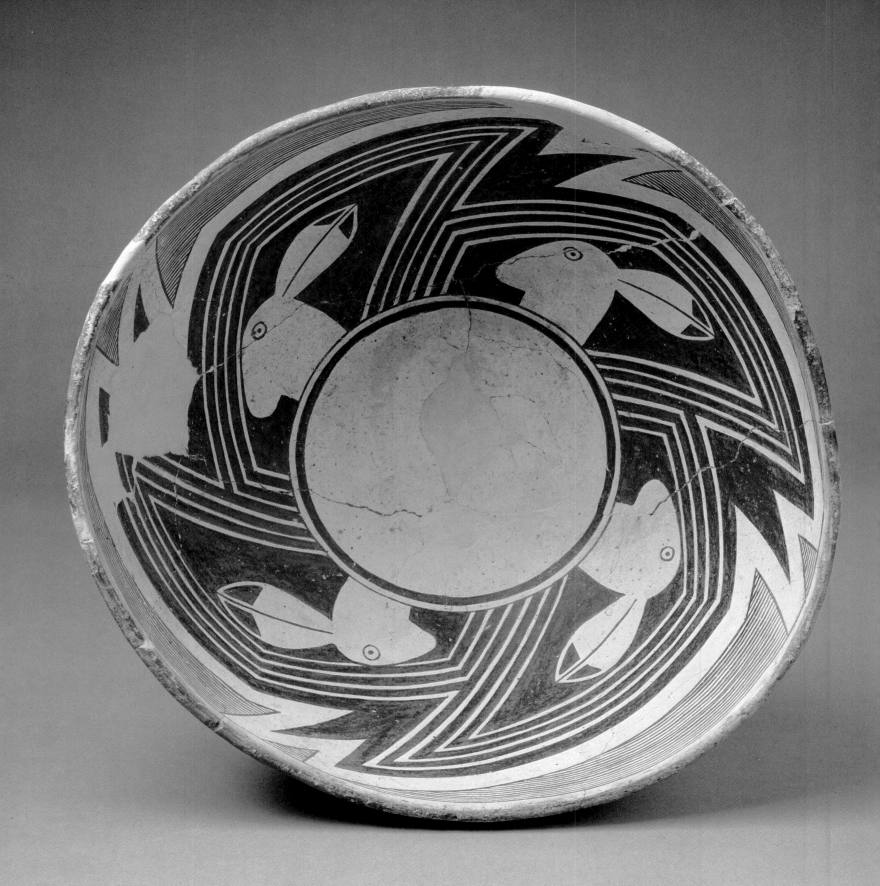

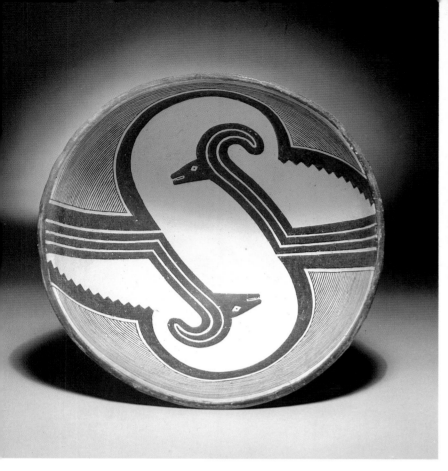

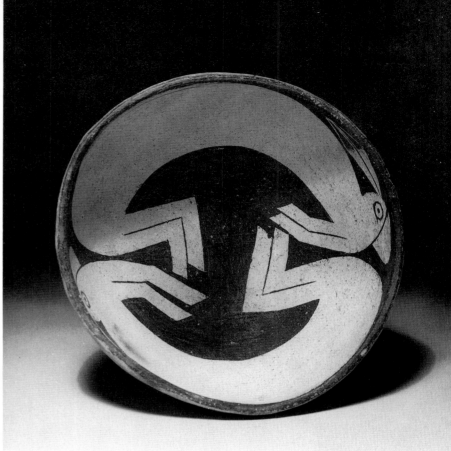

ribbons of lightning and rainbows suggest geometric design. The Mimbres metamorphosed these surroundings into objects that they could hold in their hands. Standing in the valley, one can easily perceive this world as an enormous bowl inverted over one's head.

And so the Mimbres placed bowls over the heads of their ancestors, creating a panorama for the departed. Extraordinarily intense, these images were obviously of enormous importance to the Mimbres. In simple clay bowls, they painted with all the skill and sophistication that Tiepolo employed on a grand scale in casting his divine images onto palatial ceilings. With deft hands and a keen observation of nature, the Mimbres potter revealed the world of fantasy that exists within human perception.

Much like a mandala, which is symbolic of the cosmos, a Mimbres bowl reveals the forces of nature through the vision of the artist. The Mimbres potter was probably a woman, and as the paint flowed from her yucca brush, she began to create not just a rabbit or an antelope but a model of the world.

Within the short time known as the Classic period, which spanned perhaps one hundred fifty years, the imagery on Mimbres bowls changed dramatically. Initially, the motifs were simple and geometric, suggestive of water and lightning. These abstract

Opposite:
Colorplate 3.
Bowl. Rabbit heads. Style III, Mimbres Classic Black-on-white. Swarts Ruin.
H. 4½ in. (11.5 cm), diam. 10¼ in. (26 cm).
Light restoration. Peabody Museum of Archaeology and Ethnology, Harvard University, Cambridge, Mass.

Above left:
Colorplate 4.
Bowl. Two stylized mountain sheep. Style III, Mimbres Classic Black-on-white. Mattocks site.
H. 4⅛ in. (10.5 cm), diam. 9¼ in. (23.5 cm).
Maxwell Museum of Anthropology, The University of New Mexico, Albuquerque

Above right:
Figure 3.
Bowl. Pair of rabbits. Style III, Mimbres Classic Black-on-white.
H. 3⅛ in. (8 cm), diam. 7¼ in. (18.5 cm).
Private collection

patterns were to remain the core of Mimbres design. By the Late Classic period, however, they had evolved into virtuoso drawings that ranged from spartan to ornate.

It seems to me that the bowls which the Mimbres chose to bury with a family member were not an arbitrary selection but had symbolic meaning. Only a small percentage of the painted pottery made by the Mimbres was interred, although the most impressive bowls are usually found in burials. Clearly, these bowls had a special relationship to the dead, taking on some type of ritualistic power. The Mimbres buried their relatives directly beneath the floors of their homes; this custom suggests that they had an acute awareness of their lineage.

At this time, we can only speculate on the ceremonial meaning of the bowls. One of the first creatures repeatedly depicted in bowl designs was the bird, which may have symbolized passage of the spirit of the dead to another world. During the Classic period, animals, such as rabbits and deer, and fish appeared in bowl designs. Perhaps a Mimbreño was buried with images that stood as totems for the clan from which he or she traced family ancestry; the vessels found in a single grave may also have been made by potters in villages to which the deceased could link his or her roots.

At a point in the Classic period, potters began depicting a wide variety of animals found in the Mimbres Valley, as well as the creatures that populated their fantasy world. During this period, when highly imaginative and unexpected imagery appeared, it may have been more important to be buried with a bowl from a particular village or one made by a particular potter than to have bowls with specific images. This is not to say that the bowl patterns did not have special references or meanings. It is entirely consistent with the Mimbres aesthetic that many bowls may have had multiple meanings and references.

The geometric design of figure 1 suggests a mountain sheep once one sees the slightly embellished version in colorplate 4. This sort of shorthand allows the transition from naturalism to abstraction that seems central to the Mimbres. Sometimes just the opposite occurs and the swirling design in colorplate 4 might also be read as a symbol for a celestial body. In painting it, the artist perhaps saw that the image of a mountain sheep could be superimposed on the celestial pattern by a few brilliantly placed marks. Similarly, the addition of a simple element such as an eye (figure 2) transforms what we would otherwise perceive as a geometric pattern into a human head.

Looking again at the two bowls in figure 1 and colorplate 4, one cannot help wondering if they were produced by the same hand. As interest in Mimbres painting becomes more focused and more bowls become available for study, there is bound to be speculation about the identity of individual painters. Those who present us with specific and unique experiences will stand out as the great central figures of Mimbres pottery. However, there may never be an objective checklist for identifying

specific artists. As in learning to recognize an acquaintance's voice on the telephone, only through extended contact and connoisseurship will we begin to recognize individual painters.

For example, I recognize the Rabbit Master. She paints other animals, but I identify her work by the expansive fluidity she brings to her rabbits. The distinctive way in which the feet of the animals create an abstract shape or are occasionally joined together seems to me characteristic of a single artist's work. Even though only the heads of the rabbits are visible in colorplate 3, I believe that the bowls in colorplate 3 and figures 3 through 5 are also her work.

The Polychrome Priest Painter, as I choose to call her, often draws men costumed as animals, as in colorplate 5 and figures 6 and 7. She separates the ceremonial dress from the body of the priest with the singular technique of outlining the arms and hands with an unpainted area. She usually adds a second color to her palette, a rarity in Mimbres painting. In addition to the similarity of general imagery, her repeated use of the unusual, asymmetrical background makes it clear to me that these bowls were all painted by the same hand.

With Mimbres studies still in their formative stage, there are vast speculative areas in interpreting Mimbres work. In some cases, similar bowls may be the work of

Below left:
Figure 4.
Bowl. Pair of rabbits. Style III, Mimbres Classic Black-on-white.
Private collection
(Not in exhibition)

Below right:
Figure 5.
Bowl. Pair of rabbits. Style III, Mimbres Classic Black-on-white.
Private collection
(Not in exhibition)

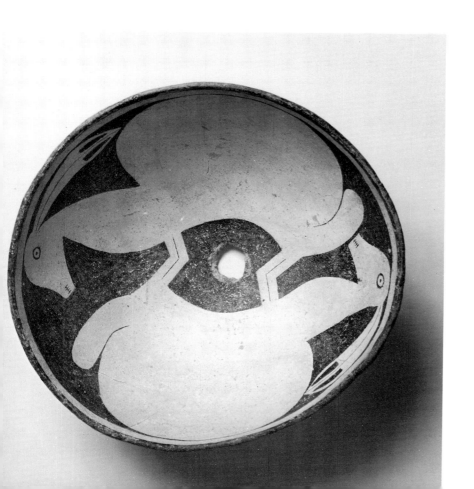

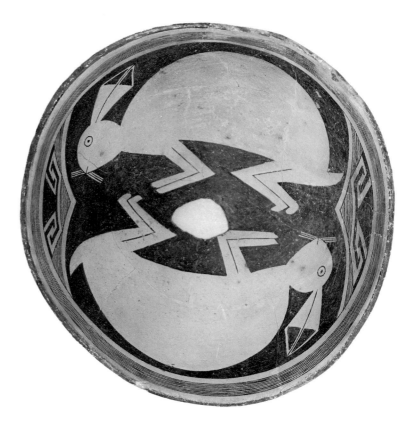

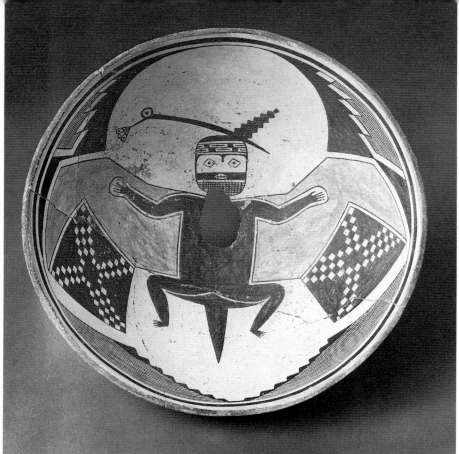

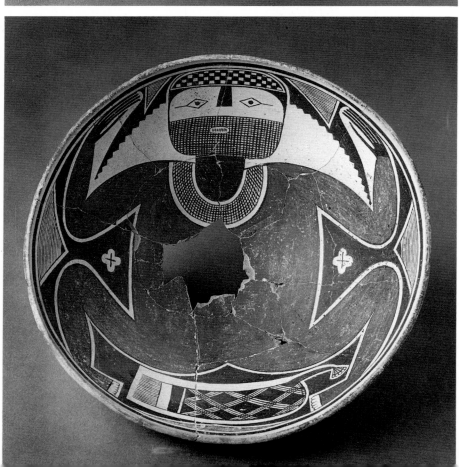

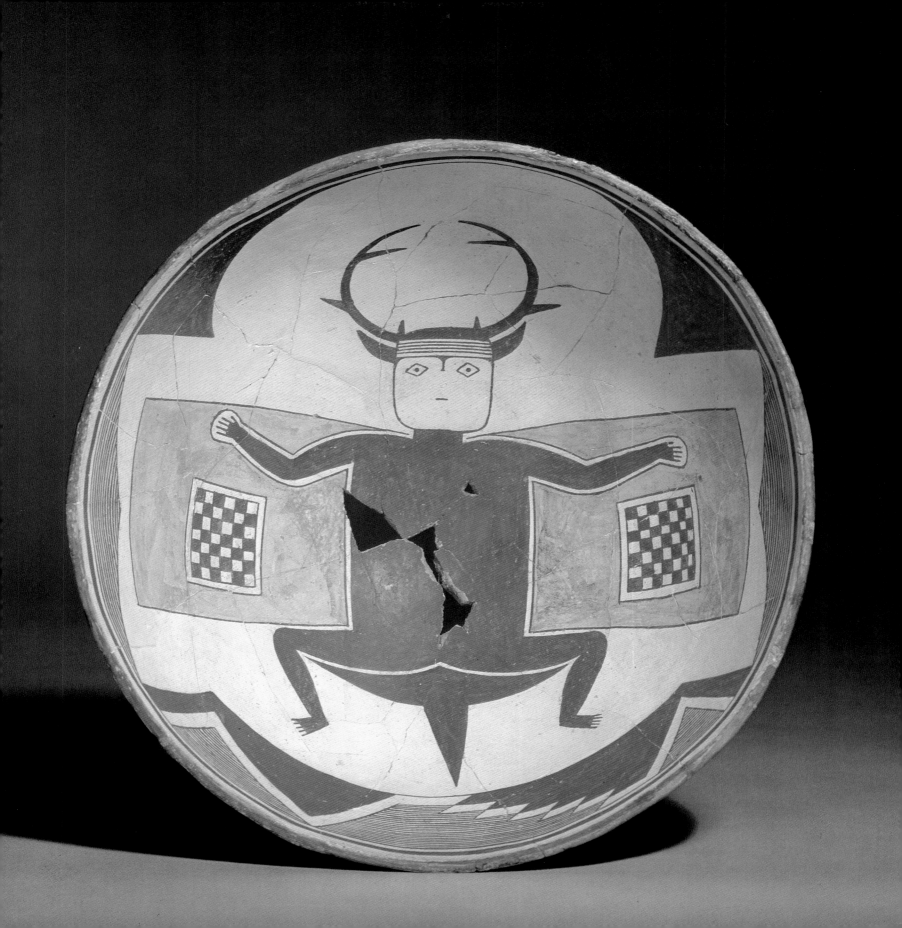

Interpretations of this picture by contemporary Hopi people differ in detail, but all suggest a significant relationship between the central figure and the two animals. The latter have been identified variously as bears, beavers, mountain lions, rabbits, badgers, armadillos, or coyotes. Some thought of these as clan symbols and some as generalized "animal." All identified the dotted crescents in the center as corn, as both physical and spiritual food. Some thought that the human in the center was shouting, others that it was a praying figure. Germination was thought to be symbolized, as well as the physical, spiritual, and social relationships that exist between humans and other animals. In that context, the zigzag lines connecting the central human figure to the two animals was thought by several people to represent an umbilical cord (Weslowski 1979: 24–25).

several members of a family following a master potter's lead, rather than the work of an individual artist. As in the works that I attribute to the Rabbit Master and the Polychrome Priest Painter, artists of transcendent talent and vision appear over the heads of the crowd. Eventually we may come to recognize these individuals as readily as we hail old friends.

Master potters were not responsible for all Mimbres bowls. The majority were made by less skillful hands. But regardless of who created them, the images on these bowls are visions that emanate from the human interior. They see the world in playful transformation. For the Mimbres, humanity is not master of the world, but rather an inseparable part of it. In figure 8, the man curled in a fetal position (unborn or dead?) has a "spirit line" that links him to animals with which he obviously has some special relationship. The figure can also be read as a face. The perfect dot on the man's shoulder which functions as an eye undoubtedly has an additional meaning which we may never grasp.

Central to the Mimbres aesthetic is a yin-yang type of sensibility. Each delineation of a form simultaneously defines the form and creates the shape of the space around it. Almost invariably, the two elements are so perfectly balanced that figure-ground relationships disappear. There are no negative spaces.

Bowl patterns often evoke a Cubist-like handling of form. The blank white interior of the bowl provides an ambiguous, dynamic field that is sliced and warped by drawing. Geometric images seem firmly anchored to the bowl edges, while representational images walk or fly into the field like dancers on a stage. So adroitly do the images fit into the concave spaces they occupy that when approached frontally, the bowls sometimes create the illusion of being flat or even convex. Subtle nuances of gesture, scale, and even time are suggested by placement, but whether or not the bowls were meant to be viewed from one position—which way is up?—is often left in doubt.

Mimbres bowl paintings declare that background and foreground are one, that animals and humans are of the same spirit, and that humanity is part of a cosmic process of transformation and change. The finest Mimbres paintings evolved from a tradition that had developed slowly, then bloomed and disappeared in less than one hundred fifty years. No one knows how or why the Mimbres vanished, but we do know that they reached a core of human experience that has a timeless veracity.

To a people who lived directly above their ancestors, the bowls are a direct link between the living and the dead. Today, these extraordinary bowls have become a "spirit line" between the Mimbres and ourselves. Like love notes from a distant culture, they reassure us that the human spirit is immortal. Through them, immortality is granted to the vanished Mimbres themselves.

Tony Berlant

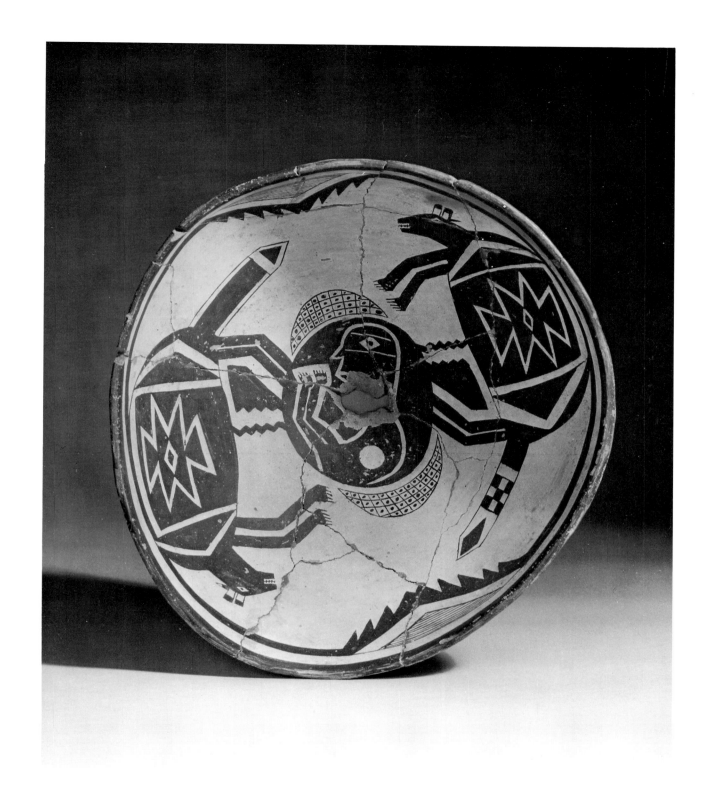

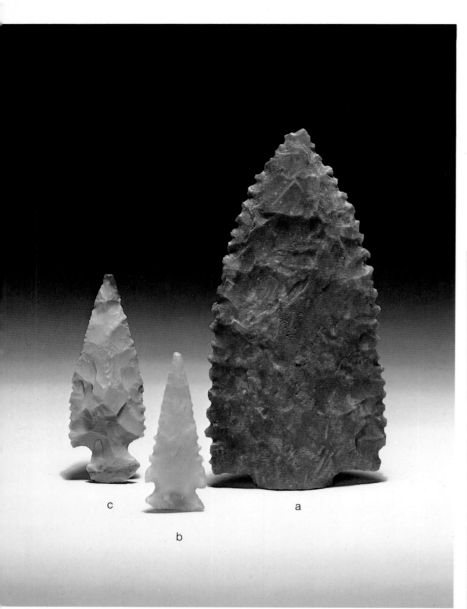

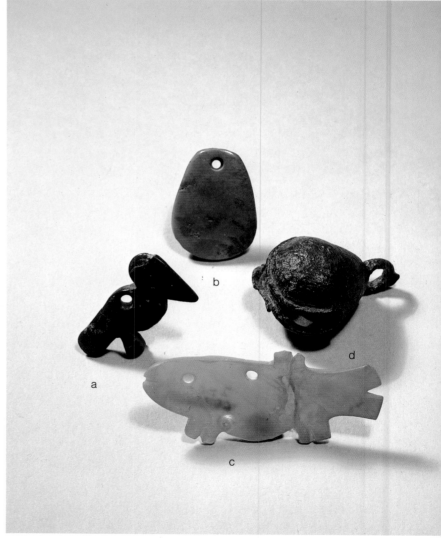

The Mimbres Culture

The Mimbres people were village-dwelling subsistence farmers who supplemented their diet by hunting and foraging. They lived in a small area of the Southwest, in what is today the southwestern corner of New Mexico.[1] The Southwest has been described as oasis America, because it is made up of pockets of arable land surrounded by thousands of acres of arid land. The mean elevation above sea level is more than five thousand feet, and much of the region is high tableland, or mountains that rise more than ten thousand feet.

In the rugged, desiccated area where the Mimbreños lived, obtaining adequate water for farming was a crucial concern. Much of the rain in the Mimbres country falls in the mountains, where it collects into small streams and rivers and courses its way into the lower, drier regions that would otherwise be uninhabitable. Like the Egyptians who irrigated their fields with the sustaining water of the Nile, the Mimbres people were dependent on the waters of the streams and rivers that crossed their country.

The high mountains surrounding the river valleys were too cold for farming, but they provided habitat for deer, bear, mountain sheep, and other animals that the Mimbreños hunted. In the warmer river valleys, with their bottomlands, oak thickets, gentle fluvial terraces, and adequate water, the Mimbreños constructed villages and cultivated corn—their major staple—and beans and squash. Although they hunted rabbits and pronghorn antelope and gathered the seeds of wild plants in the lower-lying desert areas, they rarely settled there.

The Mimbreños knew of many neighboring groups, and archaeologists have found evidence that they had contacts with people living hundreds of miles distant, but urban life, full-time craft specialization, and the intricacies of a market economy were probably beyond the experience of any of them. Theirs was a small, relatively isolated and self-sufficient society, and their experience was with people much like themselves.

THE EVOLUTION OF MIMBRES CULTURE

By 10,000 B.C. the Mimbres region was occupied by the descendants of peoples who had crossed into the Americas from Asia over the Bering Strait land bridge. These earliest Americans were skillful hunters of giant bison, mammoths, and other large game animals. By 5000 B.C. many species of the larger mammals had become

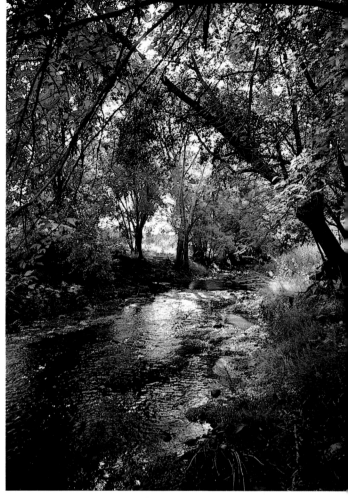

Opposite left:
Colorplate 6.
a. Stone spearpoint. L. 4 in. (10 cm). Galaz site. Department of Anthropology, University of Minnesota, Minneapolis; b. Arrowhead. L. 1⅝ in. (4 cm); c. Arrowhead. L. 2⅜ in. (6 cm). Mattocks site. Maxwell Museum of Anthropology, The University of New Mexico, Albuquerque

Opposite right:
Colorplate 7.
a. Jet bird pendant. L. 1 in. (2.5 cm); b. Turquoise pendant. L. 1 in. (2.5 cm). Mattocks site; c. Abalone fish pendant. L. 2 in. (5 cm); d. Copper bell. L. 1¾ in. (4.4 cm). Maxwell Museum of Anthropology, The University of New Mexico, Albuquerque

Above:
Colorplate 8.
Mimbres River at the foot of the Mattocks site. The flow of the Mimbres, though moderate, provided adequate water for irrigation. (©1982, Dan Budnik)

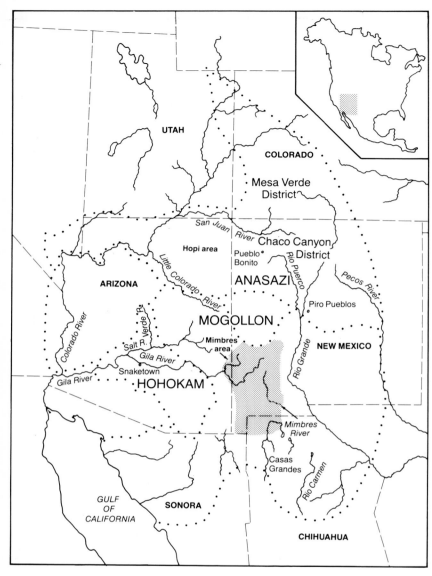

Figure 9.
The Mimbres area and the areas occupied by the three major cultural traditions in the Southwest, ca. A.D. 1100. (Adapted by Judy Skorpil from *Mimbres Painted Pottery* by J. J. Brody, University of New Mexico Press, ©1977 by the School of American Research)

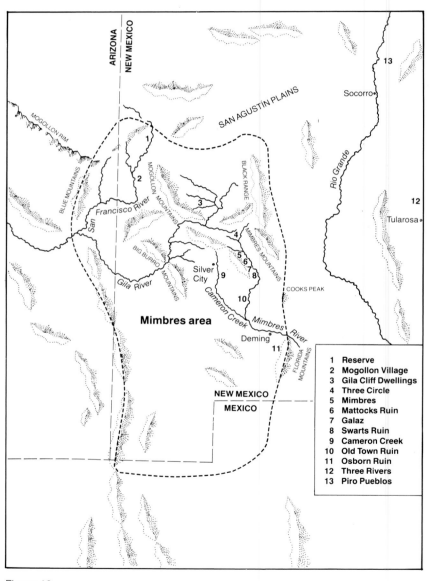

1	Reserve
2	Mogollon Village
3	Gila Cliff Dwellings
4	Three Circle
5	Mimbres
6	Mattocks Ruin
7	Galaz
8	Swarts Ruin
9	Cameron Creek
10	Old Town Ruin
11	Osborn Ruin
12	Three Rivers
13	Piro Pueblos

Figure 10.
Site Locator. (Adapted by Judy Skorpil from *Mimbres Painted Pottery* by J. J. Brody, University of New Mexico Press, ©1977 by the School of American Research)

TIME LINE

Date	The Mimbres Valley	Mimbres Pottery	Neighbors
A.D. 100	Hunting and gathering peoples in valley	Gourds and baskets used as containers	
200	Villages built on knoll tops, dwellings are pithouses	First plain brown vessels made	Arizona Hohokam making pottery
300	First permanent villages		Anasazi peoples to the north not yet making pottery
400	Increasing dependence on agriculture		
500	Population doubles	Red burnished bowls and jars	
	Larger villages of pithouses built adjacent to river		Anasazi, Hohokam, and other Mogollon people: villages become larger and more dependent on agriculture
600			
		First painted bowls	
700	Large ceremonial structures built		
		First Black-on-white bowls (Style I)	Hohokam begin to export shell ornaments to Mimbres
800		First representational designs	
		Corrugated pitchers; Style II, Black-on-white	Close resemblances between Hohokam and Mimbres pottery designs
900			
	Population doubles again	Large corrugated jars	Flowering of Chaco culture in northwest New Mexico
1000	Multi-room surface Pueblos built	First polychrome wares	
	Increasing food scarcity	Style III, Classic Black-on-white	
1100		Disappearance of painted ware	Abandonment of Chaco Canyon
	Collapse of Mimbres culture		Founding of Casas Grandes in northern Mexico
1200	Post-Mimbres villages founded		
1300			Cliff dwellings at Mesa Verde abandoned
1400			Population newly concentrated in Hopi, Zuni, and Rio Grande Pueblos
	Valley abandoned		Large areas of Southwest abandoned by Puebloan peoples
1500			
			Spanish explorers in Southwest (1540)
1600	Apaches occupy valley		

extinct, and the people of southwestern America subsisted by collecting plants and hunting smaller game. They were nomadic, did not build substantial houses, and made no pottery.

Beginning around A.D. 200, important changes occurred in the way of life of these hunter-gatherers which set the stage for the development of the Classic Mimbres culture. Until that time, the Mimbreños had lived in small groups that fluctuated in size between ten and fifty people as they moved about among ephemeral camps within a traditional home territory; now they began to settle in permanent villages. Although in former times they had sometimes cultivated small crops of corn, they had depended mainly upon wild foods; now, for the first time, they started to rely primarily upon agriculture and began to produce pottery, probably as cooking vessels.

The earliest permanent Mimbreño villages consisted of a few dwellings clustered together. At first the villages were located on high knolls and ridges well away from water sources and farmlands. Although we do not entirely understand why the Mimbreños selected these remote sites, it seems probable that the locations were chosen to provide a view of approaching strangers and to be defensible against attacks from other communities. The houses they built were semi-subterranean structures, dug into the ground three feet or more and covered by domelike frames built of wooden timbers. This framework was covered with reeds and withes and plastered with a thick layer of adobe mud to create a durable, well-insulated structure. A covered entrance was created by a long tunnel-like passageway attached to one side. In exterior view, these dwellings, which are termed *pithouses*, must have resembled dirt-covered igloos. Within a floor area averaging only one hundred fifty square feet, a pithouse provided storage and living space for a family of five or six persons.

A variety of artifacts has been recovered from these early village sites, but almost no formal burials have been found in association with them. The pottery discovered at these sites is simple undecorated ware which, over the span of the next eight hundred years, would be progressively modified into the Classic black-and-white tradition that is so well known. From the outset, Mimbres pottery vessels were produced in a variety of shapes, including bowls for serving and jars for storage, for cooking, and for hauling water.

During the long interval between A.D. 200 and A.D. 550, there were few changes in the culture of the Mimbres region: the population increased slowly and steadily, but villages remained small, rarely containing more than six or seven pithouses.

A series of major developments began after A.D. 550. The villages built on high ground were gradually abandoned, and new villages were founded just above the floodplain along the Mimbres River and adjacent to other watercourses in the area. Continuity during this period in the evolution of other features of Mimbres material

culture, including pottery, stone tools, and architecture, indicates that the change in residence patterns was an indigenous development and not the abrupt result of migrations of new people into the region.

It was during this period that most of the distinctive traits of the Classic Mimbres culture were developed. The pithouses underwent an evolution in shape from circular to rectangular, but in other ways remained the same. The Mimbreños began to build communal or ceremonial structures. These buildings, which were similar in some respects to structures seen in other parts of the Southwest, became increasingly numerous in the Mimbres area. Like the pithouses, they were constructed partly below ground, but they were larger than the typical domestic dwellings. By around A.D. 900, unusually large examples were being built which ranged up to eighteen hundred square feet in floor area, and were elaborated with stone facings on the interior walls, large, well-built hearths, and colored stones set into the floor. The structures much resemble the kivas used by the Pueblo Indians for ceremonial purposes, and as centers of social activity during recent times.

Burials are found more frequently in the sites dating to this period. At first they were made in the fill of abandoned dwellings, but by the end of the period the dead were usually buried beneath the floors of pithouses still in use. In some of these, such objects as the remains of parrots wrapped in strings of beads have been found interred beneath the floor. This practice of burying the dead in occupied dwellings continued until the end of the Mimbres sequence.

In early burials, pottery bowls and other grave offerings were placed adjacent to the body. Later, a bowl was usually broken and scattered in pieces throughout the grave, but by the end of the period this practice had been almost entirely abandoned. Instead, a single small piece was broken out of the bottom of the funerary bowl, and the bowl was then placed over the head of the deceased. Today, the small puncture hole in the bottom of Mimbres bowls is referred to as the "kill" hole. While we are inclined to assume that it must have had some ideological significance, whether it was made to release the "spirit" of the bowl, as some investigators have suggested, remains unknown.

Between A.D. 550 and A.D. 1000 the Mimbres population continued to grow; by the year 1000 it had increased to some fifteen hundred persons, about eight times the size it had been in A.D. 200. By the end of the period, villages—some comprising as many as fifty pithouses—were spaced about every three miles along the Mimbres River. Agriculture became increasingly important. Trade increased between communities within the area and with other societies beyond the borders of the Mimbres region. The most important of these trade relationships was with the Hohokam culture centered in the Phoenix area of southern Arizona. This trade had major effects on the Mimbres pottery tradition, which underwent considerable change. While there was also much modification of architectural style, burial practices, and other features of

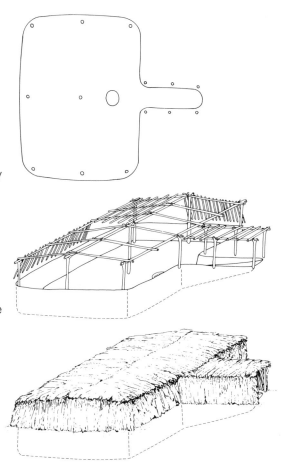

Opposite above:
Figure 11.
Yucca in the desert area below Cooks Peak.
(©1982, Dan Budnik)

Opposite below:
Figure 12.
Foothills adjacent to Mimbres River Valley. Such arid tracts contrast with the fertile river valley.
(©1982, Dan Budnik)

Above:
Figure 13.
Artist's reconstruction of a Mimbres pithouse. These semi-subterranean houses were in use from A.D. 200–A.D. 1000. Pithouses were about twelve to thirteen feet long. Entry was from a long rampway. (Adapted by Judy Skorpil from *Mimbres Painted Pottery* by J. J. Brody, University of New Mexico Press, ©1977 by the School of American Research)

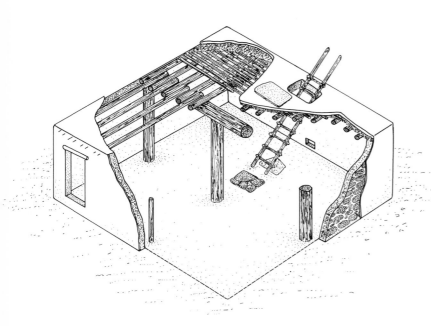

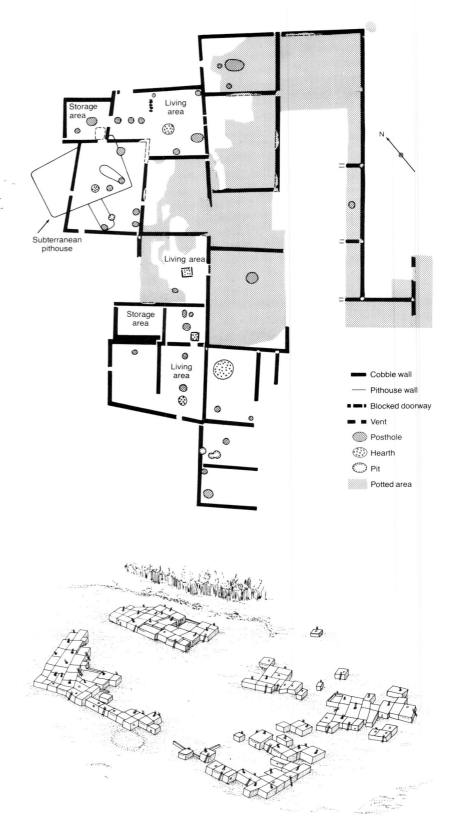

Above:

Figure 14.

Artist's reconstruction of a surface room of the Classic Mimbres period, A.D. 1000—A.D. 1150. The room was entered via a hatchway in the roof above the hearth. Rooms were built of river cobbles and were about twelve feet square. (Courtesy, the Mimbres Foundation, adapted by Judy Skorpil)

Above right:

Figure 15.

This plan shows a group of Mimbres Classic period surface rooms on the Mattocks site, which were excavated by the Mimbres Foundation. These rooms illustrate the general layout of Mimbres villages. Note that they have been constructed over an earlier subterranean pithouse village. Prior to excavation, looting in this area of the site destroyed walls and features within some of the rooms, thereby eliminating the possibility of determining their function. (Courtesy, the Mimbres Foundation, adapted by Judy Skorpil)

Right:

Figure 16.

A perspective drawing of the Galaz village at A.D. 1100. The Galaz site was one of the largest Mimbres villages; its one hundred fifty rooms housed about three hundred people. (Courtesy, the Mimbres Foundation, adapted by Judy Skorpil)

Mimbres culture, these developments were quite gradual, and the strong continuity of the Mimbres tradition is most notable.

From an archaeological standpoint, the most obvious change in Mimbres culture occurred at about A.D. 1000, when pithouses ceased to be built and were replaced by surface rooms constructed with walls of river cobbles and adobe and with flat adobe roofs supported by walls and interior posts. Individual dwelling units were combined into contiguous blocks that had as many as fifty rooms. Most rooms were entered via the roof, although doorways did exist. Larger rooms seem to have been used for general activities such as cooking and sleeping, while smaller ones were used for storage. For ceremonial purposes, there were rectangular aboveground rooms, and in keeping with the nature of the ancestral pithouse, there were small, subterranean kivas as well.

The century and a half (A.D. 1000–A.D. 1150) that followed the adoption of this new style of architecture witnessed the florescence of Mimbres pottery making and painting, and as a consequence, this period has been referred to as the Mimbres Classic period. The pottery painting produced during this time is of remarkable quality, but it remained clearly linked to the tradition of previous centuries. In Mimbres material culture as a whole, in fact, substantial continuity was maintained with past traditions. The dead, as before, were often interred beneath the floors of dwellings. Villages remained in their existing locations, and surface rooms were often built directly over the ruins of abandoned pithouses. Thus, throughout nine hundred years of gradual development, Mimbres society appears neither to have been disrupted by population movements, nor to have been much affected by outside influences of a radical nature.

Figure 17.
A nineteenth-century photograph of Zuni Pueblo showing rooms similar to those of the prehistoric Mimbres. (Courtesy, Museum of New Mexico, Santa Fe)

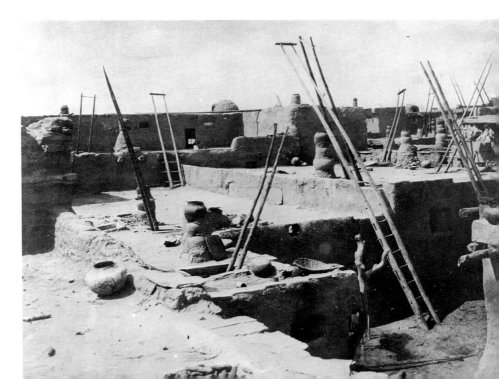

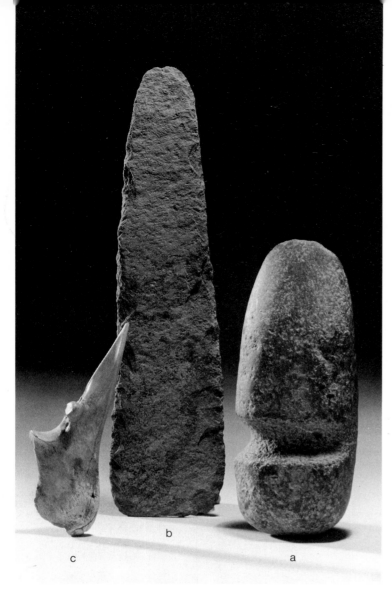

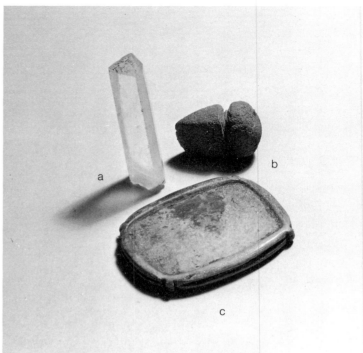

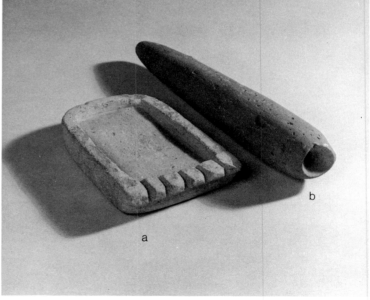

MIMBRES MATERIAL CULTURE

The Mimbres people produced a wide variety of objects besides pottery. Stone tools for grinding and pulverizing corn and other foods have been found, along with bone tools that were used as awls and needles. Arrowpoints, knives, and scrapers made from chert, obsidian, and other materials were common, and axes and mauls made from greenstone have also been found (colorplate 6, figure 18). Much that the Mimbres fashioned—baskets, textiles, and wooden objects—has not survived the passage of time; only a very few examples of these crafts have been found, in dry caves where they were protected from the elements.

The Mimbreños also produced decorative objects. They made social or ceremonial items, such as stone pipes, palettes, and stone effigies, of local materials, as well as stone beads and pendants, which were often traded among Mimbres communities or exported (colorplate 7, figures 19–23). Some ornaments, such as shell bracelets and beads, were imported from the Hohokam of Arizona. Turquoise, obsidian, and other raw materials were imported from distant regions of New Mexico, and copper bells and parrots were obtained from Mexico. The Mimbreños imported some exotic pottery, but on balance they were exporters of pottery vessels rather than importers. It is of some interest to note that almost no bowls bearing representational designs have been found among the Mimbres pots recovered in other regions.

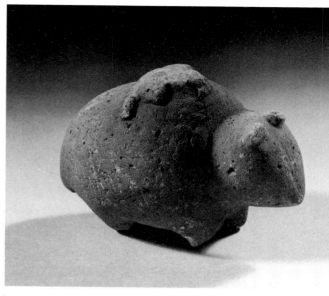

Figure 21.
Stone effigy. H. 3 in. (7.6 cm), l. 4 in. (10.1 cm).
Mattocks site.
Logan Museum of Anthropology, Beloit College, Wis.

THE DISAPPEARANCE OF MIMBRES CULTURE

At about A.D. 1150 Mimbres society disappeared as an organized and identifiable tradition. The question of what happened to the Mimbres people has intrigued archaeologists for many years. Until recently all that was known for certain was that the distinctive painted pottery of the Mimbres ceased to be produced in the Mimbres region and did not subsequently appear in any other part of the Southwest. This implied that the Mimbreños had not migrated from their homeland with their culture intact.

Recent research has given us a much better understanding of what happened to the Mimbres, but the full story is not yet known. It has been estimated that from A.D. 200 the Mimbres population increased steadily, until at its peak in the twelfth century it was about fifteen times larger than it had been when the first villages were settled. In these years the valley population reached approximately twenty-five hundred persons, and the largest villages contained as many as three hundred inhabitants. With this dramatic increase in population, many individuals were forced to occupy marginal lands for farming. Continued exploitation by large numbers of persons denuded the landscape of firewood and reduced the game populations within

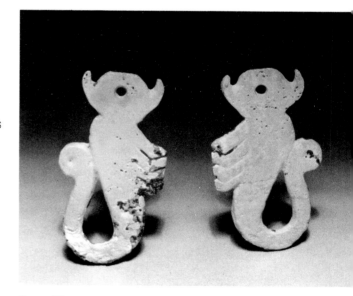

Figure 22.
Twin shell scorpion effigy pendants. L. each 1½ in. (3.8 cm). Galaz site.
Department of Anthropology, University of Minnesota, Minneapolis

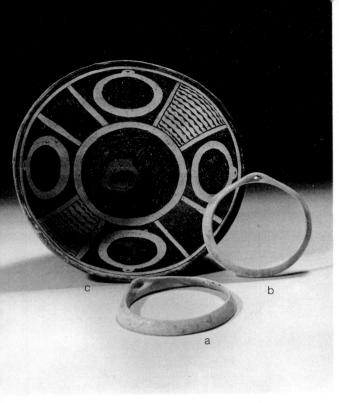

Figure 23.
a and b. Glycymeris shell bracelets. Diam. each
3½ in. (8.9 cm). Maxwell Museum of Anthropology,
The University of New Mexico, Albuquerque;
c. Bowl. Style III, Mimbres Classic Black-on-white.
Pruitt site. H. 3 in. (7.5 cm), diam. 7½ in. (19 cm).
Arizona State Museum, University of Arizona,
Tucson

convenient distances of Mimbres villages. By utilizing the resources of their environ-
ment to the limit, the Mimbres people appear to have survived in a precarious
equilibrium for some time until successive years of low rainfall led to poor harvests,
which in turn may have caused famine, impaired reproduction, produced social
disorganization, and encouraged emigration of individuals or families to other
locales where they became absorbed in different populations.

While Mimbres society of the twelfth century was increasingly constrained and
troubled by resource shortages, a new cultural center was emerging to the south of
Mimbres country, in the northern part of what is today the Mexican state of Chihuahua.
There, in a major cultural development, the largest community in the prehistoric
Southwest was built. This new town, called Casas Grandes, had thousands of rooms
in multistoried structures, ball courts, and temple platforms that closely resembled
those built earlier in Mesoamerica. Intricate networks of aqueducts and drainage
ditches attest to the complex organization of Casas Grandes, and the town's
importance as a trading center is indicated by an abundance of exotic goods
recovered from its ruins. In fact, evidence found of parrot-rearing on a large scale
and a smelter for producing copper objects suggest that it was also a center where
goods for export were produced. The town was the hub of a large cluster of villages
that extended for many miles over the neighboring countryside and were apparently
united by some form of political system. Such satellite villages appear to have been
constructed in the Mimbres region after the disintegration of the Mimbres culture.
These village sites can be identified by the presence of numerous cultural features—
distinctive adobe hearths, new pottery styles, new methods of roof support, and new
burial traditions—that clearly link them to Casas Grandes culture, but are not found
in the indigenous Mimbres tradition.[2]

It is now evident that the rapid growth of the Casas Grandes culture in its early years
cannot have been due solely to the natural population increase of the original
settlement. Other populations must have been drawn into the cultural sphere of the
town, and it seems reasonable to suggest that as Casas Grandes grew, it incorporated
elements of the Mimbres population within it. Some Mimbreños must have moved
south toward Casas Grandes itself, while others remained near the old village sites,
but adopted most of the material trappings of Casas Grandes life. Presumably it was
during this process of cultural transformation that the Mimbres bowl-painting
tradition died out.

There are other possible explanations for the replacement of Mimbres with Casas
Grandes culture. The Mimbres population may have declined sharply because of
resource exhaustion, leaving a vacuum later filled by people from Casas Grandes.
Or, the Mimbres population, though still numerous, may have been so distressed by
food shortages that it succumbed to, or even sought, the political and cultural
hegemony of Casas Grandes.[3]

Whatever the causes, it is certain that at about A.D. 1150 the Mimbres population lost its cultural identity and the bowl-painting tradition died out. Subsequent settlements in the region lasted for only about two hundred fifty years. The region was finally abandoned before the Spanish conquest in the sixteenth century and was not resettled until the nineteenth.

THE HISTORY OF MIMBRES ARCHAEOLOGY

It was during the 1870s and 1880s that accounts of ruins in the Southwest began to receive widespread attention in the East. These accounts focused on the cliff dwellings of Mesa Verde and the ruins of Chaco Canyon, but the ruins of the Mimbres area were also known to early archaeologists, among them Adolf Bandelier, who visited the region in the 1880s. For reasons that are now somewhat obscure, these early workers were either not aware of Mimbres painted pottery, or did not realize its significance.

It was not until the 1910s that J. Walter Fewkes of the Smithsonian Institution was shown this pottery by an amateur archaeologist and collector, E. D. Osborn. Fewkes

Figure 24.
The site of Casas Grandes, in what is today northern Mexico. The largest prehistoric town in the Southwest, it contained thousands of rooms, ball courts, and platform mounds. Communities related to this culture replaced those of the Mimbres culture. (Courtesy, The Amerind Foundation, Inc., Dragoon, Ariz.)

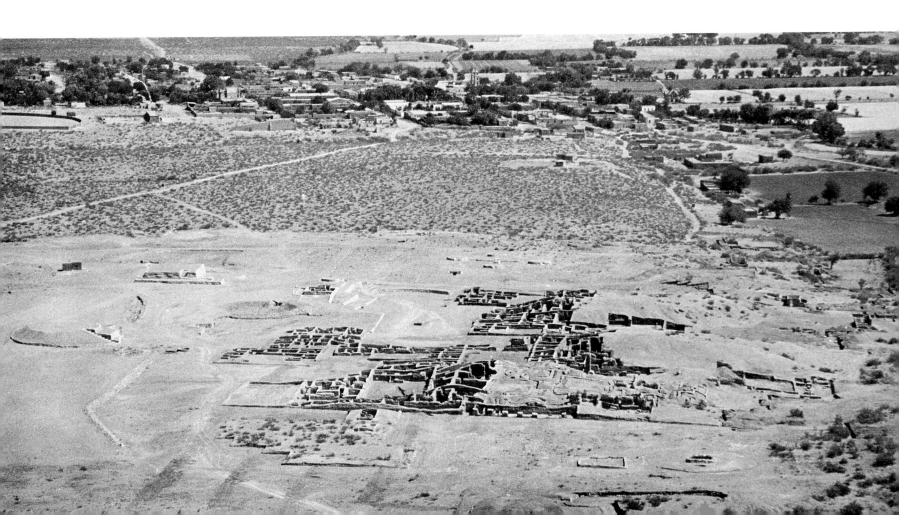

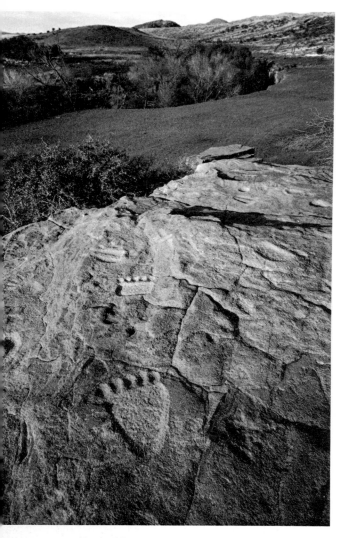

Figure 25.
Petroglyphs on a rock outcrop along Cameron Creek. This drainage lies to the west of the Mimbres River Valley. Just upstream is the important Cameron Creek site. (©1982, Dan Budnik)

made a reconnaissance of the Mimbres area and brought back the first collections of Mimbres pottery to the Smithsonian and the Museum of the American Indian, New York.[4] His discovery led to a wave of scientific excavations in the 1920s and early 1930s. It was at this time that most of the Mimbres archaeological exploration was carried out and most of the material in museums was collected. Harriet and Cornelius Cosgrove began work at the Treasure Hill site and later carried out four years of research and excavation at the Swarts ruin under the auspices of the Peabody Museum of Harvard University.[5] Wesley Bradfield did major excavations at the Cameron Creek site for the Museum of New Mexico.[6] Albert Jenks soon followed with an extended excavation program at the Galaz site for the University of Minnesota.[7] Also during this period Paul Nesbitt worked at the Mattocks site for the Logan Museum of Beloit College,[8] and Earl Morris did limited excavations on a small number of sites near the Swarts ruin, recovering material that is now housed at the University of Colorado.

The work of these decades produced the first good evidence of the full range of Mimbres material culture. Several hundred rooms were excavated and over twenty-five hundred painted bowls were recovered. However, neither the origins of the Mimbres culture, nor the reasons for its demise, nor even the time of its florescence had been worked out. The final work of this phase, done by Emil Haury in the early 1930s, concentrated on the earlier pithouse occupations and produced the first developmental sequence for the Mimbres. Using the tree-ring dating method, Haury also produced the first reliable estimates of dates for this culture.[9]

For several reasons, including the Depression and the feeling among archaeologists that a great deal was already known, by the mid-1930s active research in the Mimbres area ceased. Except for a few small projects, this state of affairs continued until the 1970s. Unfortunately, the Mimbres region was not neglected during this thirty-five-year interval. Looters, who had been active since the turn of the century, continued their activities unabated. Extremely large villages, such as the Old Town site, were almost completely destroyed over the years by their activities. Essentially, no site escaped the ravages of these diggers. Yet, their haphazard acts did not obliterate all the scientific information available from the sites they plundered, and much could still be learned even from badly looted villages.

In the late 1960s, however, the situation took a marked turn for the worse. Several individuals began to use bulldozers as a method of looting, and villages were totally destroyed in the process. Because of the rising value of the painted bowls, this incredibly destructive activity was highly profitable, and the rate of destruction accelerated. By the early 1970s, the Mimbres area was surely the most looted area in the United States. Since 1971 this trend has been reversed to a large degree. New laws have been passed to prohibit commercial looting with bulldozers and to provide

severe penalties for looting on government land. Also, a number of very important village sites have been acquired for permanent preservation by the newly formed Mimbres Foundation as a means of ensuring that future study of the Mimbres culture will be possible.[10]

In the last decade there has been renewed archaeological interest in the Mimbres. While several of these projects have focused on the peripheries of the Mimbres area, the work of the Mimbres Foundation has concentrated on the Mimbres Valley itself. These modern projects have brought new methods and approaches to the study of the Mimbres. A variety of methods of dating prehistoric sites are now available, including Carbon 14, tree-ring, obsidian hydration, and archaeomagnetic techniques. These have produced a wealth of dates, and for the first time, we now have a good understanding of the chronology of the Mimbres culture.

There are additional recovery methods available now, which make it possible for us to learn a great deal more from a site than the early workers could. By studying carbonized plant remains found in abandoned hearths we can reconstruct changes over time in the Mimbreño diet. Studies of prehistoric pollen disclose the nature of the past environment and the effects of human activity upon the plant communities of the valley.

Figure 26.
Excavations of the Galaz site, undertaken between 1929 and 1931 by the University of Minnesota. (Courtesy, Department of Anthropology, University of Minnesota, Minneapolis)

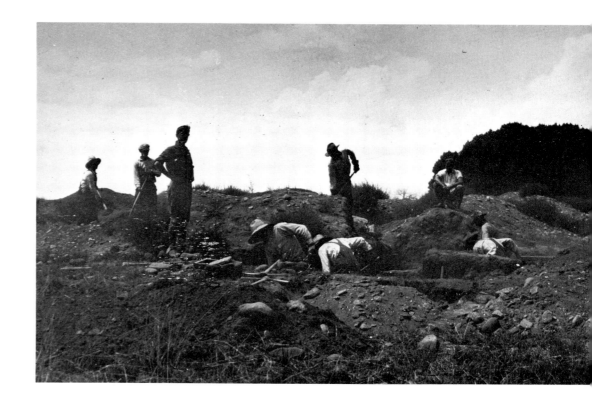

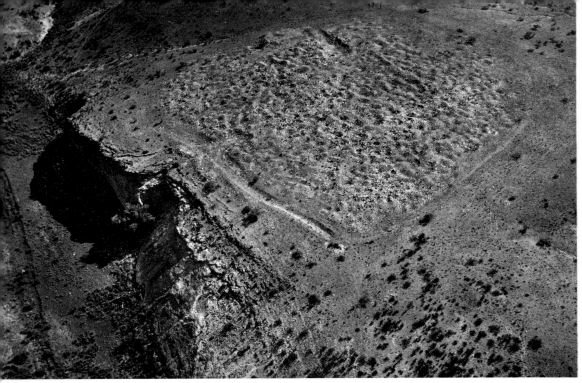

Figure 27.
Old Town Ruin, Lower Mimbres Valley. In spite of being on federally owned land and legally protected since 1906, this site, which has never been scientifically excavated, has been devastated by looting. Each crater is a treasure-hunter's hole; note bulldozer scars at top and lower edge. (©1982, Dan Budnik)

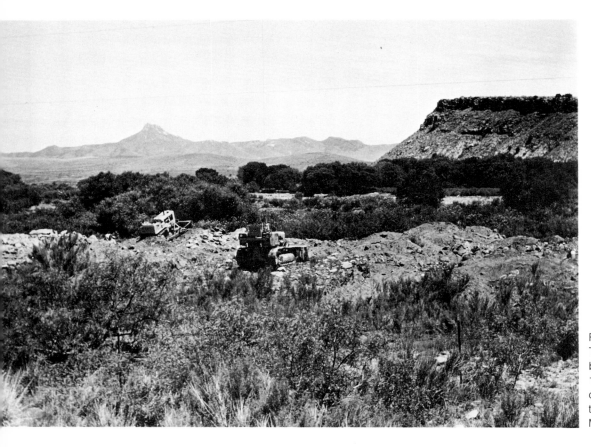

Figure 28.
Two bulldozers being used to search for Mimbres bowls in a Classic Mimbres village site during the 1970s. As a consequence, the village was totally destroyed; a similar fate has occurred to half of all the known major Mimbres villages. (Courtesy, The Mimbres Foundation / Paul Minnis)

Archaeological reconstruction depends fundamentally upon our ability to know the full pattern of spatial interrelationships among artifacts, and between artifacts and other features of prehistoric sites. Today, archaeologists are little interested in artifacts whose provenience and contextual relationships are unknown. If we know exactly where an artifact is from, we can date it and determine how it functioned in society. By the association of artifact types with skeletal materials, dwelling sites, or work areas, we can learn which members of a population used which kinds of artifacts and determine whether there were craft specialists or social elites, whether there were striking differences in the roles and statuses of the two sexes, or great privileges of age. Possession of the artifacts alone does not allow us to discover very much about prehistoric society, and the contextual information we depend upon for greater insights can be recovered only through careful scientific excavation.

Because of improved techniques used today in archaeological excavation and reconstruction, recently recovered bowls provide us with much more information than bowls collected in the 1930s. However, due to the activities of generations of looters, relatively few bowls have been found in recent years by professional archaeologists. The very substantial number of bowls recovered in the course of early scientific excavations still provide the bulk of what we know about the roles of such pieces in Mimbres society.

Steven A. LeBlanc

Notes
1. LeBlanc, 1983.
2. Di Peso et al., 1974.
3. Anyon et al., 1981.
4. Fewkes, 1914.
5. Cosgrove and Cosgrove, 1932.
6. Bradfield, 1931.
7. Anyon and LeBlanc, in press.
8. Nesbitt, 1931.
9. Haury, 1936a.
10. LeBlanc, 1983.

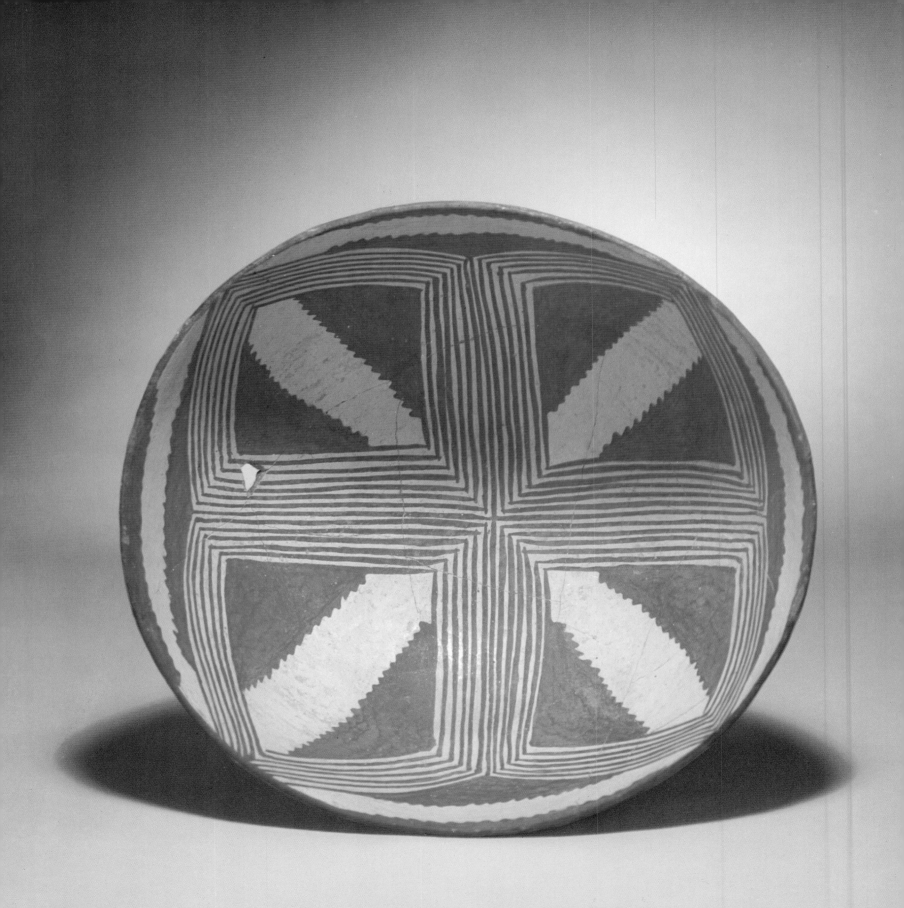

The Evolution of Mimbres Pottery

During its nine-hundred-year history, Mimbres pottery evolved from a plain brown undecorated ware to spectacular figurative black-on-white bowls. This evolution is now quite well understood. The techniques of southwestern pottery production were derived from groups to the south, in central and north-central Mexico. These earliest pottery vessels were made of a brown firing clay in shapes similar to gourds. Before the development of pottery, gourds evidently served as containers and consequently were used as models for the first pottery vessels. The earliest Mimbres pottery, which consisted principally of jars for cooking and storage, was well made, but was totally undecorated.

After its first appearance, at about A.D. 200, the pottery of the Mimbres region changed little for three hundred fifty years. The only important innovation was the attempt to produce pottery with a red finish. This color was obtained in two ways. In one method the surface of a finished and fired vessel was wiped with a wash to which pulverized red hematite had been added. This imparted a nondurable red tint to the vessel. In the other method hematite was added to the clay before the pot was fired. This was not always carefully done and, as a result, vessels were produced in a range of reds and browns.

After A.D. 550, Mimbres pottery began to change more rapidly. Techniques for producing red pottery were perfected. Prior to firing, the vessels were coated with a thin layer of red slip, which was produced by adding a substantial quantity of powdered hematite to a suspension of clay in water. After application, the slip was allowed to dry and the surface was then burnished to a high luster with a polishing stone. When fired, this pottery emerged bright red with a polished surface. It is known as San Francisco Red pottery after the San Francisco River, where some of the first known examples of the type were found in the 1930s (colorplate 10a).[1]

For one hundred years San Francisco Red pottery continued to be made along with the undecorated brown ware and there is little evidence of experimentation with other styles. But around A.D. 650 two developments occurred which established two distinct stylistic traditions in Mimbres pottery: decoration using plastic (three-dimensional) techniques was introduced, and painted designs were employed for the first time.

The majority of all vessels produced at this time were in an unpainted style that is frequently referred to as *utility* ware. This utility ware—primarily jars for cooking and storage—was decorated with plastic ornamentation of two kinds. One form involved incising or punching the exterior surface. This type disappeared sometime before

Opposite:
Colorplate 9.
Bowl. Three Circle Red-on-white.
H. 4½ in. (11.5 cm), diam. 11 in. (28 cm).
Light restoration. Private collection

39

the end of the Mimbres sequence. The other form is termed *corrugation*.[2] In a corrugated pot the coils of clay used to build the vessel are not fully obliterated by the smoothing process that generally takes place after the pot is built. In the earliest corrugated ware very fat coils were left unsmoothed on the necks of small jars, resulting in a few broad bands. On later pieces a series of narrow overlapping bands of clay remained. Because these corrugations are reminiscent of the shingling on the sides of wooden houses, this technique has been termed *clapboard corrugation*. At first these narrow bands were confined to the necks of jars; later they extended over the entire upper half of the pieces, and occasionally they covered the entire surface (colorplate 10b, c, d).

Such jars frequently bear traces of soot on the exterior surfaces, showing that they were used as cooking vessels. Some, with a capacity of twenty gallons or more, are so large that they could not have been moved when full and must have served as storage containers. Since corrugated jars were made for domestic purposes and used until they were broken, few complete specimens have been recovered. Earlier, pitcher-like vessels were frequently interred as burial goods and a number of complete examples of this type have survived.

The painted ware—which consists for the most part of bowl forms or jars used for storage—resulted from the potters' modifications of the San Francisco Red style. The bowls were made as before, with the exterior surface a polished red, but instead of covering the interior of the bowl with a red slip, the potters used the slip as a paint to make a design on the brown clay. This early pottery style, termed Mogollon Red-on-brown (figure 29), was produced for no more than a hundred years.[3] It was applied only to bowl forms, which were made infrequently and used even more rarely as burial goods. The designs on Mogollon Red-on-brown bowls are simple and linear. Pendant triangles, chevrons, serrated bands, and interlocking boxes are common motifs. No figurative elements were employed.

Because of the similarity of the red and brown hues there is low contrast between design and background in Mogollon Red-on-brown ware. Almost one hundred years later, sometime before A.D. 750, techniques were developed to make the painted designs stand out more clearly. This was achieved by applying a white slip to the interior of the bowl and then painting the design in red on top of this slip. This pottery is termed Three Circle Red-on-white (colorplate 9).[4] The use of a white slip was not initially accompanied by any design changes, but within a short time new design elements were introduced, particularly spirals and other curvilinear forms. The first Mimbres painted jars were done in this style, but this ware was produced for only a generation or two. Consequently, although Three Circle Red-on-white vessels were occasionally used as funerary offerings (which should have preserved them from daily wear and tear), complete examples of the style are now rare.

Figure 29.

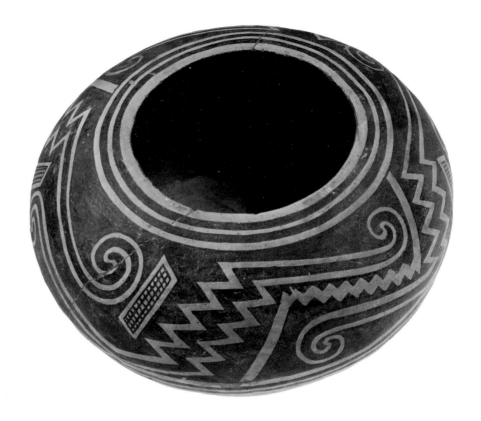

MIMBRES BLACK-ON-WHITE POTTERY

The last major change in the color scheme used on Mimbres pottery occurred sometime between A.D. 750 and A.D. 800. Before then, it was fired in an oxygen-rich kiln atmosphere that turned the hematite slip a bright red. After A.D. 750, modifications in the firing procedure allowed less oxygen to reach the pottery. As a consequence, instead of being oxidized to a red ferric compound, the hematite was reduced, usually to a black, gray, or gray-brown color on a white background. Piebald or mottled vessels of red and black were not the result of different materials being introduced into the paint, but were due to the new firing procedure. Variations in the flow of oxygen and in the firing temperature within the kiln during a single firing were sufficient to produce the range of colors—even the occasional bright red pieces—we observe today.

It was in the medium of black-on-white design that the finest examples of Mimbres painted bowls were created. The techniques used to produce this pottery remained nearly constant for about three hundred fifty years. The average size of bowls

Figure 30.
Seed jar. Style III, Mimbres Classic Black-on-white. Swarts Ruin.
H. 5⅛ in. (13 cm), diam. 7⅜ in. (18.8 cm).
Light restoration. Peabody Museum of Archaeology and Ethnology, Harvard University, Cambridge, Mass.

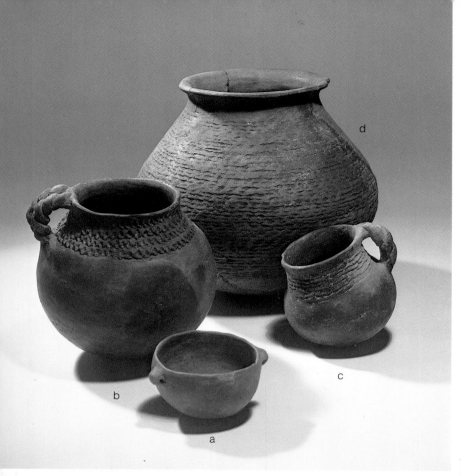

Above:
Colorplate 10.
Utility vessels. a. Redware bowl with lugs. H. 2½ in. (6.5 cm), diam. 3¾ in. (9.4 cm); b. Pitcher with punched neck decoration. H. 7⅛ in. (18 cm), diam. 6½ in. (16.5 cm); c. Jar with handle, corrugated neck decoration. Galaz site. H. 4⅜ in. (11.2 cm), diam. 4¼ in. (10.7 cm); d. Corrugated jar. Mattocks site. H. 9 in. (23 cm), diam. 9⅞ in. (25 cm). Maxwell Museum of Anthropology, The University of New Mexico, Albuquerque

Right:
Colorplate 11.
Jar. Mountain sheep effigy. Style III, Mimbres Classic Black-on-white. Swarts Ruin.
H. 10¼ in. (26 cm), l. 13¾ in. (35 cm).
Moderate restoration. Peabody Museum of Archaeology and Ethnology, Harvard University, Cambridge, Mass.

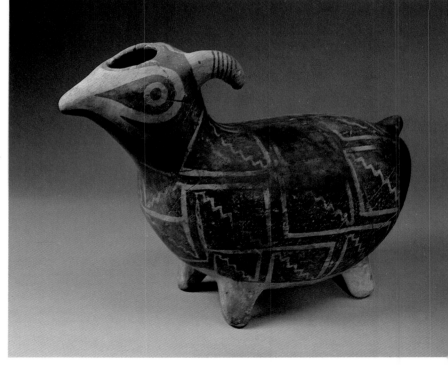

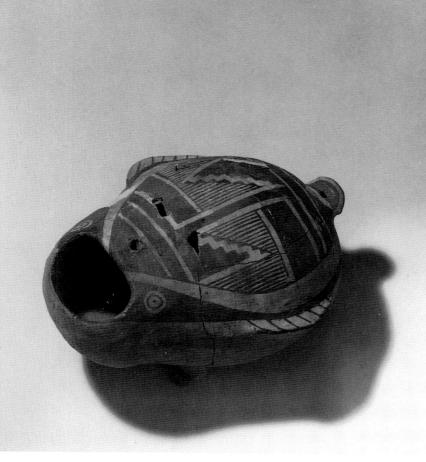

Above:
Figure 31.
Jar. Bird effigy. Style III, Mimbres Classic Black-on-white. Galaz site.
H. 3¾ in. (9.5 cm), l. 7½ in. (19 cm).
Light restoration. Department of Anthropology, University of Minnesota, Minneapolis

Right:
Figure 32.
Water jar. Style III, Mimbres Classic Black-on-white.
H. 15¾ in. (40 cm), diam. 17¾ in. (44 cm).
Heavy restoration. Edwin I. Gregson, Santa Monica, Calif.

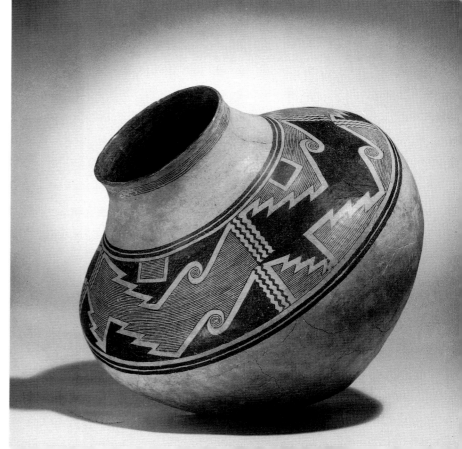

increased slightly over time, but the only substantial change occurred in the realm of design.

Mimbres Black-on-white pottery was made in four shapes. Bowls, by far the most common form, account for almost ninety percent of all Mimbres Black-on-white vessels. The rest were small jars, which are called seed jars because it is believed they were used to store seeds between the fall harvest and the next spring's planting (figure 30). Occasionally small effigy jars were made in the shape of animals, such as bighorn sheep or birds (colorplate 11, figure 31). In addition, large jars that held one or two gallons were made (figure 32). These were probably used to carry and store water. The jars are for the most part decorated with nonfigurative designs.

Almost all the complete bowls that have survived have come from funerary contexts. During most of Mimbres history it was standard practice to place a single bowl in the grave of a deceased person. Occasionally more than one bowl was interred in the same grave; a burial unearthed at the Galaz Ruin contained twenty ceramic vessels, some painted and some of ordinary utility ware. Mimbres village sites, however, have yielded literally thousands of pottery sherds from a great many contexts. The vast quantities of sherds from broken bowls make it clear that most Mimbres bowls were used, and eventually broken, in the course of daily activities and were not used as mortuary offerings. In addition to cooking and storage jars made of unpainted corrugated ware, each household possessed a number of painted bowls for serving food and, perhaps, for use in ceremonies. A large painted water jar and a seed jar probably completed the inventory of pottery used by a typical Mimbres household.

A major question about the use of Mimbres Black-on-white bowls is whether funerary bowls were selected from among those that were already in daily use or whether they were made specifically for burial with a deceased member of the household. Two facts suggest that at least some black-on-white bowls were pro-duced specifically as grave goods. First, about one third of all mortuary bowls bear figurative designs that are rarely found on sherds from bowls broken in everyday use. This implies that bowls with figurative designs were not generally used in everyday activities. Second, a substantial number of burial bowls, including most of those with the best craftsmanship and quality of design, show no evidence of use or wear. These pieces were probably intended for funerary use and were possibly also used in the ceremonial activities of the household. On the other hand, some burial bowls are of such poor design quality and show such obvious signs of use and wear, they clearly were not specifically made to serve as grave goods.

Mimbres pottery was not produced in a vacuum. Similarities can be seen between this ware and the ceramic wares produced contemporaneously in other parts of the Southwest. Early Mimbres Black-on-white pottery bears close similarities to the pottery made by the Hohokam of southern Arizona; indeed, it is likely that Hohokam

designs inspired the first Mimbres figurative elements.[5] The resemblances between Mimbres Black-on-white pottery and the pottery produced to the north of the Mimbres area are more general: both the Mimbreños and their Anasazi neighbors in the north produced pottery decorated in black and white, and both used such motifs as wavy-line hachure, free-standing rim bands, and a circular unpainted field in the base of the bowl. One exception, however, is a particularly intriguing resemblance between Mimbres Black-on-white pottery and the painted pottery made by the people who lived on the northern boundary of the Mimbres area, in the vicinity of the present town of Reserve, New Mexico. For most of their history, the inhabitants of the Reserve region did not produce painted pottery. They preferred to receive Mimbres painted vessels through trade. Around A.D. 1000, they began to make their own black-on-white pottery, which was distinctive in both its technical characteristics, such as slip and temper, and its use of design elements. However, occasional Reserve bowls are found that are technically similar to other Reserve vessels, yet bear designs similar to those found on Mimbres pieces. What form of cultural interaction these vessels reflect is as yet unknown. It is possible that pottery painters moved from Mimbres into the Reserve area, where they retained their own design tradition.

According to the traditional archaeological classification of Mimbres painted pottery, bowls made during the early period of black-on-white pottery production (A.D. 750–A.D. 1000) have been classified as Boldface Black-on-white,[6] or less commonly Mangas Black-on-white,[7] while those produced between about A.D. 1000 and A.D. 1150 have been termed Mimbres Black-on-white[8] or Mimbres Classic Black-on-white.[9] Recent work in the Mimbres area indicates that this dichotomy can be further refined into three stylistic types which developed sequentially. In some cases, early and late variations of these three types can also be identified. At present we will refer to the three stylistic types simply as Styles I, II, and III. Style I seems to have been made from about A.D. 750 until sometime in the tenth century, when it was replaced by Style II, which was produced until the early eleventh century. Style II bowls and sherds have been recovered both from pithouses built before A.D. 950 and from the surface pueblo rooms that were constructed after A.D. 1000. Style III, which to a large degree corresponds with Mimbres Black-on-white or Mimbres Classic Black-on-white, was produced from the early eleventh century until the demise of the Mimbres culture in the middle of the twelfth century.

Early archaeological work in the Mimbres area suggested, and later work has confirmed, that Mimbres Black-on-white pottery underwent a definite stylistic evolution. In some carefully excavated graves and midden deposits, it has been possible to obtain samples of known depositional age, which indicate substantial homogeneity in motifs and designs among those from the same period. Unfortunately, only a minority of Mimbres vessels can be accurately dated using archaeological techniques.

Figure 33.

Thus the age of many motifs and designs cannot be directly determined, but must be estimated by examining their associations with motifs and designs whose ages are known. Our current understanding of stylistic trends is based largely upon the analysis of over seven thousand painted designs documented in the Mimbres archive at the University of New Mexico.

While we are confident of the general correctness of this stylistic evolution, we cannot be sure about the exact date of any particular bowl painting. This is partly because motifs and designs used in early paintings were sometimes employed by later painters. Also, some bowls must have been handed down from generation to generation, serving as models for painters long after they were first made. Thus the design on a bowl is not always an exact indicator of either its time of production or the time of interment. More often than not, however, the painted design will reflect the date of the bowl.

Mimbres Black-on-white Style I
Style I could be classified as early Boldface Black-on-white because many Boldface features are characteristic of this style. Designs are usually executed in a direct, spontaneous manner with heavy brushwork, the technique that gave Boldface its name.[10] The painted decoration invariably extends up to the rim of the bowl, and

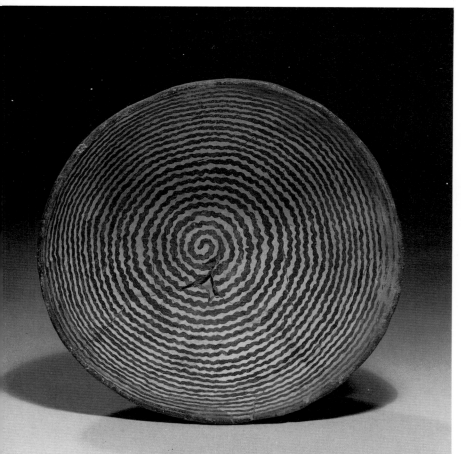

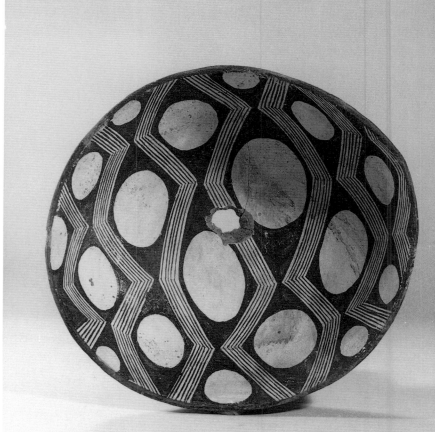

Opposite below left:
Figure 34.
Bowl. Style I, Mimbres Boldface Black-on-white.
H. 3⅛ in. (8 cm), diam. 7⅞ in. (20 cm).
Light restoration. Private collection

Opposite below right:
Figure 35.
Bowl. Style I, Mimbres Boldface Black-on-white.
Hot Springs site.
H. 4 in. (10 cm), diam. 8⅞ in. (22.5 cm).
Department of Anthropology, University of Minnesota, Minneapolis

Right:
Figure 36.
Bowl. Style I, Mimbres Boldface Black-on-white.
H. 2 in. (5 cm), diam. 5½ in. (14 cm).
Private collection

Below right:
Figure 37.
Bowl. Early Style II, Mimbres Black-on-white.
H. 4½ in. (11.5 cm), diam 7⅛ in. (18 cm).
Light restoration. Private collection

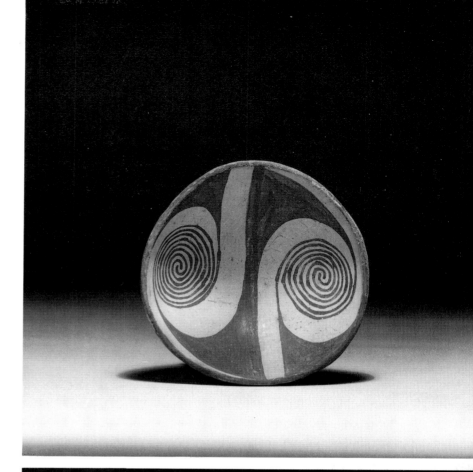

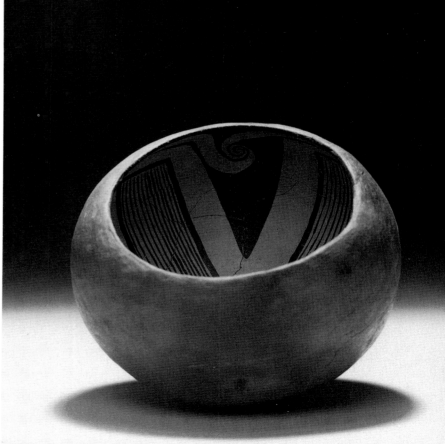

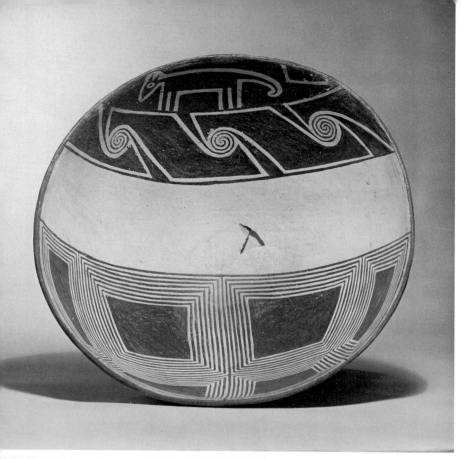

Figure 38.
Bowl. Long-tailed animal. Style I, Mimbres Bold-face Black-on-white.
H. 5¾ in. (14.6 cm), diam. 12½ in. (31.8 cm).
Moderate restoration. Private collection

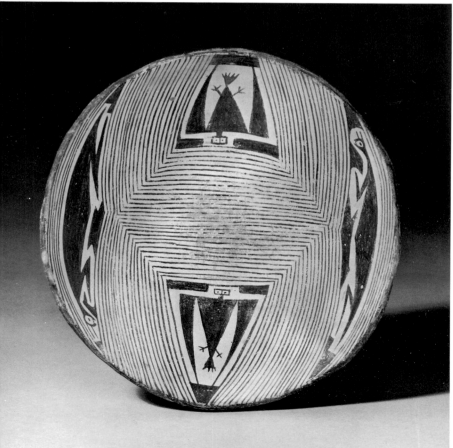

Figure 39.
Bowl. Birds and lizards. Style I, Mimbres Bold-face Black-on-white.
H. 2½ in. (6.5 cm), diam. 7⅞ in. (20 cm).
Light restoration. Laura Lee Stearns, Los Angeles

wavy lines are often used in circular designs such as spirals (figure 34) and as the filler element in fields of hachure (figure 33). Wavy lines are also used to define the edge of a solid motif, such as a triangle or rectangle, which gives the motif a toothed or ruffled appearance, a feature already in evidence on the earlier Three Circle Red-on-white bowls (colorplate 9).

The designs of most Style I bowls fall into one of three types of layout: first, where the surface is divided into quadrants (colorplate 9); second, where the layout is circular (figure 34); and third, where the design extends in unbroken fields across the surface of the bowl (figures 33, 35). In the quadrant layout the bowl's surface is divided into four roughly equal parts, each containing a version of the same design. One of the earliest found on Style I bowls, this layout had often been used on the earlier Mogollon Red-on-brown vessels as well as on the Three Circle Red-on-white pottery. While subsequent continuous-field layouts took little account of the shape of the "canvas," the circular layouts that appear later in Style I definitely stress the circular shape of the surface receiving the paint (figure 34). In a few instances the surface of Style I bowls was divided into two equal parts, with the design in each half forming an inverted mirror image of the other (figure 36).

Motifs commonly used on Style I bowls include the single scroll and the interlocking scroll, both of which are frequently shown extending outward from solid triangular motifs (figure 36; see figure 37 for an early Style II example). A motif resembling a set of nested squares or rectangles (figures 38, 39) is one of several motifs retained from the earlier Three Circle Red-on-white and Mogollon Red-on-brown styles, and it is also found on pottery vessels made by some of the Mimbres' neighbors. As already noted, solid motifs with toothed edges were also retained from Three Circle Red-on-white style. On both Three Circle Red-on-white and Style I Black-on-white bowls, the wavy line which defines the edge of the solid motif is usually rounded and irregular (colorplate 9). In later Style II and III examples, the "teeth" become more angular and more regularly spaced, giving the impression of a fine stepfret.

Crosshatching executed in straight, coarse lines is also found on Style I bowls, most frequently in a rectangular or triangular motif used as the principal design in a quadrant layout. Quite a few examples of crosshatching have been found on bowls that display both the wavy line hachure typical of Style I and the straight-line hachure that is characteristic of Style II. Crosshatching does not appear on bowls whose other features are typical of early Style I, and consequently it is likely that crosshatched motifs were introduced toward the end of the Style I period.

Long, narrow rectangular motifs filled with wavy-line hachure are frequently employed on Style I bowls. Sometimes these motifs are used as continuous, unbroken fields (figure 33). On other Style I bowls, the rectangular hachure motifs are set out within quadrants (figure 40); this design is one of the earliest examples of a

Figure 40.

49

Figure 41.

Figure 42.

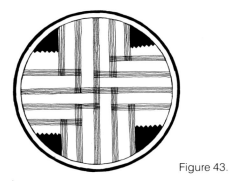

Figure 43.

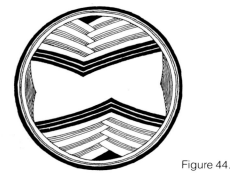

Figure 44.

stylistic sequence that can be traced from Style I through Style II and into late Style III (figures 41–44).

Figurative motifs appear rarely on Style I bowls. Those that do appear (figures 38, 39) show notable similarities—as in the case of Style I geometrics—to the motifs found on ceramics from the Hohokam region of southern Arizona. A particularly striking resemblance to Hohokam motifs is seen in the pair of lizards and pair of birds shown in figure 39.

Mimbres Black-on-white Style II and Early Style III
The most important diagnostic feature of Mimbres Style II design is the use of hachure formed by parallel straight lines framed by thick lines, which replaces the wavy-line hachure found on Style I bowls.[11] Occasionally, on pieces that bridge Styles I and II, both forms of hachure are seen. On early Style II bowls, the interior hachure lines are coarse and uneven (figure 37). Finer, more carefully painted interior hachure lines are found on later Style II bowls (colorplate 12, figure 45). While early Style II hachure was usually employed to fill long, narrow rectangular motifs with longitudinal lines (figures 37, 41), on later bowls the shape and placement of hachure motifs were varied, with the interior hachure lines often intersecting obliquely with the heavy framing lines (colorplates 12–14, figures 46, 47).

The refinement in the execution of Style II hachure was part of a general movement away from the coarse linework on Style I and early Style II bowls to the finer linework and careful execution found on later Style II and Style III bowls. Concurrently, we see more complex designs and more varied motifs. This trend toward greater design complexity escalates during the Style III years.

On early Style II bowls the design continues up to the rim of the bowl (figures 47, 48, colorplate 15); later the painted zone is bordered by a thick line or band running parallel to and just below the rim (colorplate 12, figures 45, 46). On these examples of Style II and also early examples of Style III, the painted design touches the rim band and gives the impression of being suspended from it. Rim bands set entirely apart from the painted design are a distinguishing feature of Style III and are rarely found on late Style II bowls. We can see a clear chronological progression in the position of the design in relation to the bowl's rim: at first, the design extends to the rim (colorplate 15, figures 48, 49); later, it is separated from the rim by a rim band, which remains attached to and incorporated into the design (colorplate 12, figures 45, 46); and finally, the rim band is detached entirely from the principal painted design. Rare transitional examples can be found in which a portion of the design extends to the rim while the remainder is suspended from a rim band (colorplate 14).

As in the case of individual motifs, the design layouts on Style II bowls show increasing complexity and sophistication. The simple quadrant layout found on Style I and earlier painted bowls is only occasionally seen on early Style II bowls (figures 37,

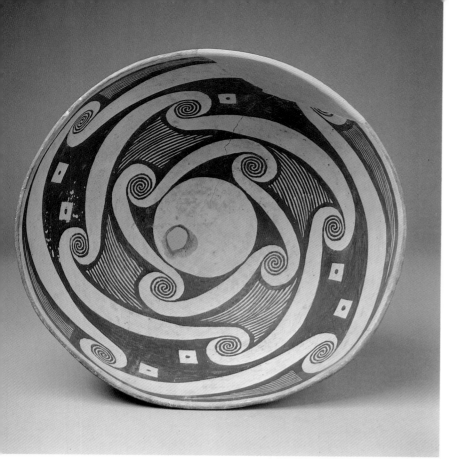

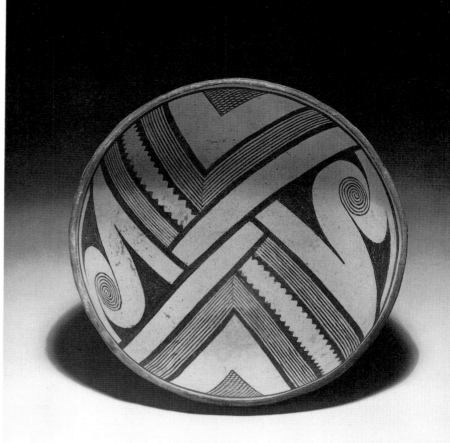

41), but more complex quadrant design layouts are commonly found on late Style II (colorplate 12) and early Style III bowls (colorplates 3, 37, figure 77). Style II bowls are often divided into halves, rather than quadrants, with a mirror image (colorplate 15, figure 48) or an inverted mirror image (figure 45) in each half. Although continuous-field design layouts are rarely seen on Style II bowls, designs that are strongly circular in organization are frequent. A late Style II bowl shows a beautifully executed set of interlocking scrolls (colorplate 12). This circular arrangement of interlocking scrolls and curvilinear motifs occurs on late Style I, Style II, and Style III bowls; however, the execution and the accompanying motifs change remarkably. In late Style II and Style III examples (colorplate 37, figure 121), the design becomes more intricate and includes a greater number of diverse motifs. On other Style II bowls, however, scrolls are used in design layouts that are not strongly circular in combination with other motifs (figure 45).

During the years of black-on-white pottery production there is a stylistic progression in the use of long, narrow rectangular motifs filled with hachure and arranged in quadrants. The organization of this design on early Style II bowls (figure 41) is the same as that found on late Style I bowls (figure 40), but the wavy-line hachure has

Above left:
Colorplate 12.
Bowl. Late Style II, transitional to Mimbres Classic Black-on-white. Swarts Ruin.
H. 5½ in. (14 cm), diam 12 in. (30.5 cm).
Light restoration. Peabody Museum of Archaeology and Ethnology, Harvard University, Cambridge, Mass.

Above right:
Figure 45.
Bowl. Late Style II, transitional to Mimbres Classic Black-on-white.
H. 4½ in. (11.5 cm), diam. 9⅞ in. (25 cm).
Light restoration. Private collection

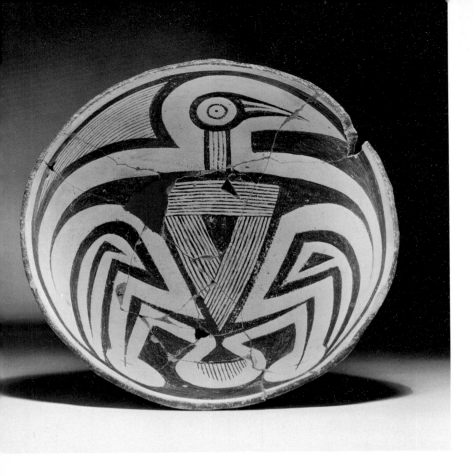

Figure 46.
Bowl. Bird image. Late Style II, transitional to
Mimbres Classic Black-on-white.
H. 3¾ in. (9.5 cm), diam. 8½ in. (21.6 cm).
Mr. and Mrs. Charles M. Diker, New York

been replaced by Style II straight-line hachure. On early Style III examples (figure 42), the thick framing lines are discarded. The number of lines within each rectangular motif decreases, while the number of rectangular motifs in each quadrant increases. The orientation of the motifs is altered to form V-shaped or chevron-like configurations. A slightly later example shows the design suspended from a thin rim band (figure 43). These V-shaped linear motifs continue to be used in combination with other motifs on late Style III bowls (figure 44).

The "toothed" line appears in Style II, possibly as an alternative to the wavy line popular with the painters of Style I bowls. This motif was formed by superimposing a zigzag over a straight line (colorplate 15). The wavy line that was often used to define the edge of a solid motif on Style I bowls now becomes more angular and more regularly spaced (figures 45, 49). On late Style II and early Style III examples, a fine stepfret appears that may have been derived through a further modification of this motif (figures 77, 117).

Both nonfigurative and figurative images portrayed in negative form are included among the motifs on Style II bowls (colorplate 12, figure 48). During the Style II years, Mimbres painters used figurative designs more frequently than heretofore. Although

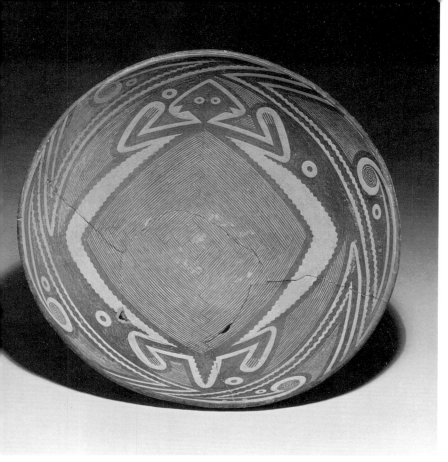

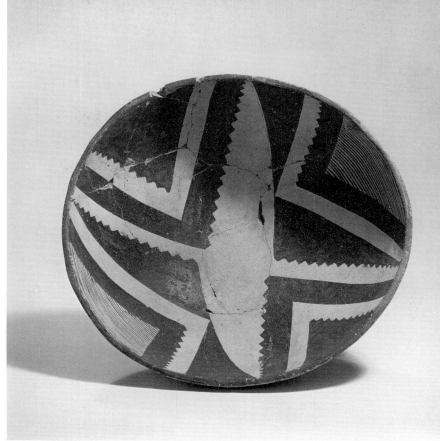

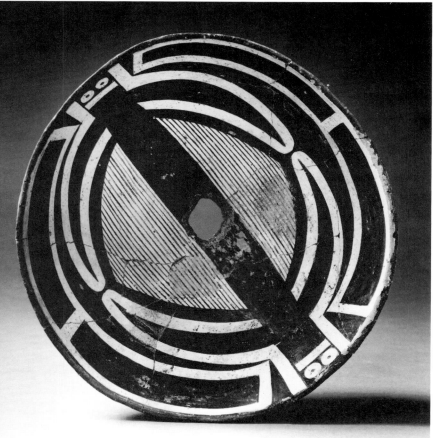

Above left:
Figure 47.
Bowl. Lizard (horned toad). Style II, Mimbres
Black-on-white.
H. 5⅛ in. (13 cm), diam. 13¾ in. (35 cm).
The Heard Museum, Phoenix, Ariz.

Left:
Figure 48.
Bowl. Winged images. Early Style II, Mimbres
Black-on-white. Swarts Ruin.
H. 2¾ in. (7 cm), diam. 7⅛ in. (18.2 cm).
Moderate restoration. Peabody Museum of Archae-
ology and Ethnology, Harvard University, Cam-
bridge, Mass.

Above right:
Figure 49.
Bowl. Style II, Mimbres Black-on-white.
H. 4 in. (10.1 cm), diam. 9⅜ in. (23.8 cm).
Brice and Helen Marden, New York

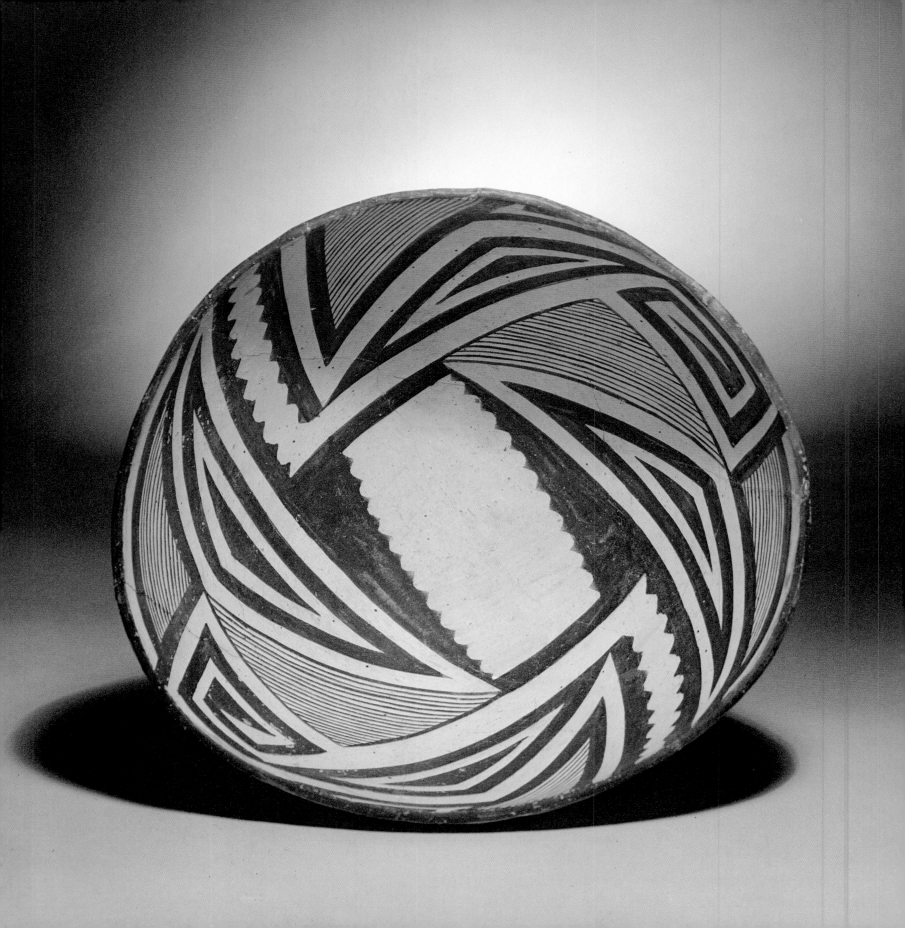

Opposite:
Colorplate 13.
Bowl. Late Style II, transitional to Mimbres Classic Black-on-white.
H. 4⅛ in. (10.5 cm), diam. 9⅞ in. (25 cm).
Light restoration. Edwin Janss, Thousand Oaks, Calif.

Right:
Colorplate 14.
Bowl. Late Style II, transitional to Mimbres Classic Black-on-white.
H. 8 in. (20.3 cm), diam. 14⅜ in. (36.5 cm).
Moderate restoration. Private collection

Below right:
Colorplate 15.
Bowl. Early Style II, Mimbres Black-on-white.
Galaz site.
H. 4⅜ in. (11 cm), diam. 9⅞ in. (25 cm).
Department of Anthropology, University of Minnesota, Minneapolis

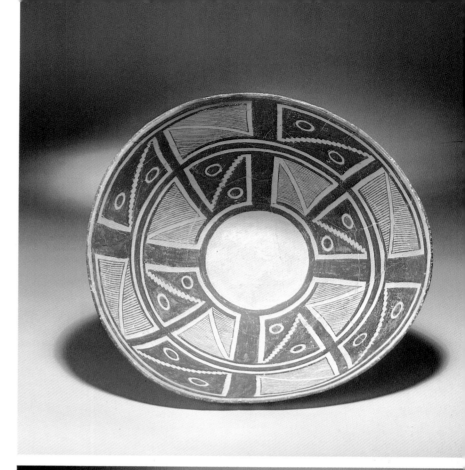

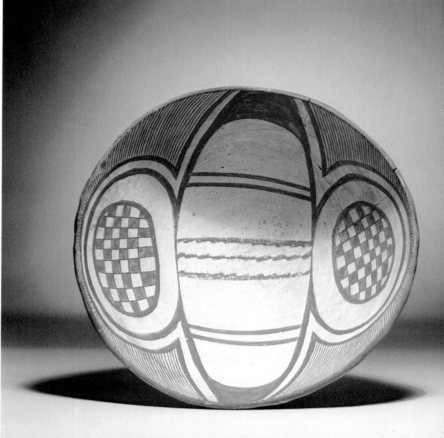

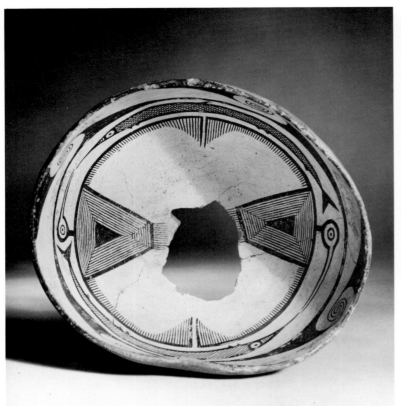 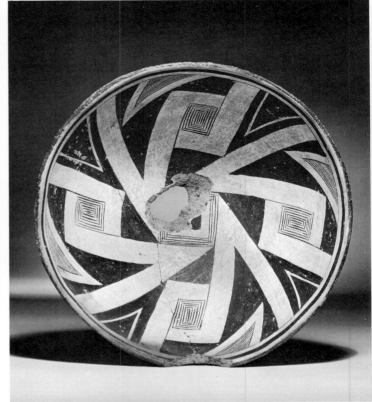

Above left:
Figure 50.
Bowl. Birds and fish. Style II, Mimbres Black-on-white.
H. 4½ in. (11.5 cm), diam. 8⅝ in. (22 cm).
Light restoration. Millicent Rogers Museum, Taos, N. Mex.

Above right:
Figure 51.
Bowl. Style III, Mimbres Classic Black-on-white. Galaz site.
H. 4½ in. (11.5 cm), diam. 10¼ in. (26 cm).
Department of Anthropology, University of Minnesota, Minneapolis

the treatment of figures begins to show the inventiveness that is apparent in Style III pieces, the Style II figuratives are often treated in stylized ways that resemble Hohokam representations of animals and birds. Birds, horned toads (figure 47), and other kinds of lizards are commonly depicted, as they are on Hohokam ceramic vessels, and the heads of birds are similarly portrayed in profile (figures 46, 50).

On the latest Style II bowls, the painters used not only the typical Style II hachure, but also the hachure motifs bordered with thin lines that are a characteristic feature of Style III designs (colorplates 13, 14). The scarcity of such transitional pieces suggests, however, that this change in the treatment of hachure motifs was rapidly accomplished.

Mimbres Black-on-white Style III
Archaeologists' descriptions of Mimbres Classic Black-on-white published in the 1930s emphasized the fineness of the painted decoration, of both the composition of

the design and the brushwork.[12] Special note was made of the use of fine, regularly spaced hachure bordered by thin lines which reflected the steady hand of the Mimbres Classic painter. It was also observed that the principal painted designs on Mimbres Classic bowls are restricted to a zone bordered by at least one rim band. While some early Style III pieces would have been called Boldface Black-on-white by these traditional criteria, later Style III closely corresponds to Mimbres Classic Black-on-white and shares these features.

The treatment of rim bands on Style III bowls displays much variety. The design on most early Style III bowls is suspended from a thin rim band (colorplate 37, figures 77, 117). However, in Style III bowls there may be a single thick band (figures 51, 52), two thick bands (colorplate 1, figures 53, 110), three thick bands (colorplate 25, figures 54, 55), several thin bands (colorplate 16, figures 56, 58), or a combination of thin and thick bands (colorplate 17, figures 59, 60). Thin lines are most frequently used as rim bands when a figurative form is to be portrayed. The single thick band, rarely seen on late Style II pieces, was apparently one of the earliest forms of rim

Figure 52.
Bowl. Style III, Mimbres Classic Black-on-white. Old Town Ruin.
H. 5½ in. (14.2 cm), diam. 11⅝ in. (29.5 cm). Moderate restoration. National Museum of Natural History, Smithsonian Institution, Washington, D.C.

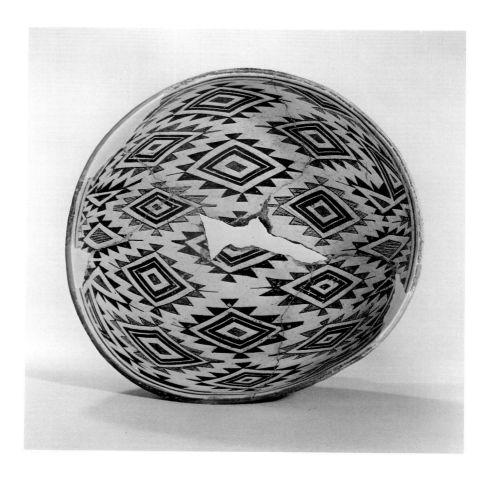

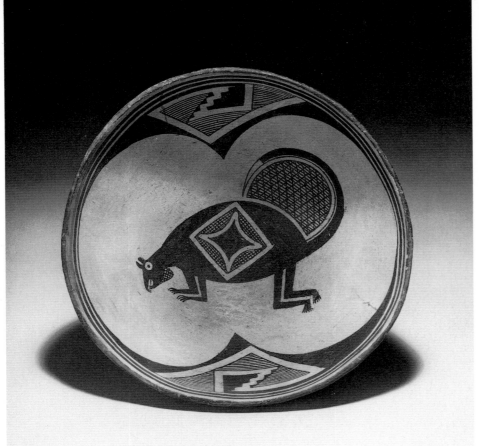

Left:
Figure 53.
Bowl. Rodent (?). Style III, Mimbres Classic Black-on-white.
H. 3⅞ in. (10 cm), diam. 10 in. (25.5 cm).
Moderate restoration. Private collection

Opposite:
Colorplate 16.
Bowl. Pair of quail on a staff. Style III, Mimbres Polychrome.
H. 4¾ in. (12 cm), diam. 10½ in. (26.6 cm).
Moderate restoration. Museum of the American Indian, Heye Foundation, New York

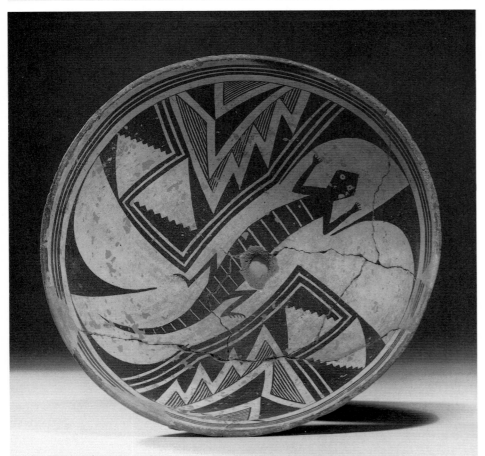

Figure 54.
Bowl. Lizard. Style III, Mimbres Classic Black-on-white.
H. 4¾ in. (12 cm), diam. 11⅜ in. (29 cm).
Light restoration. Private collection

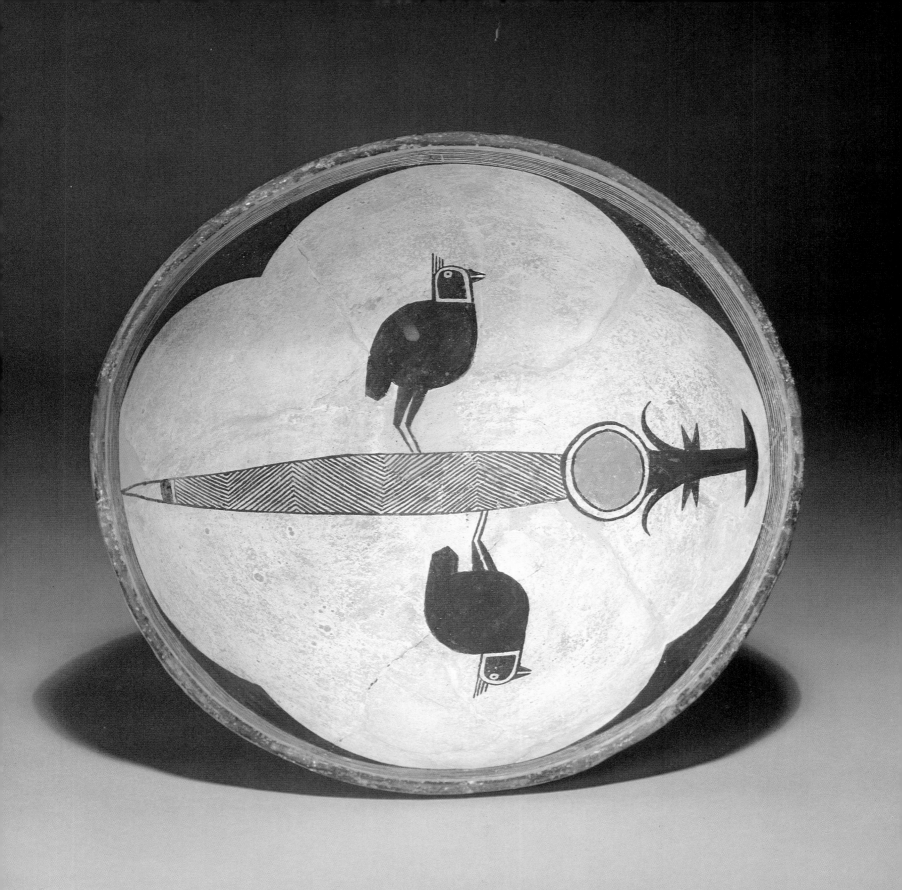

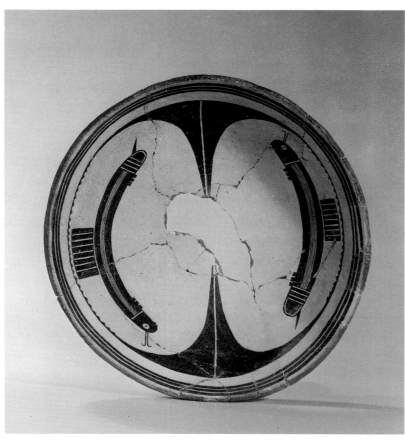

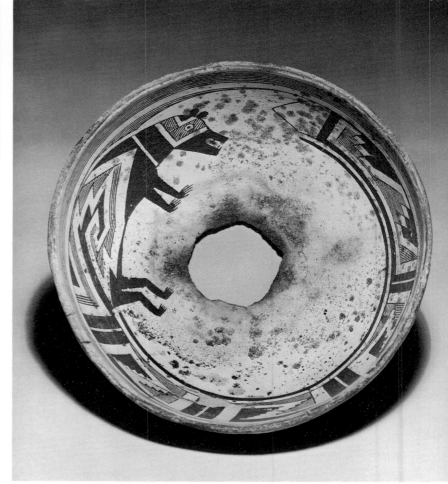

Above:
Figure 55.
Bowl. Caterpillars. Style III, Mimbres Classic Black-on-white. Mattocks site.
H. 4 in. (10 cm), diam. 9½ in. (24 cm).
Moderate restoration. Maxwell Museum of
Anthropology, The University of New Mexico,
Albuquerque

Right:
Figure 56.
Bowl. Long-tailed animal. Style III, Mimbres Classic Black-on-white. Old Town Ruin.
H. 4⅜ in. (11 cm), diam. 9⅞ in. (25 cm).
Light restoration. National Museum of Natural
History, Smithsonian Institution, Washington, D.C.

band. It continued to be used throughout the Style III years, however, and so some bowls with a single rim band are contemporaneous with bowls decorated with multiple rim bands. Consequently, we cannot determine the relative ages of bowls on the basis of the number or complexity of the rim bands.

The rim band is frequently mirrored by a circular band in the base of the bowl. These upper and lower bands enclose a region around the interior surface of the bowl in which geometric designs are painted (figures 61, 110). The open field in the base of the bowl may contain a figurative depiction (figure 121).

Not long after the appearance of Style III there was an explosion of creativity that generated the development of an incredibly varied and sophisticated design vocabulary. Although few new nonfigurative design motifs were introduced, great diversity in design was achieved by altering the shape and size of basic motifs (triangles, rectangles, hemispheres, circles), by combining and connecting the motifs in different ways, and by modifying the organization of the design.

a

b

c

Figure 57.

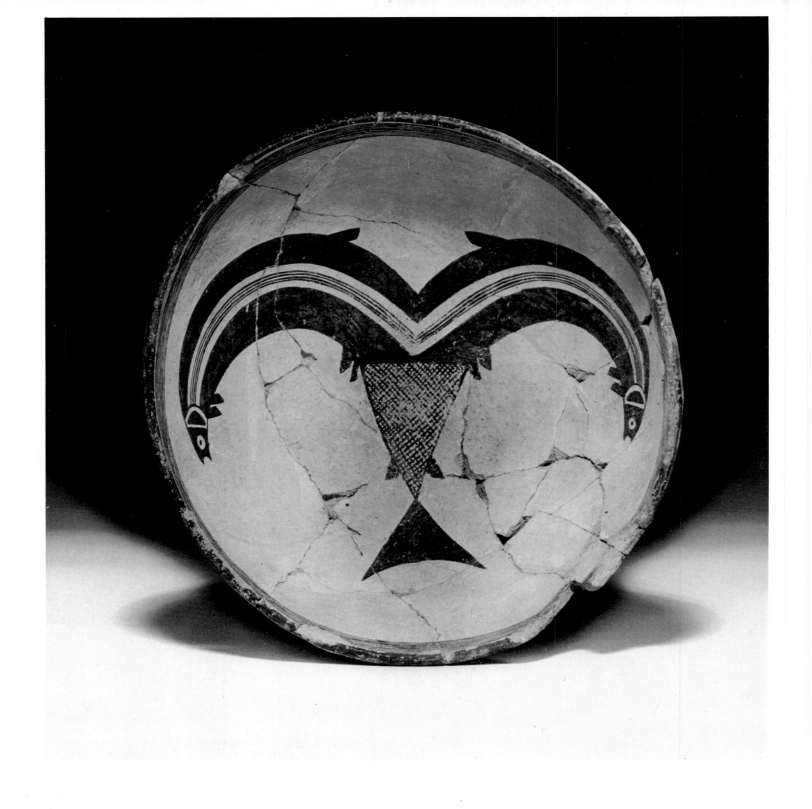

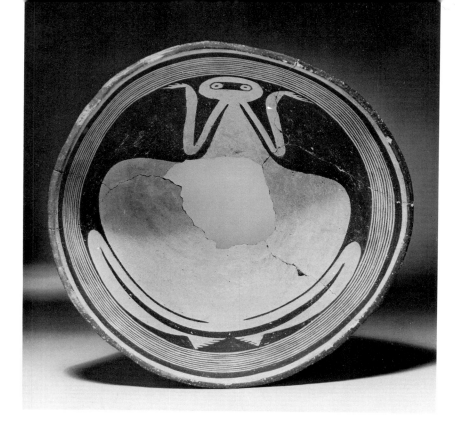

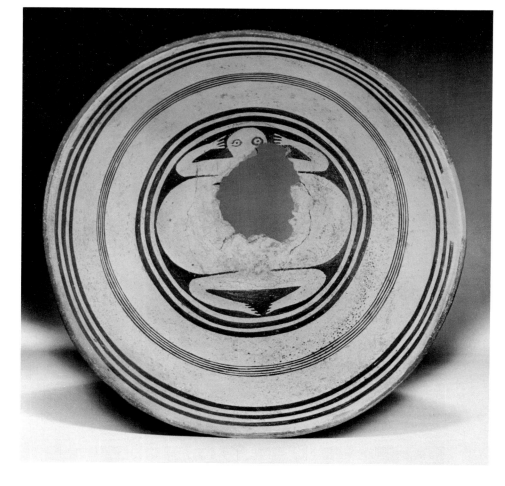

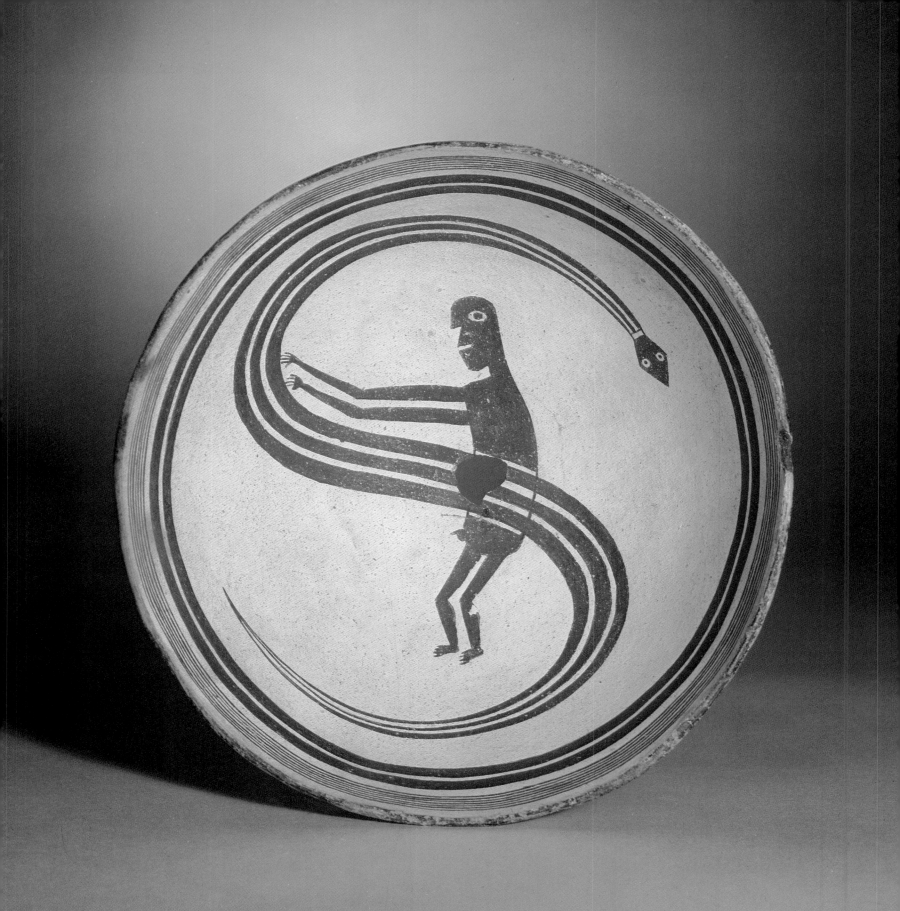

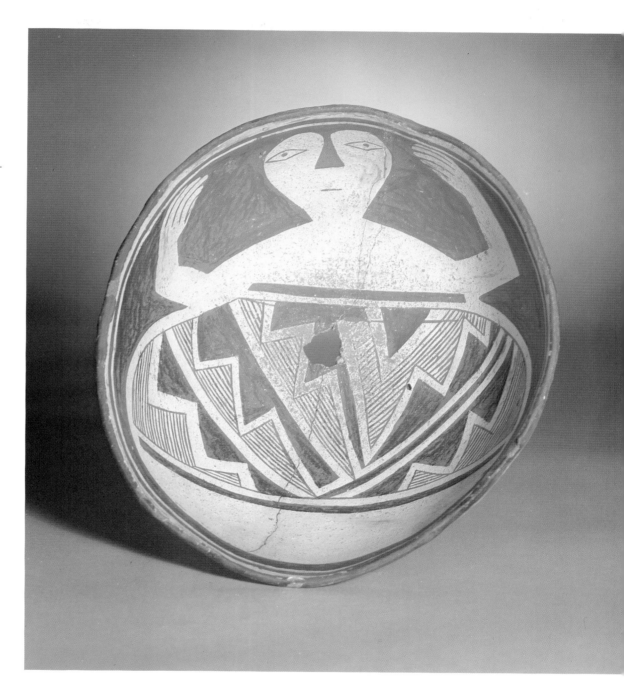

Consider, for example, the variety achieved by the Mimbres painters by making a few relatively minor changes in the simple quadrant design layout. In the earliest painted styles (Mogollon Red-on-brown through early Black-on-white Style II) the surface of the bowl was divided into four equal quadrants, with the lines defining the quadrants crossing in the center of the bowl (figures 40, 57a).

On some Style III bowls, the lines defining the painted zone within each quadrant meet at some distance from the bowl's center, leaving a star-shaped space open in the base of the bowl (figure 57b). Another variation was produced when the two lines defining the painted zone were of unequal length, resulting in an asymmetric shape (figures 44, 57c). A further variation was produced when the painted zone was

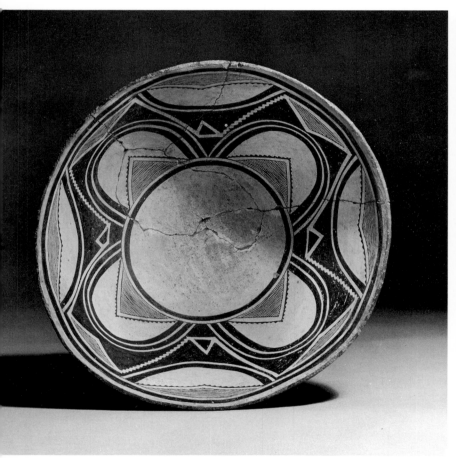

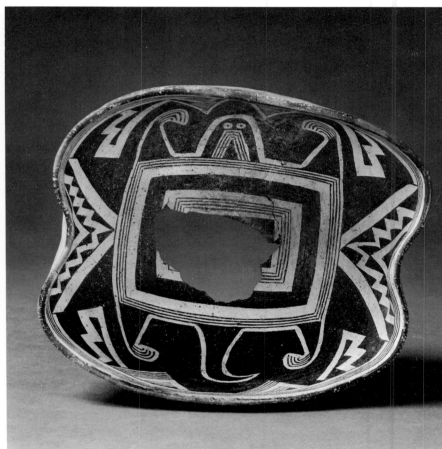

Figure 61.
Bowl. Style III, Mimbres Classic Black-on-white.
Las Dos site.
H. 5¼ in. (13.5 cm), diam. 13⅜ in. (34 cm).
School of American Research Collection in the
Museum of New Mexico, Santa Fe

Figure 62.
Bowl. Opossum (?). Style III, Mimbres Classic
Black-on-white. Swarts Ruin.
H. 3½ in. (9 cm), diam. 7¾ in. (19.8 cm).
Moderate restoration. Peabody Museum of
Archaeology and Ethnology, Harvard University,
Cambridge, Mass.

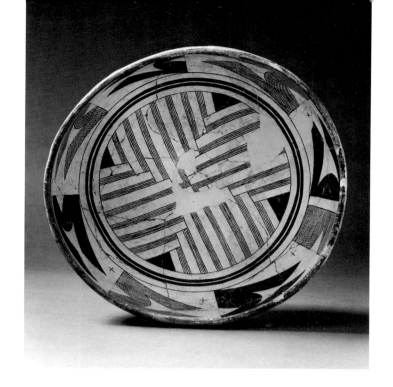

Figure 63.
Bowl. Flying birds. Style III, Mimbres Classic Black-on-white. Swarts Ruin.
H. 4⅞ in. (12.5 cm), diam. 9⅞ in. (25 cm).
Light restoration. Peabody Museum of Archaeology and Ethnology, Harvard University, Cambridge, Mass.

bordered by curvilinear rather than straight lines (figure 79). With minor changes such as these the Mimbres painters developed an astonishing number of design configurations.

Style III figurative paintings portray mammals of various kinds, birds, fish, insects, and hybrid creatures, as well as human figures. Figurative depictions are often incorporated into geometric designs (colorplate 3, figure 62), frequently through the juxtaposition of negative and positive forms (colorplate 18, figure 63). Figurative forms are also used to mimic a typical encircling band of nonfigurative design (figure 56).

The complexity of geometric design, the great variety of motifs and their arrangement, and the subtlety of figurative depictions have made it difficult to map out the later development of Mimbres Black-on-white Style III designs. On the other hand, it is just these qualities that make the study of Mimbres pottery so rewarding.

Catherine J. Scott

Notes

1. Cosgrove and Cosgrove, 1932; Haury, 1936a, 1936b.
2. Cosgrove and Cosgrove, 1932; Haury, 1936b.
3. Haury, 1936b.
4. Haury, 1936b.
5. Brody, 1977.
6. Haury, 1936b.
7. Gladwin and Gladwin, 1934.
8. Gladwin and Gladwin, 1934.
9. Cosgrove and Cosgrove, 1932.
10. Haury, 1936b.
11. LeBlanc, 1976.
12. Cosgrove and Cosgrove, 1932; Gladwin and Gladwin, 1934.

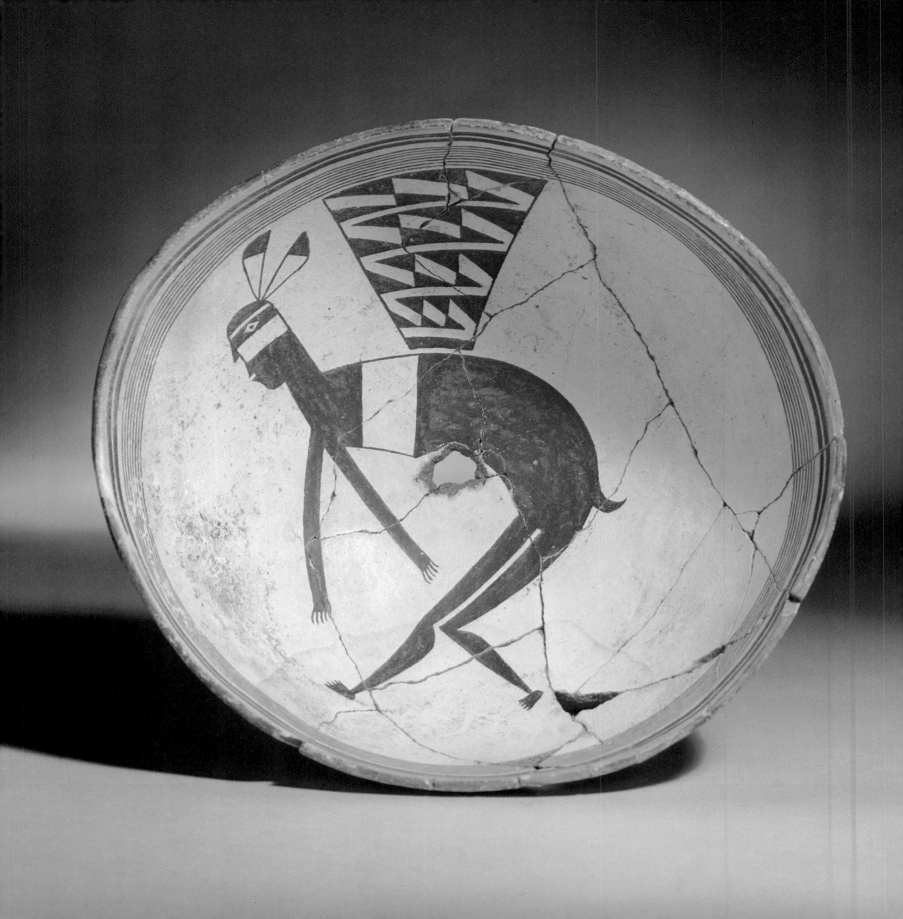

Mimbres Painting

ARTISTIC CONTEXT

All of the Mimbres art that we know was utilitarian, either everyday objects that were made beautiful, or artistic artifacts made for special occasions to serve social or ritual functions. No Mimbreño made a living by making art; it is doubtful that any made art without having a good idea about who would use it and how; and none of their art would fit a definition of art objects as "useless things."[1]

Relatively little is known about their art other than the painted pottery. A few fragmentary painted wooden objects recovered from caves in the general vicinity of the Mimbres Valley may have been made by Mimbres people, but the circumstances in which these objects were recovered have made certain cultural identification almost impossible. Many of them are wooden slats sewn together in fanlike configurations, perhaps to represent bird tails or to serve as elements of headdress and costume. Constructions that suggest puppet-like figures have also been recovered. Carved and painted wooden and stone figures are known, but again, most are without clear cultural associations. Far more common and infinitely better documented are ornaments of shell, bone, and stone recovered from Mimbres village sites (colorplate 7a, c, and figure 23a, b). Many of these portable objects are virtually identical to ornaments known to have been made by the neighboring Hohokam, and their identification as a Mimbres art may be doubted.[2] Other ornaments, including compact and robustly carved stone animal figures, closely resemble those used by northern Mogollon people (figure 21).

Other kinds of Mimbres art are best known from pictures on Mimbres pottery. Large conical burden baskets with flaring rims (colorplates 19, 20), flared-rim basketry bowls (figure 64), and globular baskets (figure 65) are all shown in detail on Mimbres pots. Most of these have geometric decorations similar to the designs that were sometimes painted on pottery. Patterned textiles (figure 66), painted or engraved wooden objects (colorplate 21, figure 67), body and facial decorations (colorplate 22, figure 70), masks (figure 71), featherwork (figures 72, 73), and headdresses (colorplate 5) are also pictured on Mimbres pottery.

The only other works of Mimbres art preserved in quantity are petroglyphs, such as those found in the vicinity of Cooks Peak and near the modern towns of Deming and Hatch. Important rock art sites much farther away, near El Paso, Texas, and Three Rivers, New Mexico, have also been identified with the Mimbres on the basis of resemblances—in subject matter, style, or motifs—to Mimbres pottery paintings.[3]

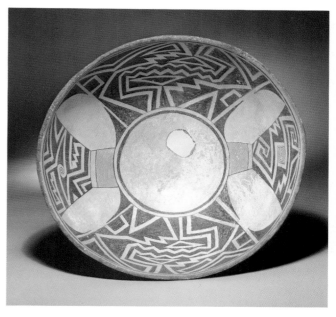

Above:
Colorplate 20.
Bowl. Pair of burden baskets. Style III, Mimbres Polychrome.
H. 6¼ in. (16 cm), diam. 13¾ in. (35 cm).
Light restoration. Private collection

Opposite:
Colorplate 19.
Bowl. Rabbit-man with burden basket. Style III, Mimbres Classic Black-on-white. Cameron Creek Village.
H. 4⅜ in. (11 cm), diam. 10¾ in. (27.3 cm).
School of American Research Collection in the Museum of New Mexico, Santa Fe

Hopi consultants generally identified this figure as a nonhuman animal with human attributes. It was called, among others, a deer, a rabbit, a coyote, and an antelope, and it was also thought to represent a deer dancer and a person costumed to represent a clan deity. Some thought the picture was intended to demonstrate that animals were really humans inside who shed their animal skins at night and then lived as humans. The picture was also thought to illustrate the changing of a human into an animal by sorcery. The design above the figure was identified as both a basket and an abstraction. One man thought that the zigzag lines could represent the psychic energy involved when humans are changed into animals and that the design might be the emblem of a witchcraft society (Weslowski 1979:4–5).

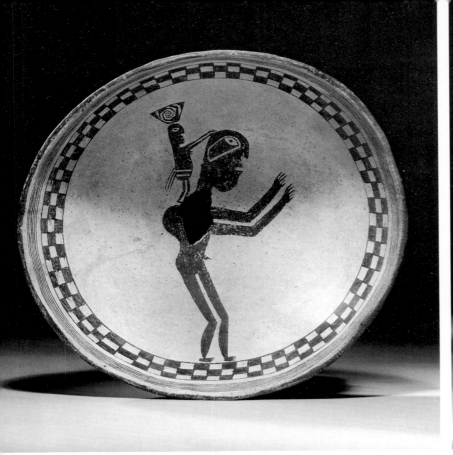
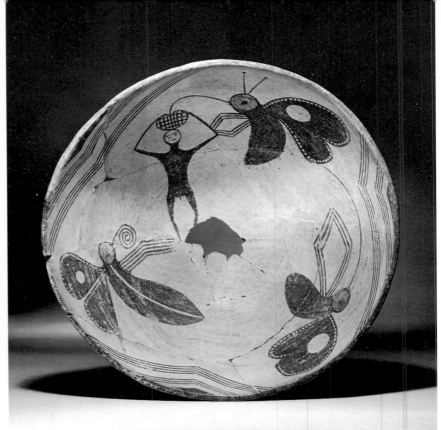
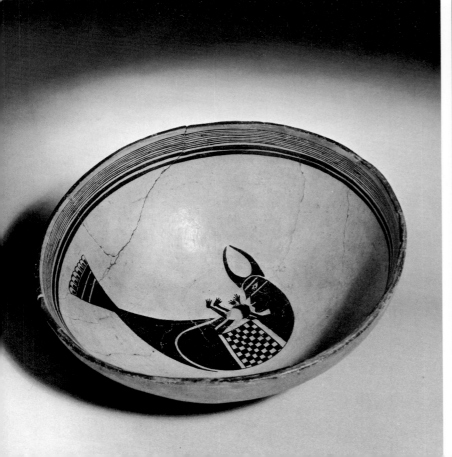
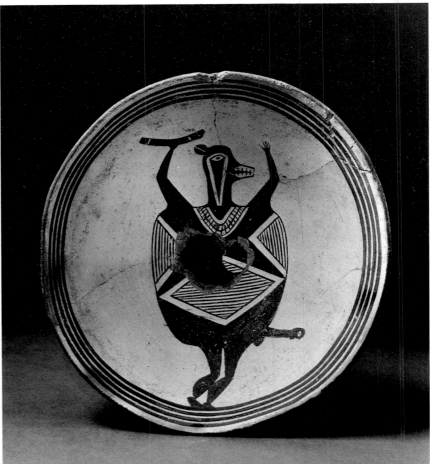

Opposite far left:
Figure 64.
Bowl. Humpbacked man with woman and basket.
Style III, Mimbres Classic Black-on-white.
H. 3½ in. (9 cm), diam. 8⅝ in. (22 cm).
Light restoration. Laura Lee Stearns, Los Angeles

Opposite left:
Figure 65.
Bowl. Nectar-eating insects, man with basket.
Early Style III, Mimbres Polychrome. Goforth site.
H. 4½ in. (11.3 cm), diam. 10⅝ in. (27 cm).
Light restoration. Western New Mexico University
Museum, Silver City

Fred Kabotie called this painting *The Butterfly
Charmer.* He thought the insects combined attri-
butes of the Monarch butterfly and the Sphinx
moth and suggested associations with a butterfly
clan and perhaps a woman's society similar to
that which performs the Basket Dance at Hopi.
He identified the human as a woman on the basis
of its actions (Kabotie 1982:27–28).

Right:
Figure 68.
Petroglyph, Mimbres Valley. (©1982, Dan Budnik)

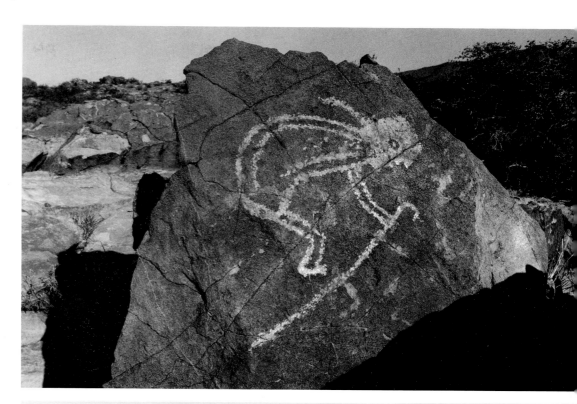

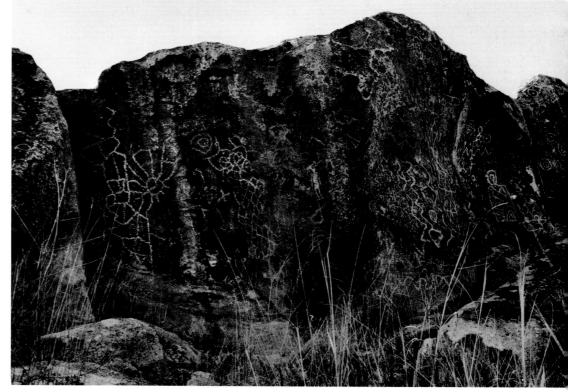

Opposite far left:
Figure 66.
Bowl. Crouching man with bird tail, horns on
head. Style III, Mimbres Classic Black-on-white.
H. 4⅜ in. (11 cm), diam. 10⅝ in. (27 cm).
Light restoration. Taylor Museum of the Colorado
Springs Fine Arts Center

Opposite left:
Figure 67.
Bowl. Dancing man-bear. Style III, Mimbres Clas-
sic Black-on-white. Swarts Ruin.
H. 3½ in. (9 cm), diam. 9 in. (23 cm).
Light restoration. Peabody Museum of Archaeol-
ogy and Ethnology, Harvard University, Cam-
bridge, Mass.

Right:
Figure 69.
Petroglyphs, Mimbres Valley. (©1982, Dan Budnik) .

71

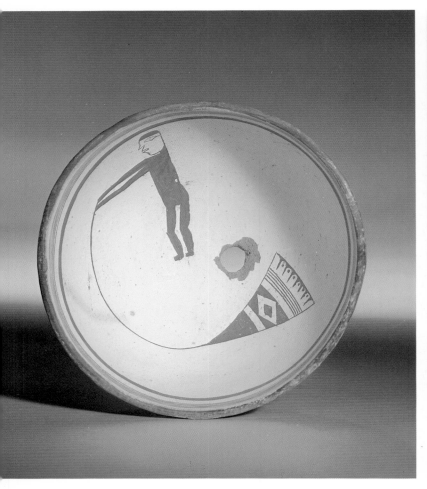

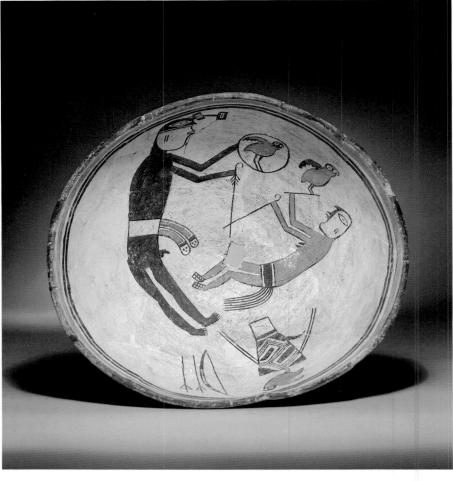

Colorplate 21.
Bowl. Man whirling a bull-roarer. Style III, Mimbres
Classic Black-on-white. Mattocks site.
H. 3½ in. (9 cm), diam. 7½ in. (19 cm).
Maxwell Museum of Anthropology, The University
of New Mexico, Albuquerque

Colorplate 22.
Bowl. Parrot ritual. Style III, Mimbres Polychrome.
Mattocks site.
H. 5 in. (12.7 cm), diam. 10⅞ in. (27.6 cm).
Moderate restoration. Logan Museum of Anthro-
pology, Beloit College, Wis.

The birds here were identified by Hopi consul-
tants as eagles, parrots, owls, and sparrow
hawks. All agreed this represented an important
ceremony, but there was no consensus about
specifics, and identification of the birds de-
pended on the ceremonial activity that was thought
to be pictured. One person thought the black
body and eye paint on the man were warrior
society markings and two others thought the two
figures were representations of the Little War gods
(Hero Twins) (Weslowski 1979:21–22). Fred
Kabotie believed that this painting was of an
initiation ceremony (Kabotie 1982:17–18).

There is, however, almost no direct evidence to tell us when these rock pictures were made or who made them, and there are fundamental conceptual differences between the rock art and Mimbres pottery paintings. Most pottery pictures are organized as cohesive, self-contained compositions within framed spaces. Most of the rock pictures identified as Mimbres are individual images placed on borderless expanses of rock wall. These images do not appear to be related elements within larger compositions; rather, their relationships with other images and with the environment that surrounds them are uncertain at best and often appear to be random.

Many rock art subjects, such as feathered serpents and masked figures, refer to the world of mythology and the supernatural, and to rituals associated with religion. The cultural meanings of other subjects, such as animals or geometric emblems, are less easily characterized. Because most rock art is clustered in particular locations, it is tempting to think of these locales as religious shrines and to view the pictures as icons that functioned like the representations of historic religions and cults. There is, in fact, little evidence to support any specific hypotheses about how the rock art images were used or why they were made.

Figure 70.
Bowl. Two figures and two flowers. Style III, Mimbres Classic Black-on-white.
H. 6 in. (15.2 cm), diam. 13 in. (33 cm).
Moderate restoration. Private collection

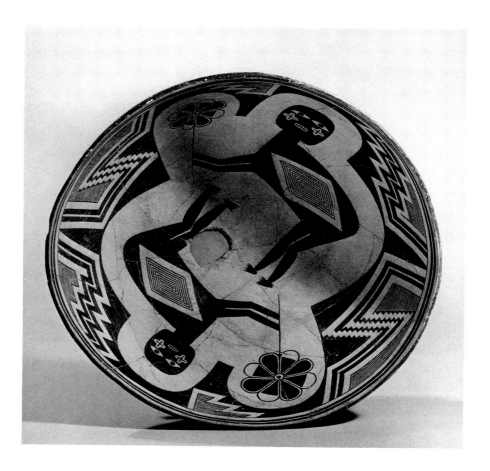

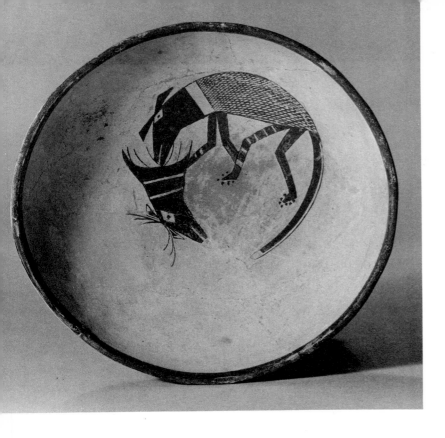

Figure 71.
Bowl. Armadillo with deer mask. Style III, Mimbres Classic Black-on-white.
H. 3⅜ in. (8.5 cm), diam. 8⅛ in. (20.5 cm).
Moderate restoration. Southwest Museum, Los Angeles

The motifs and patterning of the Mimbreños' paintings on pottery show many resemblances to their basketry and textile designs. Likewise, the subject matter and style of their representational paintings are echoed in the rock art and carved ornaments that have also been attributed to the Mimbres. There are many more surviving examples of their painted pottery than of their other arts, and much more is known about the uses of these paintings than is known about the other art they produced. But the importance of Mimbres paintings goes beyond numbers or knowledge. To a surprising degree, Mimbres pottery paintings are like the easel paintings of our own traditions. They are familiar to us conceptually and, therefore, form an intellectual bridge linking these alien and ancient people to ourselves.

MEDIA, STRUCTURE, AND FORM

Pottery painting was a widespread domestic skill practiced by most ancient agrarian people of the American Southwest and of northern Mexico. In its earliest stages, Mimbres painted pottery was only a local variant within this area-wide tradition of pottery making, but by the time of its maturity during the Mimbres Classic period, it had evolved into a distinct style that placed unusual stress on only a few characteris-

74

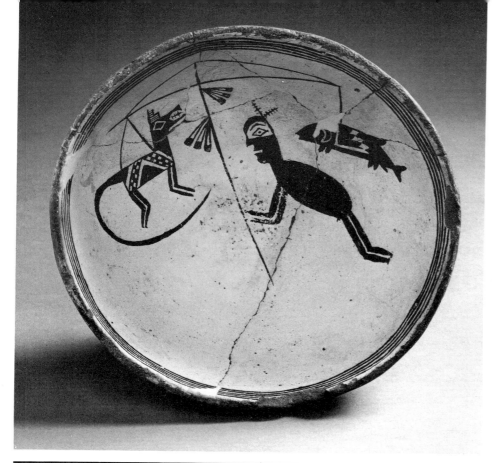

Figure 72.
Bowl. Man balancing a fish and a dog suspended from a staff. Style III, Mimbres Classic Black-on-white. Swarts Ruin.
H. 3⅛ in. (8 cm), diam. 7½ in. (19.1 cm).
Light restoration. Peabody Museum of Archaeology and Ethnology, Harvard University, Cambridge, Mass.

Fred Kabotie called this the *Man with a Staff* and suggested that the central figure was a person of high ceremonial ranking shown acting as a mediator in a dispute between two opposing clans. The clan emblems, a fish on the right hand and a fierce animal on the left, are balanced on the staff and thus shown to be of equal importance. The dark paint on the man's body was thought to be blue clay (Kabotie 1982:25–26).

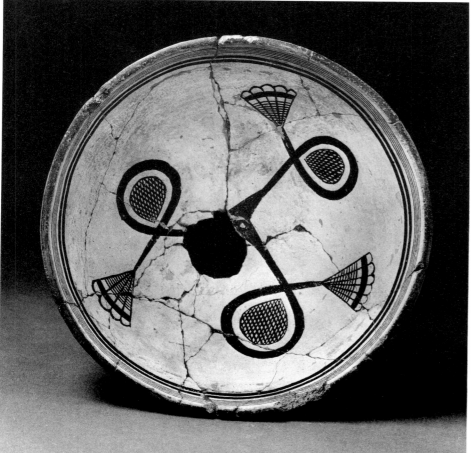

Figure 73.
Bowl. Three bird-tails. Style III, Mimbres Classic Black-on-white. Swarts Ruin.
H. 3⅞ in. (9.8 cm), diam. 9¼ in. (23.5 cm).
Light restoration. Peabody Museum of Archaeology and Ethnology, Harvard University, Cambridge, Mass.

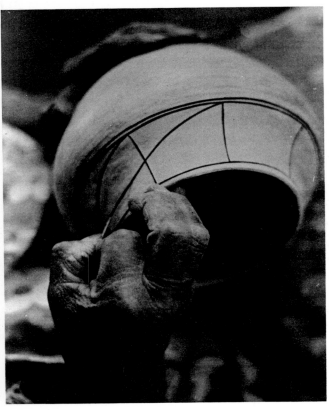

Figure 74.
Ácoma potter, Santana Antonio, at work, ca. 1978.
(Courtesy, Acoma Museum, Acoma Pueblo, N.
Mex. Photograph, Janice McDonough)

tics of the regional tradition. The vast majority of Classic Mimbres paintings are made on the interiors of simple hand-molded bowls. The exteriors of these containers were roughly finished, unslipped, marred by firing clouds, and, when compared to the interiors of the same vessels, appear to be deliberately rustic. Bowl interiors were smoothed, polished, and covered with a fine white slip that provided the ground for the paintings that were so carefully placed on them.

While unpainted pottery vessels came in a great variety of shapes, textures, and sizes, the majority of painted vessels were simple hemispherical bowls about nine to eleven inches across and three to four inches deep. An occasional piece is as small as three inches across or as large as eighteen inches. There are deep, flat-bottomed bowls, others with complex rim shapes, and some that are rectangular (figure 62). Paintings were also made on jar exteriors (figure 32), on figurines (colorplate 11), and on other forms. Clearly, the Mimbreños had the technology and the skills to create a variety of forms, and the simplicity and consistency of the shape and size of most of their painted vessels appear to reflect a deliberate exercise of choice on the part of the potters. The careful preparation of the surfaces to be painted and the standardization of the shape, size, and proportions of these surfaces suggest that many vessels were considered less as containers than as surfaces on which to make paintings.

The vessels were formed of native clays that were cleaned, aged, and tempered. They were hand-molded of coils that were welded together while plastic and then scraped smooth, dried, slipped, polished, painted, and fired. The slip was a fine kaolin clay and the paint was of iron-bearing minerals. Self-consuming outdoor ovens, usually designed to produce a reducing atmosphere, were used to fire the pots, so that the end product showed black lines on a bright white surface. In many instances, the paint could be red or brown and the slip pink or tan if oxidation occurred late in the firing process. In fact, a large number of Mimbres painted vessels are red, buff, brown, or tan rather than black on white.

We can never know if the same individuals who made the pots also painted them, and we can only assume that the potters were women, as is the case today among southwestern Pueblo people. The diversity of practices observed during historic times among the Native Americans of the Southwest and northern Mexico would seem to lend support to almost any reasonable assumptions about the gender of Mimbres potters and painters. In any case, the technology of painting was a relatively simple one that required a steady hand and keen imagination but no lengthy apprenticeship.

A liquid vehicle—probably water—was used so that the mineral paint could be applied with a brush. It is likely that the brush was made of a fibrous plant, such as yucca leaf, that was trimmed to size and softened by chewing. It was cut square at the tip, was relatively long though with a short handle, had little spring to it, and when

Above:
Figure 75.
Bowl. Style II, Mimbres Black-on-white.
H. 4⅛ in. (10.5 cm), diam. 8⅜ in. (21.3 cm).
Light restoration. Private collection

Above right:
Figure 76.
Bowl. Style III, Mimbres Classic Black-on-white.
H. 5⅜ in. (13.5 cm), diam. 9½ in. (24 cm).
The Heard Museum, Phoenix, Ariz.

Right:
Figure 77.
Bowl. Early Style III, Mimbres Classic Black-on-white. Mattocks site.
H. 5½ in. (14 cm), diam. 12⅝ in. (32 cm).
Moderate restoration. Museum of New Mexico
Collections, Santa Fe

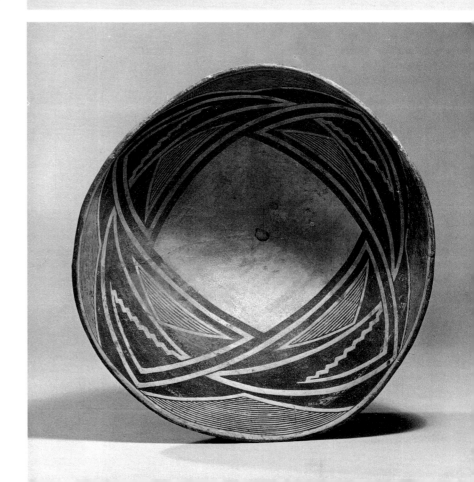

wet would cling to a surface so that it could follow the contours of a concave-shaped bowl leaving a firm and even-sided line. That line, once made, was difficult to remove without leaving evidence of the erasure. This technology put a premium on planning and the decisive application of paint (figures 75, 76).

Most Mimbres paintings are monochromatic and untextured. Line is a basic visual element and even-sided, evenly applied contour lines are characteristic. Blocks of opaque black were used to fill spaces whose outlines had previously been delineated. Other kinds of space fillers included fine line hachures and, in the type called Mimbres Polychrome, a semiopaque red-brown slip.

VISUAL ORGANIZATION

Figure 78.
Bowl. Style III, Mimbres Classic Black-on-white. Swarts Ruin.
H. 2⅜ in. (6 cm), diam. 6½ in. (16.5 cm). Light restoration. Peabody Museum of Archaeology and Ethnology, Harvard University, Cambridge, Mass.

Two distinct classes of subjects are seen in Mimbres painting: representational or figurative; and nonrepresentational, nonfigurative, or geometric. Different compositional systems were used in treating the two classes of subjects, but these systems were related and overlapping. Representational images were usually isolated within framed voids, while nonrepresentational subjects were usually integrated within

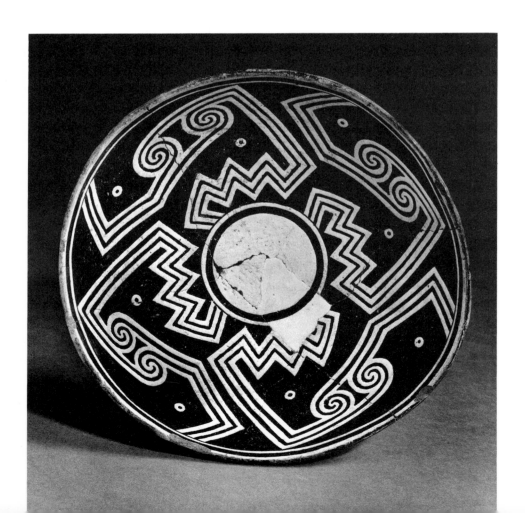

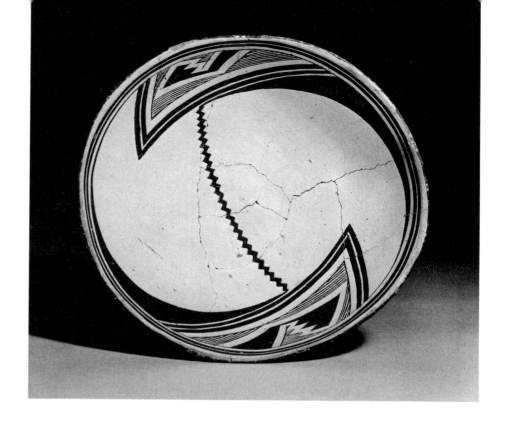

Figure 79.
Bowl. Style III, Mimbres Classic Black-on-white.
Pruitt site.
H. 4⅜ in. (11 cm), diam. 9½ in. (24 cm).
Arizona State Museum, University of Arizona,
Tucson

complex geometric assemblages. The Mimbreño aesthetic system may not have been formally stated, but its consistency suggests that the makers and users of the art all understood a shared set of rules, and indeed, that art criticism may well have been consciously practiced.

All Mimbres compositional schemes achieve an immediate impact. The ideal shape of the painting surface was a small, moderately deep and concave sub-hemisphere that could be held in the hands easily and was mobile. Therefore, the ideal image could be correctly read from any angle and had no top or bottom. By Mimbres Classic times, the outer margin of the painting area was framed by a series of rim bands that effectively isolated the picture from its surroundings. Nonfigurative paintings within that frame, as in earlier times, were usually subdivided into four symmetrically balanced units, each a visually complex arrangement of lines and masses that were generally oriented to the center of the picture space (figure 61) This four-part structure, which is potentially so static, was made complex in a great variety of ways which tended to create visual dynamics (figures 77, 78). By Classic times, the division of a vessel into four equal quadrants was not always obvious and by then, emphasis on the center of a bowl was increased by leaving a large, blank framed space there (colorplate 1). This restricted the available picture space to a band encircling the walls of the vessel. Even in these pieces the lines that often divide the band into quadrants may appear to converge in the center of the vessel.

1. Four equal wedge-shaped segments, each with the same pattern

2. Four equal wedge-shaped segments, with a different pattern in each pair of opposed wedges

3. The bisecting lines are offset, wedges rotate, wedges filled as in 1 or 2

4. Wedges rotate about a reserved design area in the center

5. The related parts of an image are in a quartered pattern, the bisecting lines are implied

6. An overall "wallpaper" pattern which can be extended indefinitely

7. Same as 1 through 5 but division is into three segments

8. Same as 1 through 5 but division is into five or more segments

9. Division into three segments along a vertical axis, the center usually dominant

10. Division along the horizontal plane, wall pattern dominates, center reserved

11. Central picture space dominates, top-bottom orientation with side-wall painting as a frame

12. As in 11 but with the figure in the central picture space curved to avoid top-bottom orientation

13. Figure in central space integrated with frame; orientation is top-bottom

14. Pair of opposed but non-interacting figures within framed space; the picture space is implicitly divided into two separate units

15. Two or more figures integrated with the frame, central space blank

16. Group of interacting figures within framed picture space; each is on axis oriented to an invisible vanishing point near the bowl center

Thus the original system of organization was modified, but its concern for central forms and quadrants was continued. Ultimately, variant organizations such as division into pairs, threes, or five or more units became more common (figures 79, 81–83). Even these late designs were oriented toward the center of the painted surface, and some sort of dual division of the composition was maintained, as is evident in the variety of basic compositional schemes shown in figure 80.

Given the constraints of Mimbres compositions and picture surfaces, figurative subjects that were best perceived if given a top-bottom orientation obviously presented special problems. About twenty percent of the seven thousand or so known Mimbres paintings are figurative, and most of these depict only a single image isolated within the framed space of an otherwise blank surface (figures 84–91). Because many of these figures represent single animals whose stances suggest the presence of earth, sky, and a horizon, correct perception requires that a viewer imagine a top and a bottom and denies the mobility of the painting surface (figure 92). However, when such a painting is held in the hands, it becomes a far more dynamic and satisfactory composition than when exhibited in a stable and vertical position or reproduced flatly in a drawing or photograph. The curvature, depth, and mobility of the picture surface have important visual effects; they create active relationships between a figure and its ground which are generally lost when the

Opposite:
Figure 80.
Basic compositional schemes (layouts) of Mimbres Boldface through Classic pottery painting traditions. (Reproduced by permission of the University of New Mexico Press from *Mimbres Painted Pottery* by J. J. Brody, University of New Mexico Press, ©1977 by the School of American Research)

Below left:
Figure 81.
Bowl. Style III, Mimbres Classic Black-on-white. H. 4½ in. (11.5 cm), diam. 11⅝ in. (29.5 cm). Moderate restoration. Museum of the American Indian, Heye Foundation, New York

Below right:
Figure 82.
Bowl. Style III, Mimbres Classic Black-on-white. H. 5⅛ in. (13 cm), diam. 11½ in. (29 cm). Light resforation. Museum of the American Indian, Heye Foundation, New York

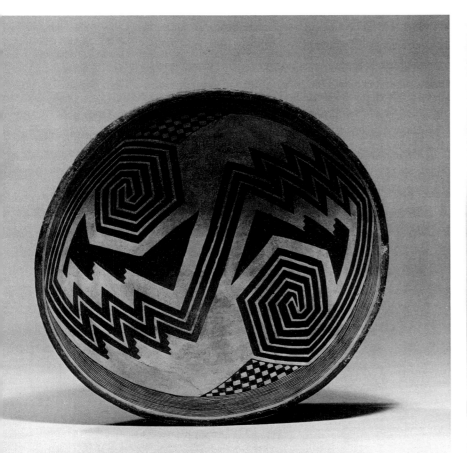

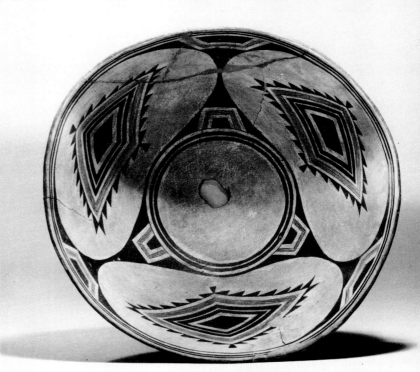

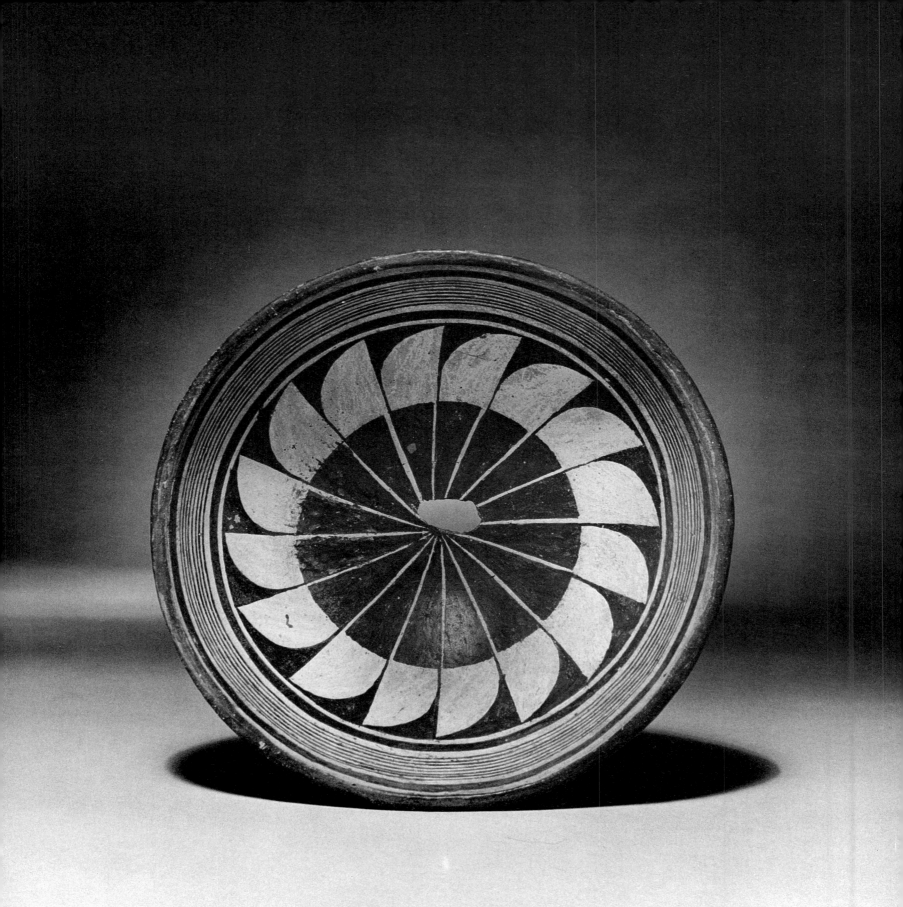

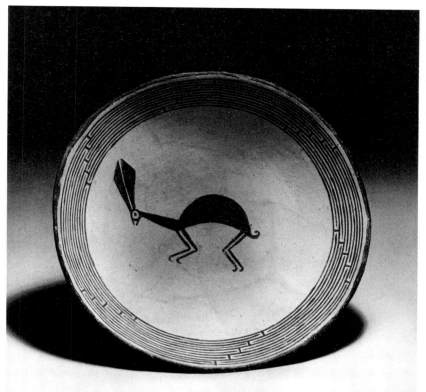

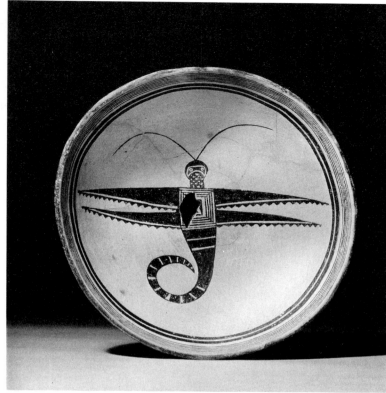

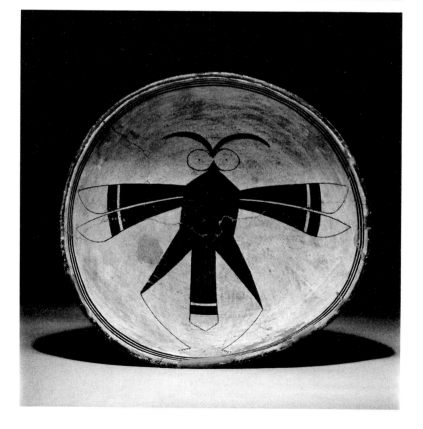

Opposite:
Figure 83.
Bowl. Style III, Mimbres Classic Black-on-white.
Galaz site.
H. 3⅛ in. (8 cm), diam. 6⅞ in. (17.5 cm).
Department of Anthropology, University of Minnesota, Minneapolis

Above left:
Figure 84.
Bowl. Rabbit. Style III, Mimbres Classic Black-on-white.
H. 3⅛ in. (8 cm), diam. 9½ in. (24 cm).
Moderate restoration. Private collection

Above right:
Figure 85.
Bowl. Dragonfly. Style III, Mimbres Classic Black-on-white.
H. 3½ in. (9 cm), diam. 10¼ in. (26 cm).
Light restoration. William Janss, Sun Valley, Idaho

Right:
Figure 86.
Bowl. Dragonfly. Style III, Mimbres Classic Black-on-white.
H. 5½ in. (14 cm), diam. 11 in. (28 cm).
Moderate restoration. Museum of the American Indian, Heye Foundation, New York

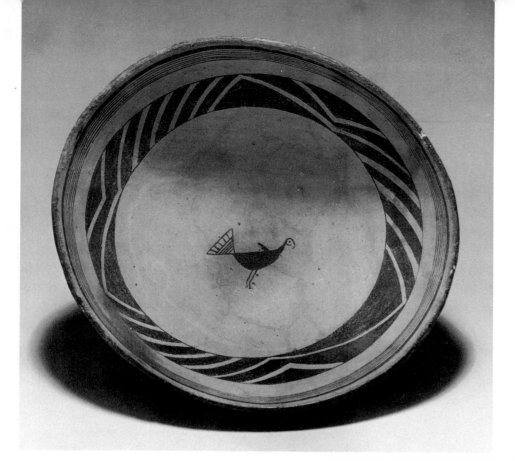

Above:
Figure 87.
Bowl. Turkey. Style III, Mimbres Classic Black-on-white.
H. 3½ in. (9 cm), diam. 9 in. (23 cm).
Moderate restoration. Private collection

Right:
Figure 88.
Bowl. Crane. Style III, Mimbres Classic Black-on-white.
H. 4⅞ in. (12.4 cm), diam. 7 in. (17.7 cm).
Light restoration. Private collection

84

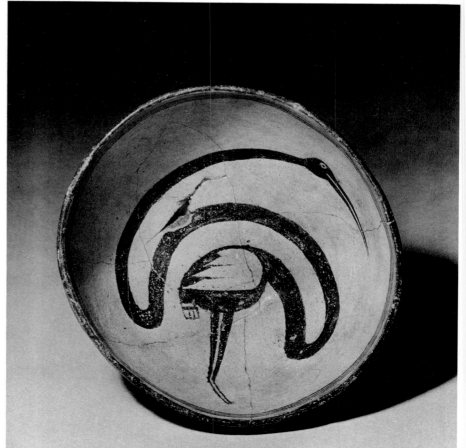

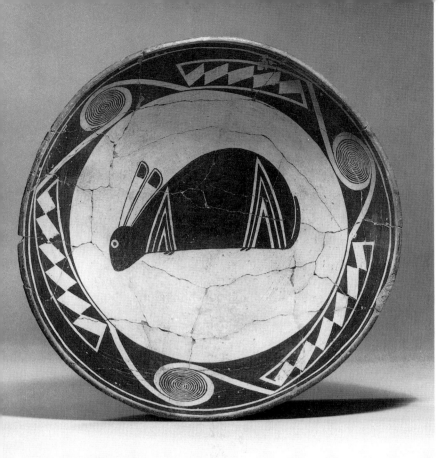

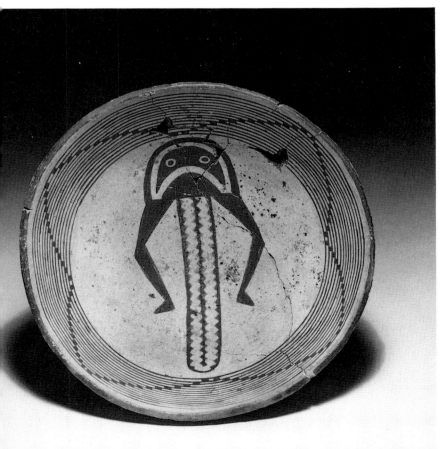

Left:
Figure 89.
Bowl. Rabbit. Style III, Mimbres Classic Black-on-white.
H. 6 in. (15.2 cm), diam. 12⅞ in. (32.7 cm).
Light restoration. William Janss, Sun Valley, Idaho

Below left:
Figure 90.
Bowl. Problematic animal. Style III, Mimbres Classic Black-on-white. Galaz site.
H. 2¾ in. (7 cm), diam. 6⅞ in. (17.5 cm).
Department of Anthropology, University of Minnesota, Minneapolis

Below:
Figure 91.
Bowl. Man dancing or running. Style III, Mimbres Classic Black-on-white. Galaz site.
H. 4⅜ in. (11 cm), diam. 8⅞ in. (22.5 cm).
Light restoration. Department of Anthropology, University of Minnesota, Minneapolis

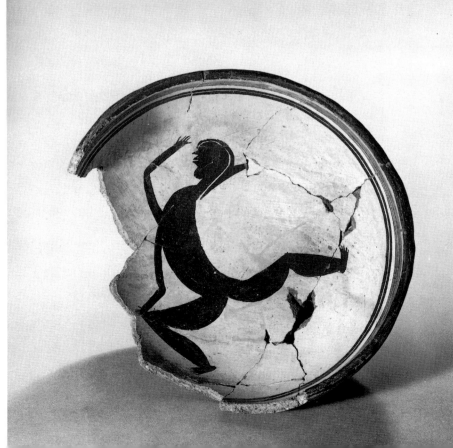

image is immobilized or reproduced in two dimensions. In short, while paintings that include such images are rarely as imaginative or complex as nonfigurative compositions, they are generally more dynamic than the reproductions suggest.

The visual organizations of figurative paintings that contain more than one image are often similar to those used for nonfigurative pictures (figure 93). The images are often integrated with geometric motifs or are organized into sets of symmetrical pairings exactly as are nonfigurative designs (figures 94–96). The common inclusion of geometric motifs within the bodies of animals also serves to integrate the two imagery systems (colorplates 23–25, figure 97).

A relatively few figurative compositions that have multiple images are less rigidly formal. In these, interactions between figures suggest real-world environments even though the contextual details are generally left to the imagination of the viewer (colorplates 26, 27, figures 98–100). The curved shape of the bowl is sometimes used to strengthen the illusion of real-world spatial relationships; this is strikingly effective when, for example, standing figures or upright objects are placed vertically on bowl walls (figures 101–103). Orientation is usually to the center of the bowl: the center itself, or an imaginary point near or below it, may act as the equivalent

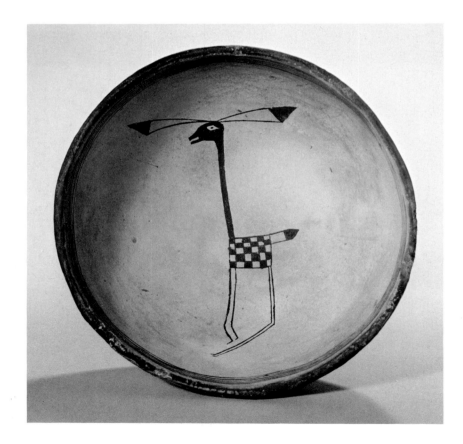

Figure 92.
Bowl. Deer. Style III, Mimbres Classic Black-on-white. Eby site no. 2.
H. 4 in. (10 cm), diam. 7⅝ in. (19.3 cm).
The University of Colorado Museum, Boulder

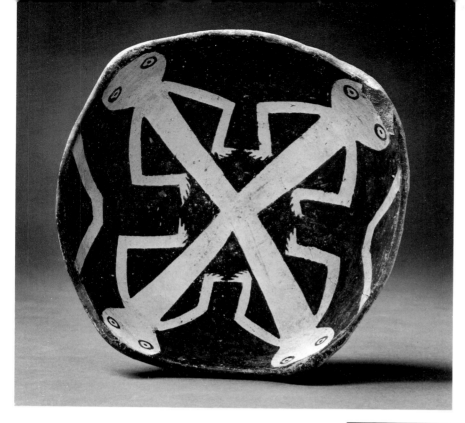

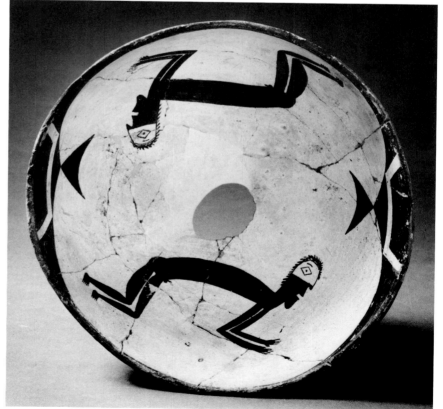

Above:
Figure 93.
Bowl. Four joined figures. Style III, Mimbres Classic Black-on-white. Swarts Ruin.
H. 2⅛ in. (5.5 cm), diam. 5½ in. (14 cm).
Peabody Museum of Archaeology and Ethnology, Harvard University, Cambridge, Mass.

Right:
Figure 94.
Bowl. Two men. Style III, Mimbres Classic Black-on-white. Swarts Ruin.
H. 4⅛ in. (10.5 cm), diam. 9⅝ in. (24.4 cm).
Light restoration. Peabody Museum of Archaeology and Ethnology, Harvard University, Cambridge, Mass.

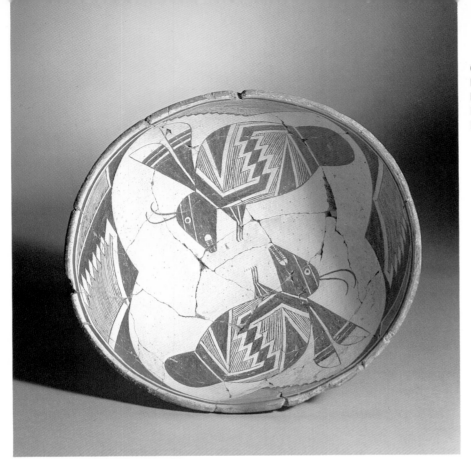

Colorplate 23.
Bowl. Two insects. Style III, Mimbres Classic Black-on-white.
H. 5 in. (12.5 cm), diam. 10½ in. (26.5 cm).
Private collection

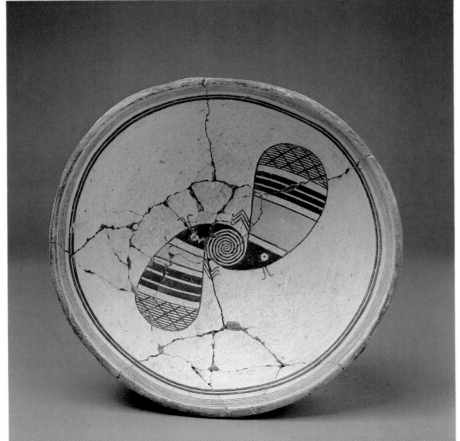

Colorplate 24.
Bowl. Two insects. Style III, Mimbres Polychrome. Swarts Ruin.
H. 3⅝ in. (9.2 cm), diam. 7⅞ in. (20 cm).
Light restoration. Peabody Museum of Archaeology and Ethnology, Harvard University, Cambridge, Mass.

These insects are called *Sand-Blowers* by Fred Kabotie and are thought to burrow into desert sands (Kabotie 1982:63).

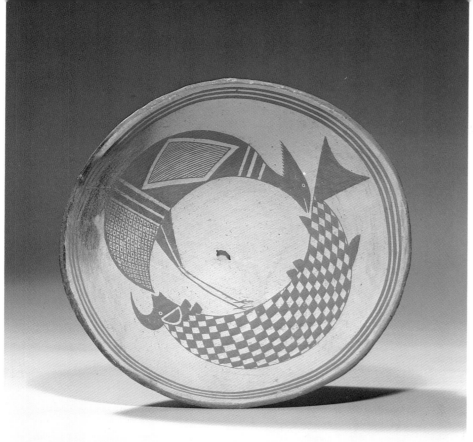

Colorplate 25.
Bowl. Two mythic animals. Style III, Mimbres Classic Black-on-white.
H. 4⅛ in. (10.5 cm), diam. 11 in. (28 cm).
Light restoration. Samuel Hale, Manhattan Beach, Calif.

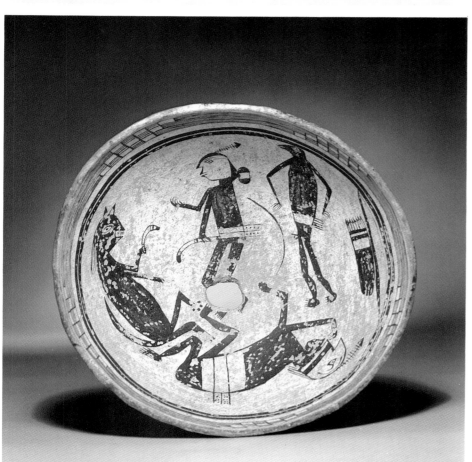

Colorplate 26.
Bowl. Hunters—men and mythic beings. Style III, Mimbres Classic Black-on-white.
H. 4½ in. (11.4 cm), diam. 9 in. (23 cm).
Private collection

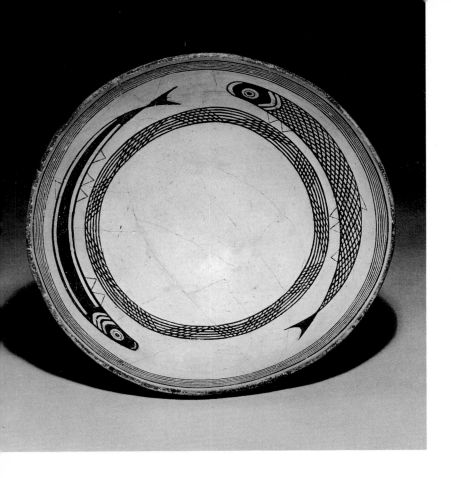

Figure 95.
Bowl. Pair of gar-like fish. Style III, Mimbres Classic Black-on-white.
H. 6 in. (15.2 cm), diam. 11¼ in. (28.6 cm).
Moderate restoration. Private collection

of the invisible vanishing point that is fundamental to illusionistic perspective drawing (colorplates 28, 29, figure 104). In Mimbres art, this imaginary position served as a focal point to which several figures could relate and thus provided the theoretical frame of reference for a perspectival drawing system.

For example, a painting that appears to show a woman and child, with dog, gathering wood (colorplate 29) in fact depicts two adults; the figure that appears to be a child is that of a grown man shown small because he is in the distance behind the woman and dog. All three figures are located on axes that pass through an imaginary point located near the edge of the painting below the woman; the variation in scale is a device used by the artist to portray the figures in perspective. Similar use of perspective is seen in other paintings. In one example, a disproportionately large image of what appears to be a bird's tail is attached by a curved line to a small man (colorplate 21). If read as a perspective drawing, this curved object may be interpreted as a small bull-roarer on a string whirling about the head of the man. In another painting, two men are shown as if they differed radically in stature in order to indicate that a distance exists between them (colorplate 28).

In some examples, the outside framing line, rather than the bowl center, is used as

the primary point of spatial reference. Here the spatial position of each figure is established by its relationship to the frame (colorplates 30, 31, figure 105), and the central space is of unknown dimensions. If the continuous and closed framing line is imagined as the equivalent of an open-ended horizon line, then the figures lie in linear rather than axial relationship to each other.

While Mimbres figurative paintings hold the greatest attraction to modern viewers, they are, on the whole, less complex than the geometric ones (colorplates 32, 40, figures 106–108). It is the intrinsic humanity of these representational paintings and the ingenious means that Mimbres artists sometimes invented to solve the compositional problems that make them interesting to us.

Most paintings were structured sequentially, first by dividing the entire picture space into its major units, then by subdividing each unit, and finally by filling the defined spaces with small-scale motifs. Design units were made by outlining an area or motif and then filling it with a wash of paint or fine line hachure. It appears that entire compositions—even the most complex—were thought through before the first line was drawn.

Despite their apparent intricacy, Mimbres paintings used relatively few elements in their motifs. Triangles in great variety were the most common design units, and combinations of triangles were used to create motifs that were conceptually more

Below left:
Figure 96.
Bowl. Fish and stylized clouds. Style III, Mimbres Classic Black-on-white.
H. 4⅜ in. (11 cm), diam. 10⅝ in. (27 cm).
Light restoration. Edwin Janss, Thousand Oaks, Calif.

Below right:
Figure 97.
Bowl. Three insects. Style III, Mimbres Classic Black-on-white. Clanton Draw site.
H. 3½ in. (9 cm), diam. 8⅛ in. (20.5 cm).
School of American Research Collection in the Museum of New Mexico, Santa Fe

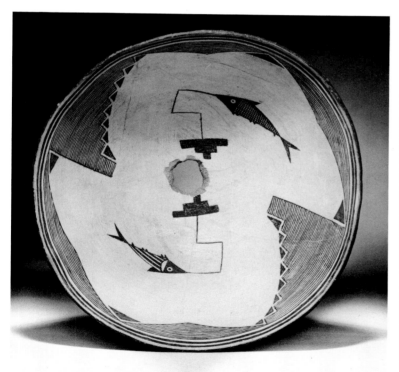

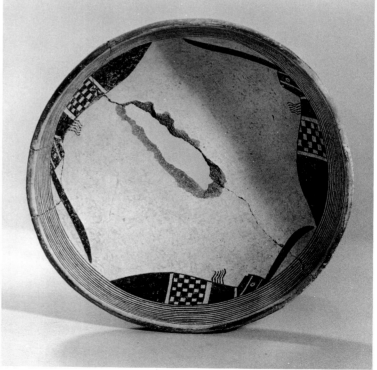

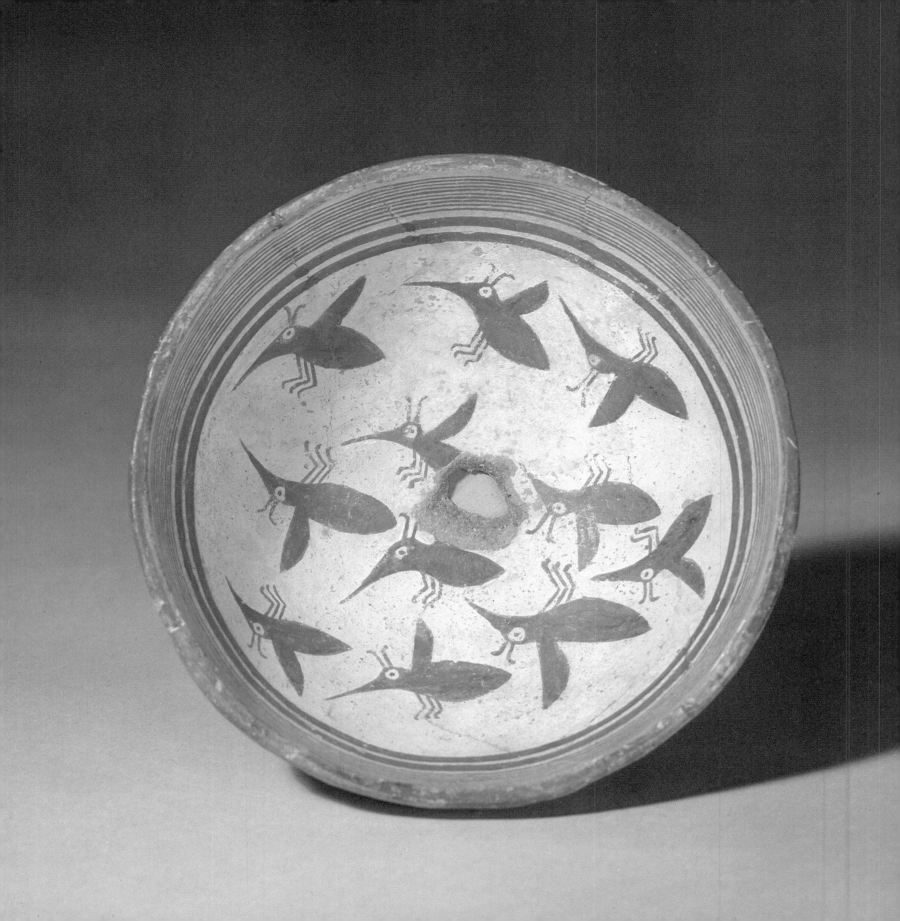

Pat Carr suggests that this picture illustrates an
incident in the myth cycle of the Little War Twins
(Hero Twins). The heroes may be shown here
ending a drought by recovering the rain (symbol-
ized by the design on the back of the fish monster)
from the malignant being known as Cloud Swal-
lower (Carr 1979:25–26).

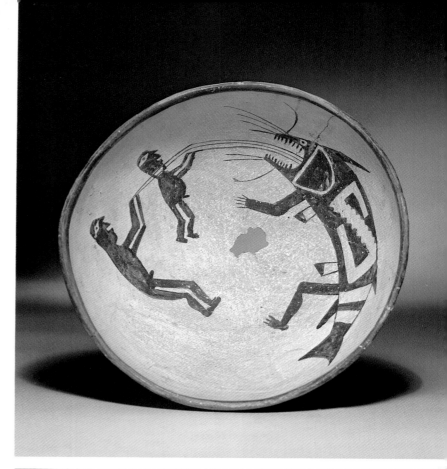

Left:
Figure 98.
Bowl. Two men setting bird snares. Style III, Mimbres Classic Black-on-white.
H. 4 in. (10 cm), diam. 8¼ in. (21 cm).
Private collection

Above right:
Figure 99.
Bowl. Birds and chicks. Style III, Mimbres Classic Black-on-white.
H. 5 in. (12.5 cm), diam. 12¼ in. (31 cm).
Light restoration. Millicent Rogers Museum, Taos, N. Mex.

Above far right:
Figure 100.
Bowl. Fish and swimming people. Style III, Mimbres Classic Black-on-white.
H. 4⅜ in. (11 cm), diam. 9½ in. (24 cm).
College of Santa Fe, N. Mex.

All origin legends of the modern Pueblos tell of the search by their ancestors for "The Middle Place" and the present home of each group. Pat Carr identifies this painting with a tragic incident in that myth cycle wherein a group of people are changed into fish. In one version these are late-arriving Winter People who are destroyed by a malignant wizard, in another they are children whose mothers were driven frantic by fear. Here we see the moment of transfiguration (Carr 1979:15–16).

Below right:
Figure 101.
Bowl. Locust collectors. Style III, Mimbres Classic Black-on-white. Mattocks site.
H. 4⅞ in. (12.4 cm), diam. 10¼ in. (26 cm).
Moderate restoration. Logan Museum of Anthropology, Beloit College, Wis.

According to Fred Kabotie, in his grandmother's day, a century ago or longer, the Hopi would pick locusts off bushes and shrubs and impale them on sticks for roasting purposes. Rather than being famine food, roasted locusts were relished as a tasty treat (Kabotie 1982:39–40).

Below far right:
Figure 102.
Bowl. Parrots and a mythical being. Style III, Mimbres Classic Black-on-white. McSherry Ruin.
H. 3½ in. (9 cm), diam. 6⅞ in. (17.5 cm).
Moderate restoration. The University of Colorado Museum, Boulder

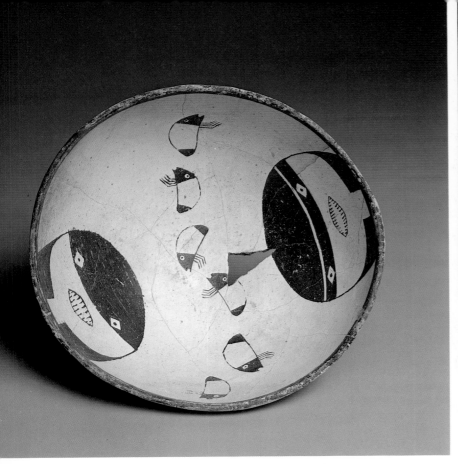

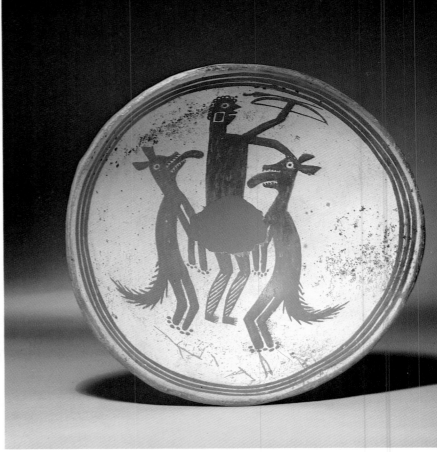

Colorplate 30.
Bowl. Masked heads and bugs, Style III, Mimbres
Classic Black-on-white.
H. 4⅛ in. (10.5 cm), diam. 10 in. (25.4 cm).
Mr. and Mrs. Edward Kitchen, Santa Monica, Calif.

Colorplate 31.
Bowl. Hunter with two canines. Style III, Mimbres
Classic Black-on-white.
H. 2¾ in. (7 cm), diam. 8½ in. (21.5 cm).
Private collection

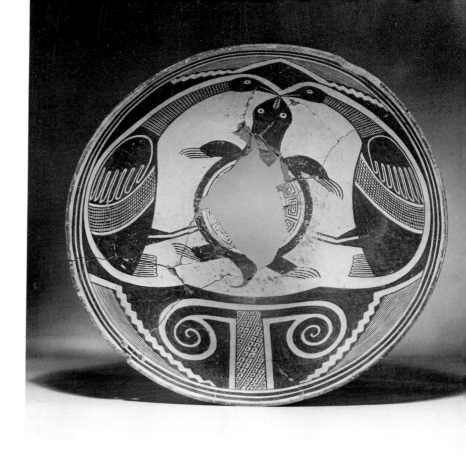

Figure 103.
Bowl. Turtle and water birds. Style III, Mimbres
Classic Black-on-white.
H. 4½ in. (11.4 cm), diam. 12 in. (30.5 cm).
University of Arkansas Museum, Fayetteville

complex. For example, a series of triangles connected to each other by a base line could be arranged to form a stepped figure, a sawtooth, or a terrace. Two such sets facing each other would create a negative image of diamonds, rectangles, rhomboids, or other figures occupying the space between them (figure 109).

Curvilinear forms were also used, particularly S curves that often interlocked to form a series of unending running scrolls (colorplates 12, 33). Frequently, these scrolls appear as negative images, while the lines that create them form entirely different and opposing positive shapes (colorplate 37). The deliberate ambiguity of such positive/negative pairings contributes to the complexity of Mimbres pictures—a complexity due more to precise execution, subtle changes of scale and position, and inversion and repetition of design elements than to the use of a large inventory of motifs (figures 110–112).

The quality of Mimbres art is, as much as anything else, a function of its provocative use of symmetry (figures 113, 114). Most compositions include two or more opposing pairs of figures oriented to the center of a concave hemisphere. The arrangement is basically static, but dynamic tensions are created by placing the symmetrically arranged contrasting units in a variety of perceptual situations. Each

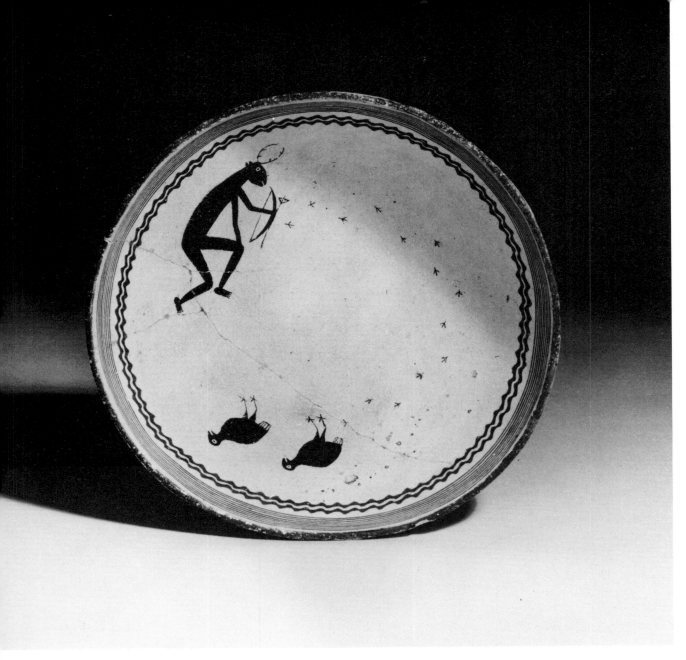

Above:
Figure 104.
Bowl. Deer-headed hunter and quail. Style III,
Mimbres Classic Black-on-white.
H. 2¾ in. (7 cm), diam. 7⅝ in. (19.5 cm).
Private collection

Opposite above left:
Figure 105.
Bowl. Two men with prayer stick. Style III, Mimbres
Classic Black-on-white.
H. 3⅞ in. (9.7 cm), diam. 9 in. (21.8 cm).

Moderate restoration. Museum of New Mexico
Collections, Santa Fe

Both figures were identified as men by Hopi
consultants on the basis of hair style. The seated
figure was called a priest, a father, a grandfather,
an older man, and a kachina (supernatural being)
by different Hopis, while the standing one was
referred to as an initiate, a messenger, a son, or a
youth. One consultant who interpreted the scene
as showing the manufacture of prayer sticks did
not distinguish the status or age of either figure
(Weslowski 1979:15–16).

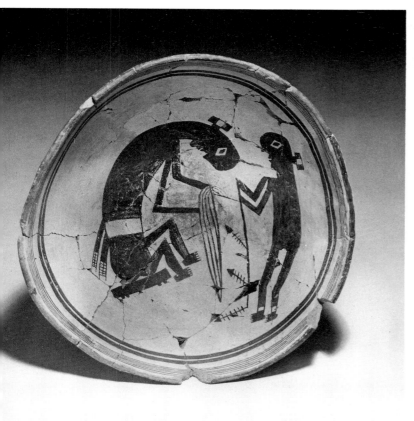

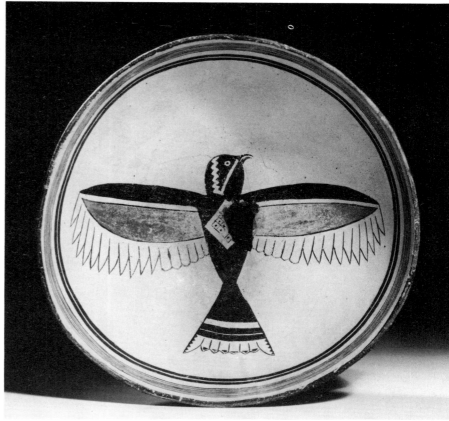

Above:
Figure 106.
Bowl. Flying bird. Style III, Mimbres Polychrome.
H. 4⅛ in. (10.5 cm), diam. 9½ in. (24 cm).
Light restoration. Taylor Museum of the Colorado
Springs Fine Arts Center

Left:
Figure 107.
Bowl. Fantastic animal. Style III, Mimbres Classic
Black-on-white.
H. 4¼ in. (10.8 cm), diam. 9⅜ in. (23.8 cm).
Light restoration. Private collection

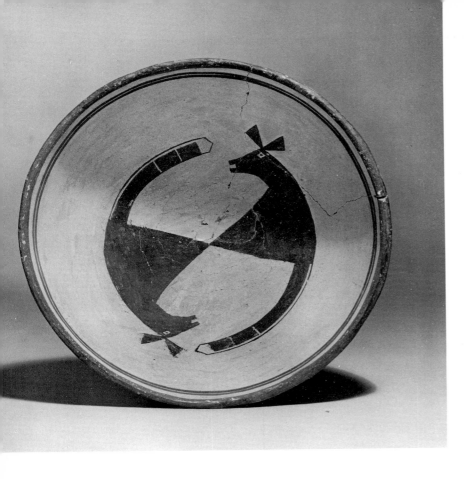

Figure 108.
Bowl. Two animals. Style III, Mimbres Classic
Black-on-white. McSherry Ruin.
H. 4 in. (10 cm), diam. 8¾ in. (22.2 cm).
Light restoration. The University of Colorado
Museum, Boulder

pair threatens to destabilize the static arrangement and thus creates the illusion of motion (figure 115). Inversions, forceful negative patterns in unpainted areas, the use of diagonals all contribute to ambiguous and multiple readings (colorplate 34).

At times, negative images become so visually important that they carry their own story, which may complement or contradict the positive lines and masses that create them. Such paintings may be read as either black-on-white or white-on-black (figure 116). The balance between dark and light was often as symmetrical as the compositional structure (figure 117) and all visual elements of a painting contributed to its dynamics. A picture that could be read as center oriented might, with equal confidence, be seen as oriented to its framed outer edge (figure 118). If some linear elements appear to lie in front of others, a shift of viewpoint may cause the reverse illusion (figure 77). The balancing of all possible options was universal, deliberate, and intense, and at their most complex, Mimbres paintings are superb examples of controlled ambiguity (colorplates 35, 36, figures 119, 120). Positive or negative, light or dark, center or perimeter, movement inward or movement outward, deep-space illusion or shallow-space illusion, all readings are possible, all may be correct, all are

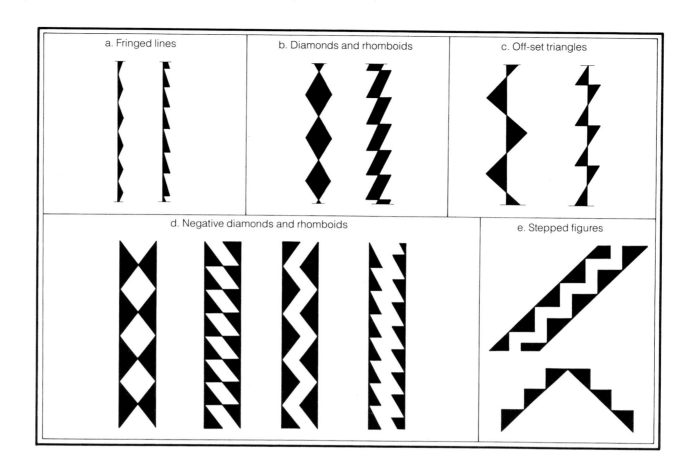

| a. Fringed lines | b. Diamonds and rhomboids | c. Off-set triangles |
| d. Negative diamonds and rhomboids | | e. Stepped figures |

contingent upon the visual assumptions a viewer may be forced to make, but cannot rely upon.

MEANING AND MOTIF

The tensions, oppositions, and ambiguities of Mimbres paintings extend beyond their patterning. Motifs, emblems, images, the very subjects of the pictures, whether figurative or nonfigurative, often have two or more potential identifications. And if a series of separate but interlocking white scrolls is the negative by-product of a whirling black form, which of the two images is primary and intended to be read first (colorplate 37)? If four white birds are the negative by-products of four black fleur-de-lis-like emblems, we cannot know which set of images was intended to be most important (figure 116).

Animal representations that appear to be straightforward are also often ambiguous; indeed, the characteristic features of one species may be grafted onto another. An

Figure 109.
How triangles were used as zone-filling elements, linear embellishments, and motifs on Mimbres Boldface through Classic painted pottery. (Reproduced by permission of the University of New Mexico Press from *Mimbres Painted Pottery* by J. J. Brody, University of New Mexico Press, ©1977 by the School of American Research)

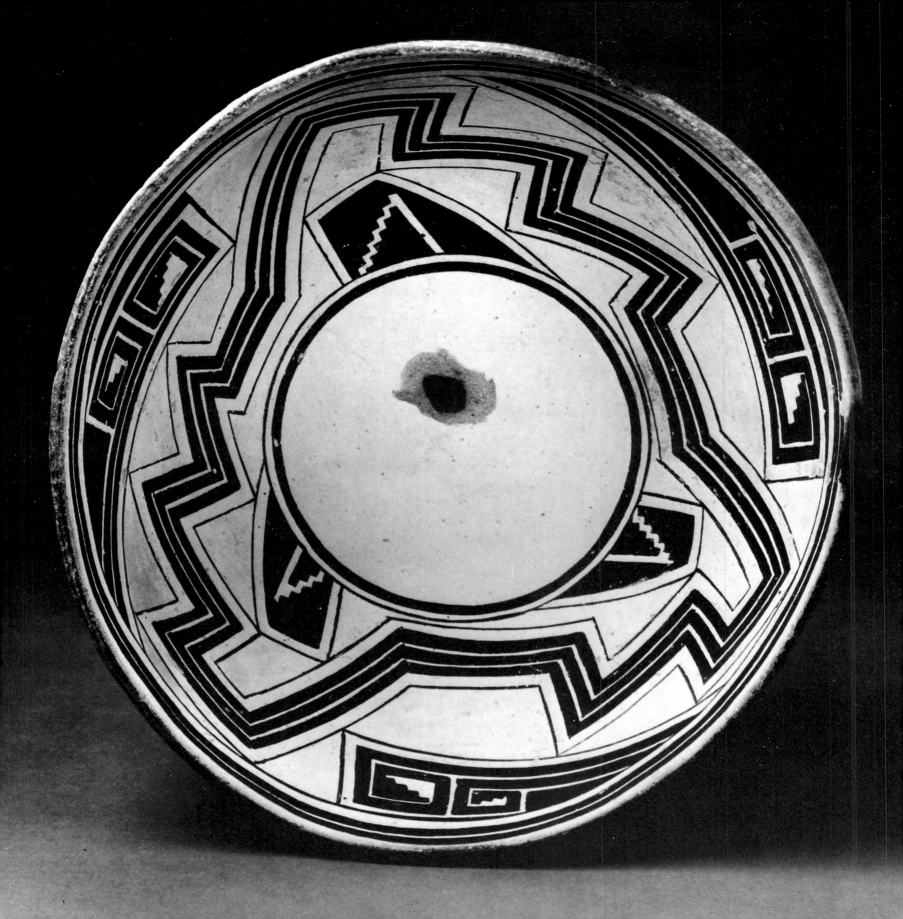

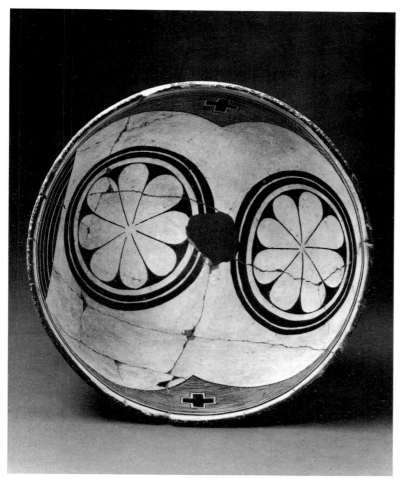

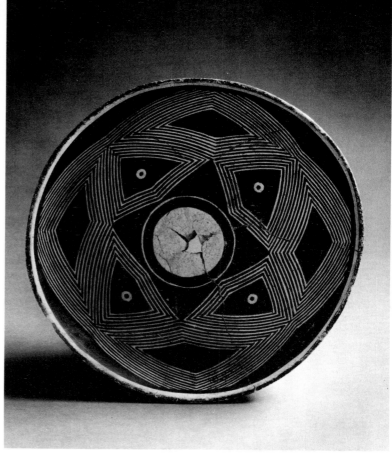

Opposite:
Figure 110.
Bowl. Style III, Mimbres Polychrome. Swarts Ruin.
H. 4¾ in. (12.2 cm), diam. 10⅝ in. (27 cm).
Peabody Museum of Archaeology and Ethnology,
Harvard University, Cambridge, Mass.

Above:
Figure 111.
Bowl. Style III, Mimbres Classic Black-on-white.
Swarts Ruin.
H. 5⅛ in. (13 cm), diam. 10⅝ in. (27 cm).
Light restoration. Peabody Museum of Archaeol-
ogy and Ethnology, Harvard University, Cam-
bridge, Mass.

Figure 112.
Bowl. Early Style III, Mimbres Classic Black-
on-white.
H. 3⅝ in. (8.7 cm), diam. 11 in. (28 cm).
Moderate restoration. Peabody Museum of
Archaeology and Ethnology, Harvard University,
Cambridge, Mass.

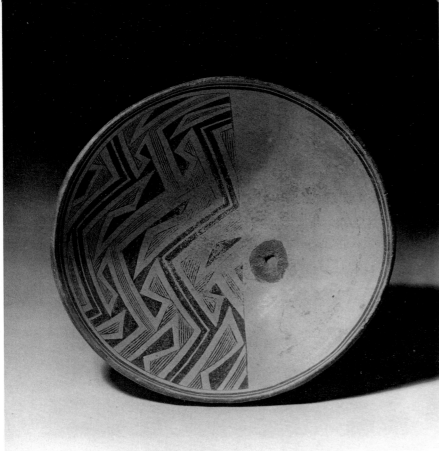

Left:
Figure 113.
Bowl. Style III, Mimbres Classic Black-on-white.
H. 4 in. (10 cm), diam. 9¼ in. (23.5 cm).
Light restoration. Taylor Museum of the Colorado
Springs Fine Arts Center

Below left:
Figure 114.
Bowl. Birds and eels. Style III, Mimbres Classic
Black-on-white.
H. 5⅛ in. (13 cm), diam. 9⅞ in. (25 cm).
Heavy restoration. Mr. and Mrs. Nicholas
Woloshuk, Santa Fe, N. Mex.

Opposite:
Figure 115.
Bowl. Stylized mountain sheep. Style III, Mimbres
Classic Black-on-white.
H. 4 in. (10.2 cm), diam. 10½ in. (26.7 cm).
Moderate restoration. Private collection

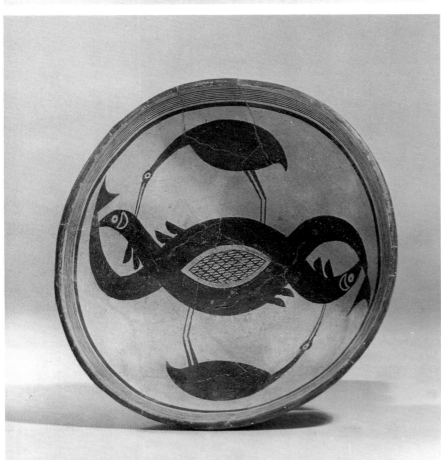

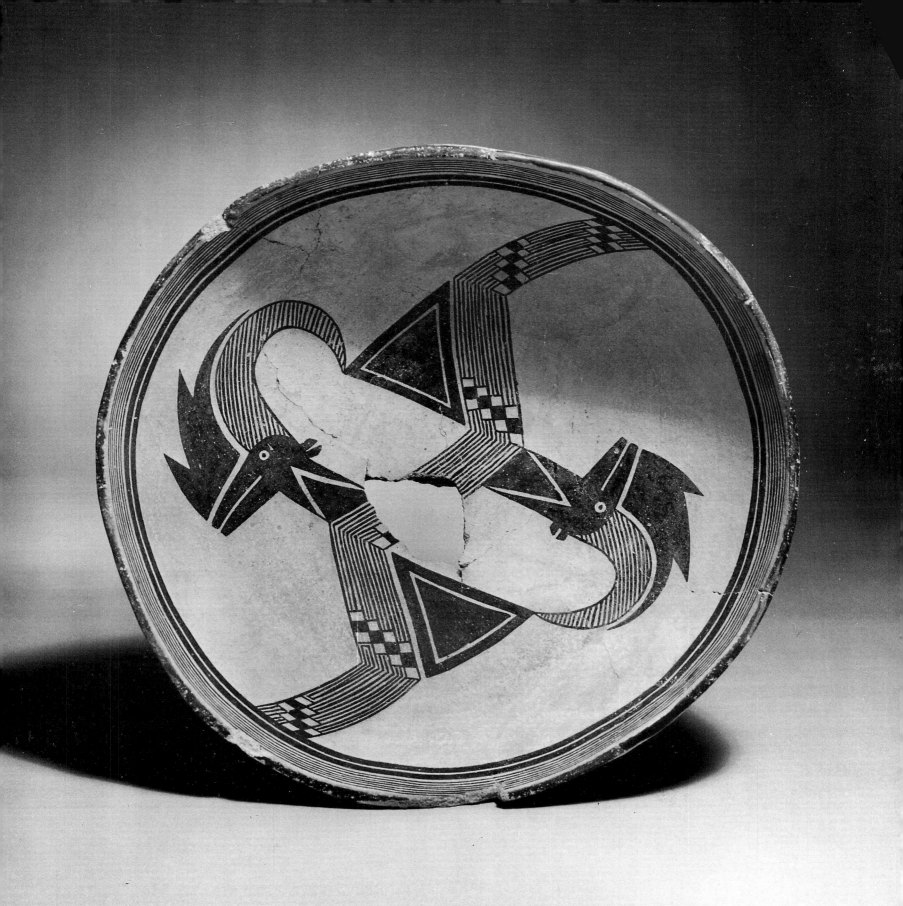

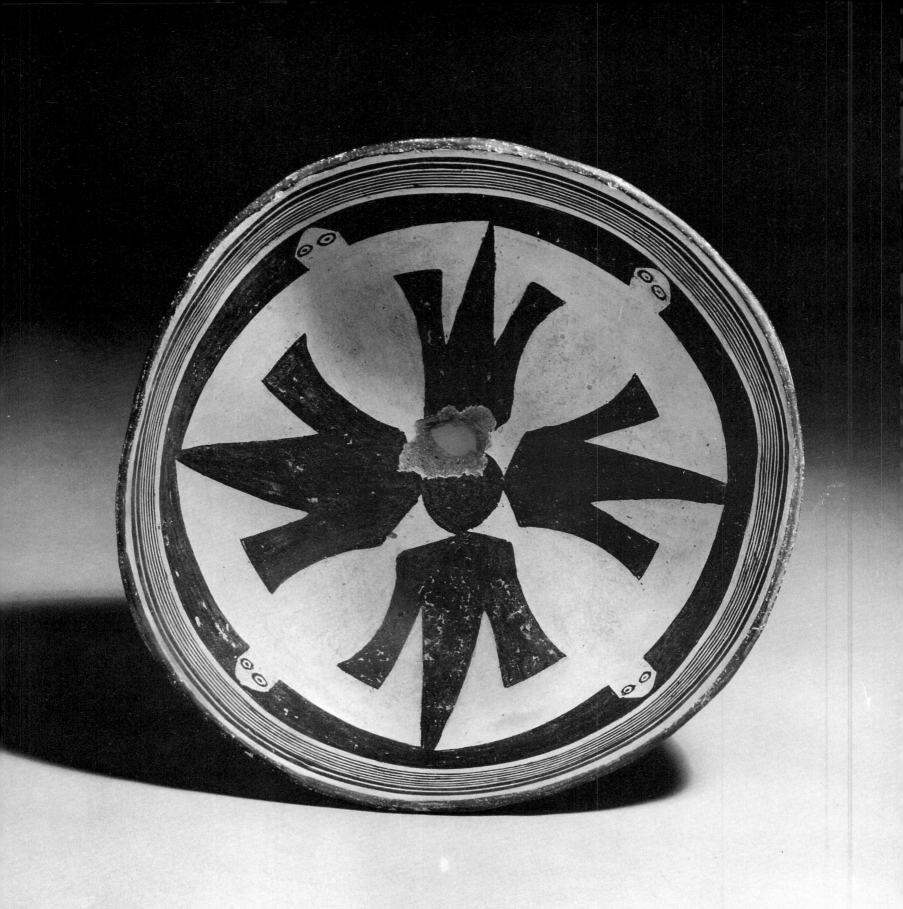

Opposite:
Figure 116.
Bowl. Flying birds. Style III, Mimbres Classic Black-on-white.
H. 4 in. (10 cm), diam. 9⅞ in. (25 cm).
Dagny Janss, Los Angeles

Right:
Figure 117.
Bowl. Early Style III, Mimbres Classic Black-on-white.
H. 4⅜ in. (11 cm), diam. 10¼ in. (26 cm).
Light restoration. Private collection

Below right:
Figure 118.
Bowl. Style III, Mimbres Classic Black-on-white. Swarts Ruin.
H. 5½ in. (14 cm), diam. 12⅜ in. (31.4 cm).
Moderate restoration. Peabody Museum of Archaeology and Ethnology, Harvard Univesity, Cambridge, Mass.

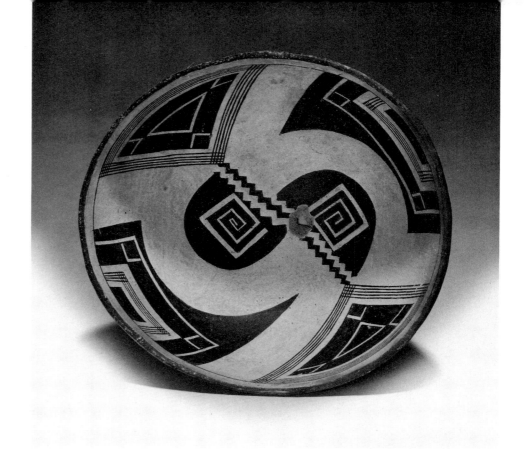

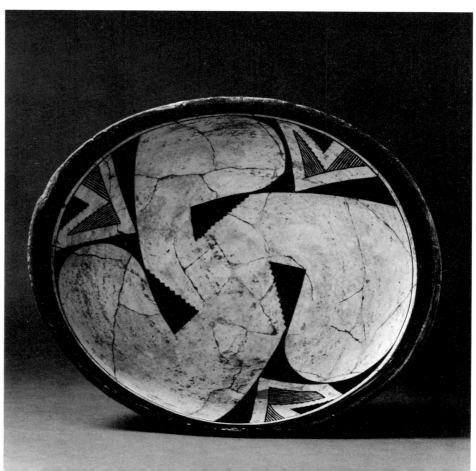

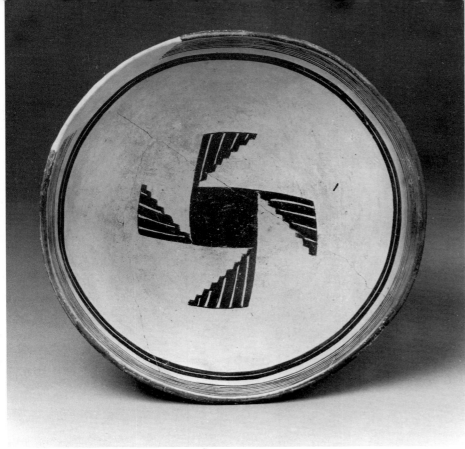

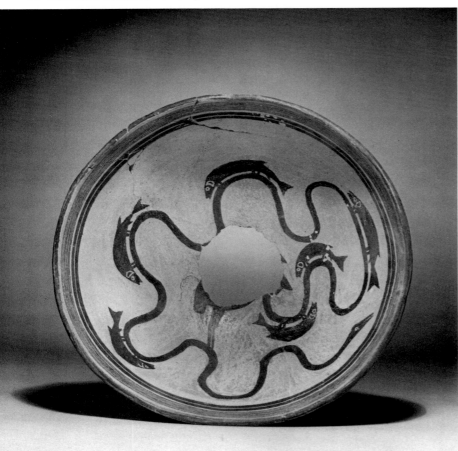

Left:
Figure 119.
Bowl. Style III, Mimbres Classic Black-on-white.
Swarts Ruin.
H. 4 in. (10.2 cm), diam. 9⅛ in. (23.2 cm).
Light restoration. Peabody Museum of Archaeology and Ethnology, Harvard University, Cambridge, Mass.

Below left:
Figure 120.
Bowl. Crane and fish. Style III, Mimbres Classic Black-on-white. Mattocks site.
H. 4⅜ in. (11.2 cm), diam. 10½ in. (26.8 cm).
Light restoration. Logan Museum of Anthropology, Beloit College, Wis.

The Feast of the Crane, according to Fred Kabotie, may illustrate a moral fable intended to teach respect for the aged and for Nature. Children are told how the cranes, who love to eat fish, are only permitted to eat the "bad little fish" who have lost the protection of their Fish Chief (Kabotie 1982:49–50).

Opposite:
Colorplate 32.
Bowl. Lizard. Style III, Mimbres Polychrome. Swarts Ruin.
H. 4 in. (10 cm), diam. 9¼ in. (23.5 cm).
Light restoration. Peabody Museum of Archaeology and Ethnology, Harvard University, Cambridge, Mass.

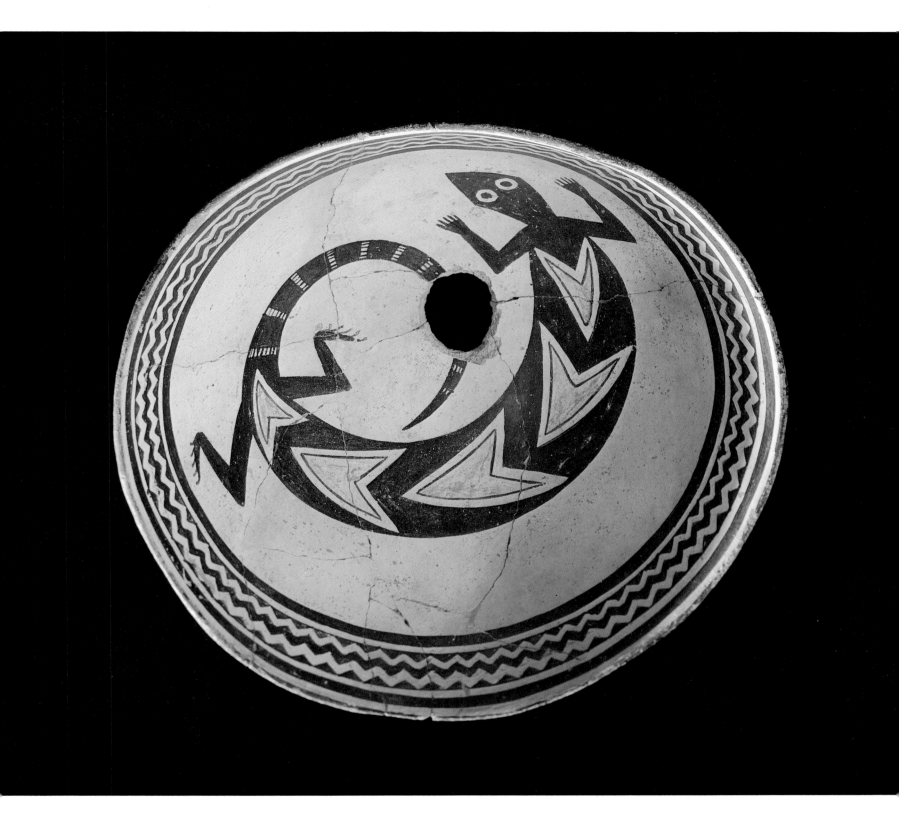

insect may have an animal horn on its head (figure 121) or the tail of a rattlesnake may be grafted to the body of a lizard (figure 122). More subtly, the ears of a bat may be inverted to form the beak of its birdlike second face or another bat may have the ears of a rabbit (colorplates 38, 39). These ambiguities create great problems when attempts are made to discover the particular meanings that the images the Mimbreños fashioned may have had for them. Above all, we may be asking about the wrong images.

Logically, the basis for interpreting Mimbres imagery must rest upon analogies drawn to the beliefs and iconic systems of those modern southwestern Pueblo Indians believed to be in part descended from the Mimbres. However, about eight hundred historically eventful years separate the Mimbreños from any possible descendants and make it difficult for us to judge the validity of interpretations based on contemporary traditions. Further, there is no clear evidence to link the Mimbres with any particular Pueblo, and today, as in the past, the Pueblos—despite all similarities—are not a cohesive cultural, linguistic, or political community. Their ideologies differ in many details, and different Pueblos may give different interpretations to similar images.

Linking of the Mimbreños to any historically known people is little more than guesswork. It is thought that some of the Mimbres people or their descendants were among the settlers who ultimately coalesced at modern Zuni Pueblo. There are archaeological hints that other Mimbreños moved east of the Rio Grande and were later absorbed at some of the dozen or more Piro Pueblos whose people were themselves widely dispersed late in the seventeenth century. Resemblances between the representational art of the Mimbres and the art made several hundred years later at Hopi Pueblo is suggestive of a possible relationship between the two cultures that has yet to be demonstrated.

Nonetheless, the Pueblos of Hopi and Zuni may provide the best clues about the original meanings of Mimbres art. The oral histories and mythologies recorded at those Pueblos late in the nineteenth century form the earliest and most complete set of Pueblo traditions known to outsiders. Hopis and Zunis are still the most outgoing of Pueblo people in their relationships with outsiders and the most willing to discuss their interpretations of Mimbres paintings. Temporally closer but geographically and culturally much farther removed are the written and oral traditions collected from native peoples of the Valley of Mexico and the areas farther south by sixteenth-century Spanish scholars. Examinations of these sources may also provide insights into the meanings of Mimbres paintings.

The very structure of most Mimbres pictorial compositions suggests a visual metaphor that is appropriate for all of the Pueblos of the Southwest, as well as for many Native American peoples of northern Mexico, Middle America, and other parts of the New World. In a general way, the number four is in some sense sacred to most

Figure 121.
Bowl. Mythic animal. Style III, Mimbres Classic
Black-on-white.
H. 4 in. (10.2 cm), diam. 9⅛ in. (23.2 cm).
Light restoration. Dr. Arthur P. Zeitlin, Palos Verdes
Estates, Calif.

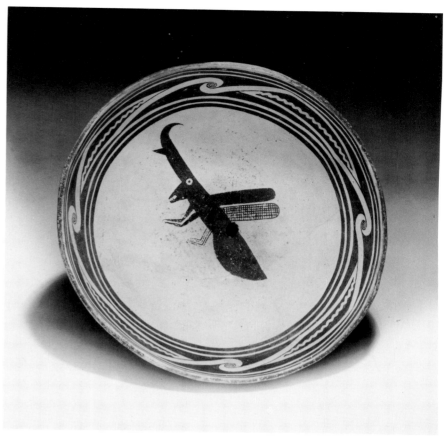

Figure 122.
Bowl. Mythic animal. Style III, Mimbres Classic
Black-on-white. Eby site no. 5.
H. 4 in. (10 cm), diam. 11⅜ in. (29 cm).
Light restoration. The University of Colorado
Museum, Boulder

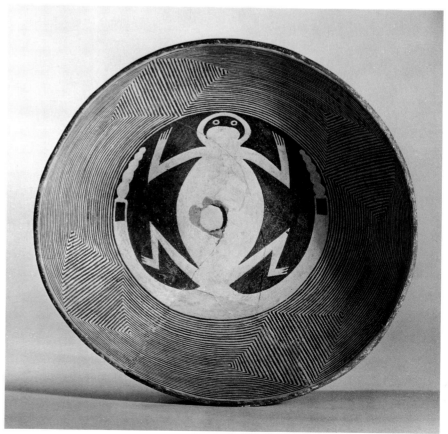

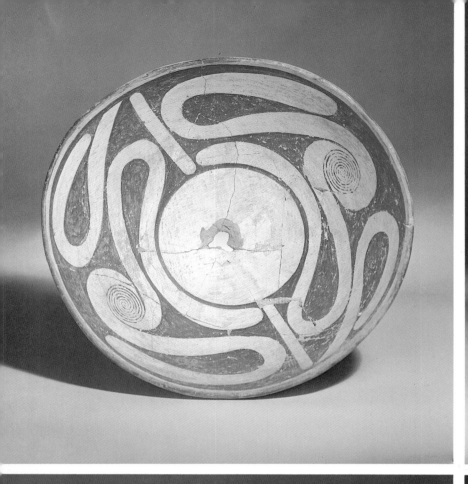
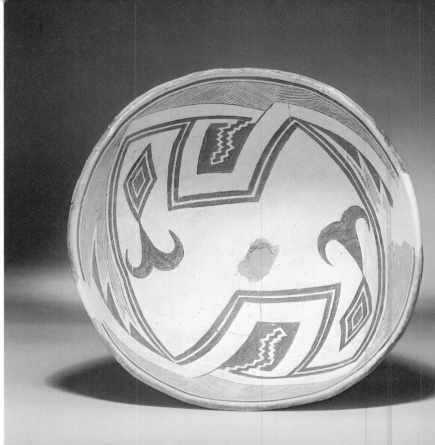
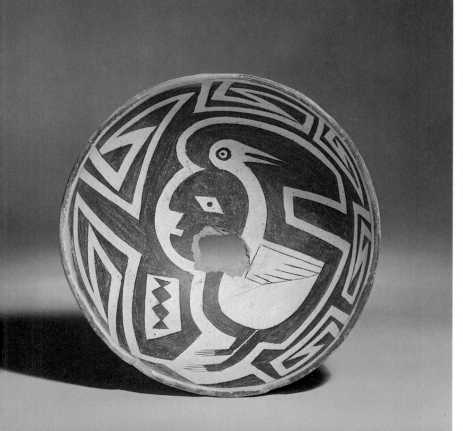
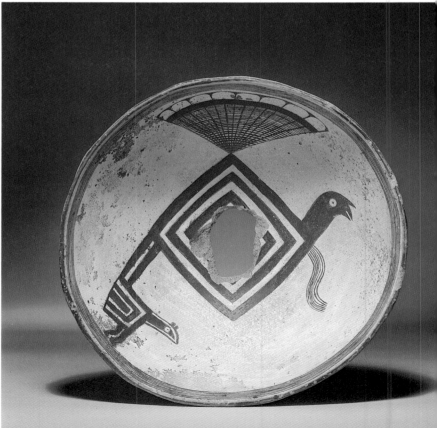

Above far left:
Colorplate 33.
Bowl. Style III, Mimbres Classic Black-on-white. Galaz site.
H. 5⅛ in. (13 cm), diam. 11½ in. (29 cm).
Department of Anthropology, University of Minnesota, Minneapolis

Above left:
Colorplate 34.
Bowl. Style III, Mimbres Classic Black-on-white. Pruitt site.
H. 4¾ in. (12 cm), diam. 9⅞ in. (25 cm).
Moderate restoration. Arizona State Museum, University of Arizona, Tucson

Below far left:
Colorplate 35.
Bowl. Man-bird. Style III, Mimbres Classic Black-on-white. Mattocks site.
H. 4⅛ in. (10.5 cm), diam. 9⅞ in. (25 cm).
Janss Foundation, Thousand Oaks, Calif.

Below left:
Colorplate 36.
Bowl. Turkey and skunk. Style III, Mimbres Classic Black-on-white.
H. 3⅛ in. (8 cm), diam. 8¼ in. (21 cm).
Western New Mexico University Museum, Silver City

Right:
Colorplate 37.
Bowl. Early Style III, Mimbres Classic Black-on-white.
H. 4⅜ in. (11 cm), diam. 11 in. (28 cm).
Light restoration. Private collection

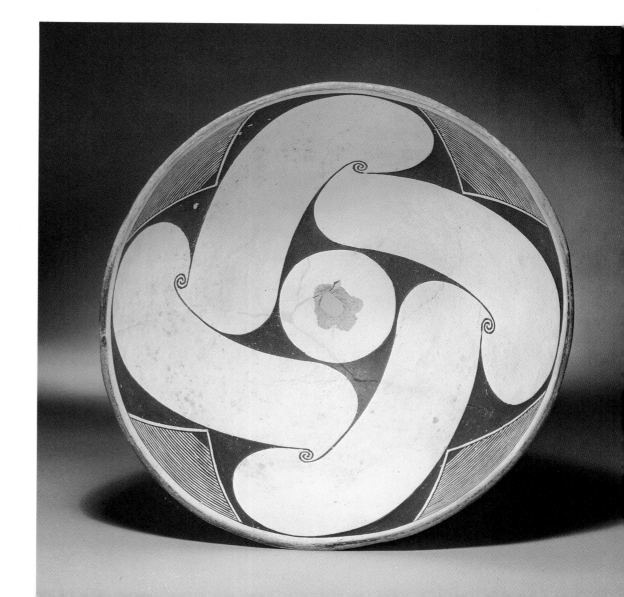

Native American cultures. The cosmological structure of the Pueblo universe includes four horizontal directions (not necessarily the cardinal points), the zenith, and the Underworld. These are the Six Directions, but a seventh, the Middle Place, is recognized in some versions of the cosmology as the present home of the group. The division made by the Mimbreños of their globular picture spaces into four quarters made by lines that meet near a center, which could also indicate the above and the below, suggests the Six Directions of the Pueblos and their Middle Place. Likewise, it suggests the four world quarters, the up, the down, and the center place that appear in native cosmological maps of northern Mexico and Middle America. If this reading is correct, then the vast majority of Mimbres paintings were, consciously or not, representations of place and space, pictures of a cosmological universe.

Among Pueblo people, certain colors and prey animals are identified with the Six Directions. Colors, of course, cannot now be read into any black-and-white Mimbres patterns, and indeed, the inventory of animals they depicted includes mostly the preyed upon rather than the preying. Thus, the reading of Mimbres paintings as representing metaphysical space cannot be supported by the identification of detailed correspondences between any of the directions and the colors or animals associated with them by the modern Pueblos.

Most Mimbres figurative paintings represent only a single creature, and about half of these are birds or nonhuman mammals. Rabbits, mountain sheep, deer, and antelope make up the majority of the latter, while most of the birds are waterfowl or other game birds. Humans make up about fifteen percent of all images and fish another ten percent. The remaining twenty-five percent are divided fairly evenly among insects, amphibians, reptiles, and mythic creatures. It can be concluded that most Mimbres representational subjects were food animals, but the plants that formed the critical subsistence base for the Mimbres were rarely pictured.

What does it mean to represent food animals? Why were rabbits (figure 3), the most common food animal of Classic Mimbres times, and mountain sheep (colorplate 4), among the least common, the two mammals most often pictured by Mimbres artists? Are the paintings prayers for hunting success? Are they offerings of thanks commemorating successful hunts? Are they prayers for fertility and increase? We know that the Pueblo people, like most other southwestern Native Americans and, indeed, most other people who hunt for or grow their own food, have rituals to express gratitude or concern for successful hunts and harvests, for bounty, fertility, and increase. To suggest that the Mimbreños painted images of food species because of a similar intent merely recognizes logic and the commonplace. Given our present knowledge, we can do little more than state the obvious: the Mimbres painted animals that were of interest to them.

A far greater potential for meaningful interpretation is provided by the minority of

representational paintings in which two or more figures interact; or whose subjects do not accurately represent real-world species. These images provide great potential for interpretation if they can be accurately identified simply because they are unusual. Because they are facts of culture rather than facts of nature, analogies drawn to similar images that have been ethnographically documented and explained have great potential for illuminating their significance in Mimbres culture.

For example, a decapitation scene interpreted without reference to any ethnographic analogy can hardly be explained as anything other than evidence of human sacrifice (figure 123). On examining this painting, the Hopi artist, Fred Kabotie, recalled that his people traditionally practiced human sacrifice as supplication on very rare occasions, under extreme stress of famine due to drought.[4] A rain priest authorized to perform the sacrifice would probably not have worn a Horned Serpent headdress, as seen in this painting, but the Horned Serpent is identified by the Hopi and other Pueblos with water, fertility, and natural forces that can be either harmful or beneficial.

The archaeologist Charles Di Peso interpreted the same painting in the light of his research at the prehistoric site of Casas Grandes in northern Mexico, a site that may have coexisted with the Mimbres. By analogy with late prehistoric practices in the Valley of Mexico, he identified this painting as illustrating the sacrifice of a Mimbres warrior by a Casas Grandes Warrior Society priest. The headdress identifies the priest with the Mexican deity Quetzalcoatl in the persona of Ehactl, the Wind God.[5]

A third interpretation of the same picture, based on the *Popol Vuh*, the Maya Book of the Dead, holds that it illustrates a critical event in the mythic cycle of the Hero Twins. These culture heroes perform their greatest feat by vanquishing the evil Lords of the Underworld. This painting may show the critical event in this struggle: a sham decapitation of one twin by the other that tricks the twins' enemies into believing that the loss of their heads will make them immortal. The decapitated brother is revived, and each of the Underworld Lords volunteers to have his own head cut off in the expectation that he too will survive and profit by the experience.[6]

Although this particular event has not been ethnographically recorded as part of Pueblo folklore, the Twins are prominent culture heroes in the Southwest, where they are associated with the Warrior Societies. Quetzalcoatl and the Pueblo Horned Serpent are certainly related and ritual warfare, ritual sacrifice, fertility, death, and the Underworld are all inextricably intertwined among the Pueblos—lending some plausibility to each of the three interpretations.

If all three analogical interpretations are treated as substantially correct instead of mutually contradictory, then they provide a rich web of potential meaning that relates this painting to the belief systems of the ancient Maya of Middle America, to the ancient Valley of Mexico, and to contemporary as well as nineteenth-century Pueblos.

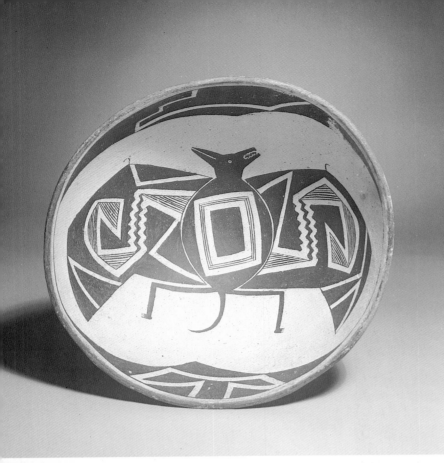

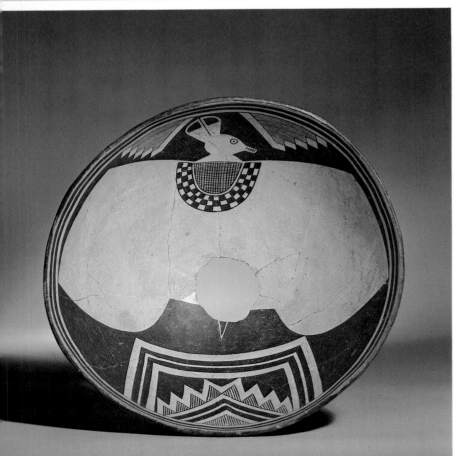

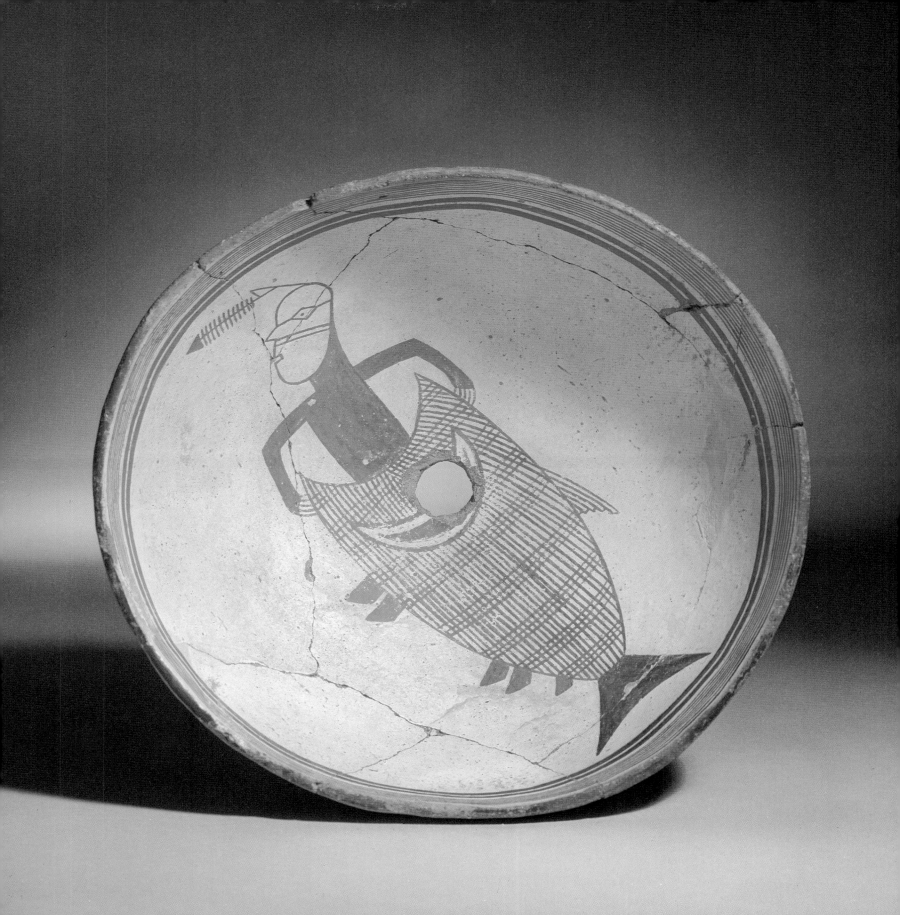

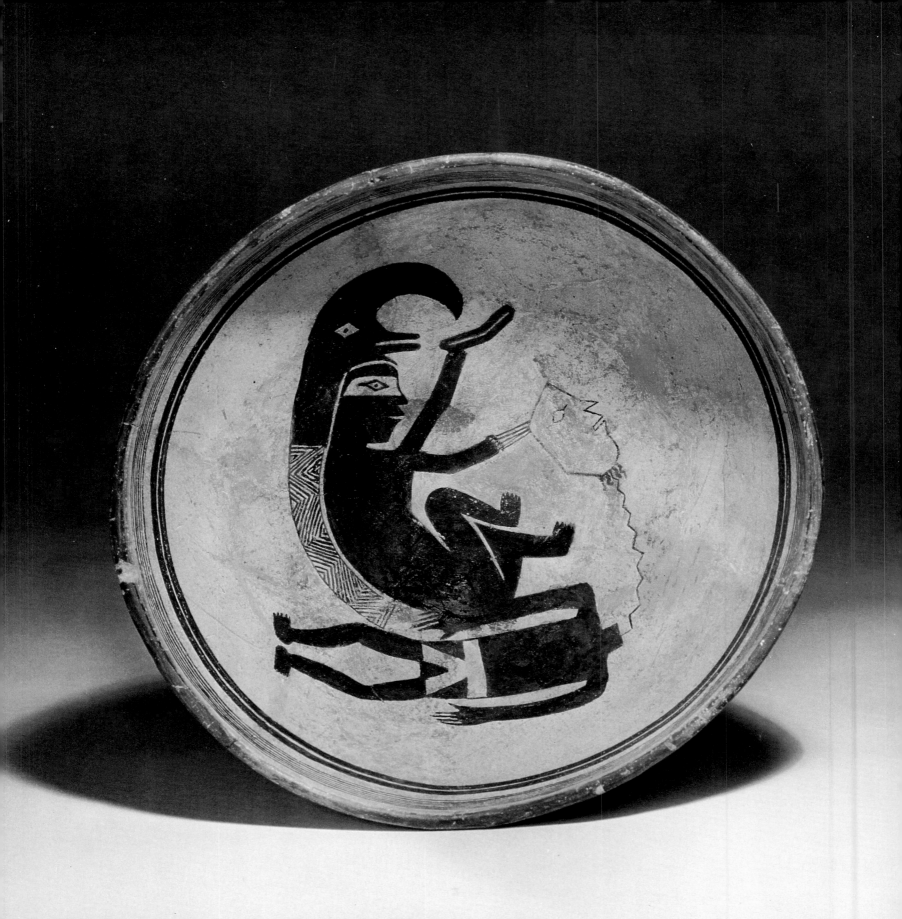

Opposite:
Figure 123.
Bowl. Ritual decapitation. Style III, Mimbres Classic Black-on-white. Eby site no. 4
H. 4⅞ in. (12.3 cm), diam. 10¼ in. (26 cm).
Moderate restoration. The University of Colorado Museum, Boulder

This painting is discussed on page 115 of the text. Pat Carr also associates it with the myth cycle of the Little War Twins (Hero Twins) and suggests that the decapitation is being performed by Old Kiva Man. The victim in that case is a monster defeated by the Twins in a foot race (Carr 1979:20–24).

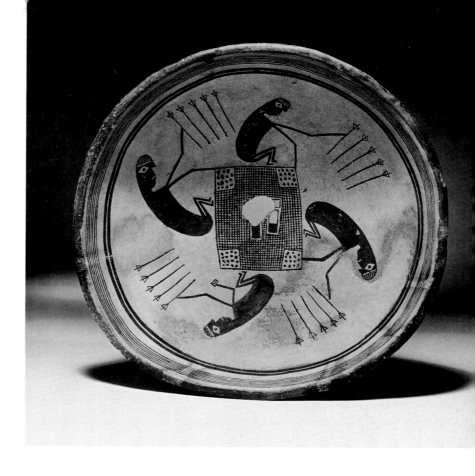

Time and space are the dimensions that deny us access to the meaning of Mimbres art. The Mimbres were as close in time to sixteenth-century native Mexico as they were in space to the nineteenth-century Pueblos. Their cosmology was most likely similar and related to, but different from that of both logical sources of interpretation. Synthetic and ambiguous explanations that deny neither may give a sense of the quality if not the detail of Mimbres intellectual life.

A painting that appears to be a genre scene of gamblers throwing dice on a blanket and wagering arrows can be given a range of analogical interpretations (figure 124). Pueblo ethnographies indicate that important decisions pertaining to warfare were sometimes made by the play of the dice, and that this gaming was sanctioned by the supernatural example of the Twins, who also gambled. In the painting, the four players wear warrior's caps of the sort worn by the Twins, and an assumption may be made that the stakes of the game have to do with war and peace, although it is not clear whether the players play in this world or a supernatural one. Just as the decapitation scene may illustrate both an occurrence in the real world and a mythic event, so this one may show that in the Mimbres mind the

Above:
Figure 124.
Bowl. Men with arrows. Style III, Mimbres Classic Black-on-white. Cameron Creek Village.
H. 3½ in. (9 cm), diam. 9 in. (23 cm).
Moderate restoration. School of American Research Collection in the Museum of New Mexico, Santa Fe

This painting, which is also discussed in the text on this page, is called the *War Ceremony* by Fred Kabotie. Each figure wears a war cap, two of which are knitted, as are those worn by the two Little Warrior Gods (Little War Twins, Hero Twins). The center rectangle is identified as a sand altar or sand painting representing the world as the foundation and root of life. The rectangles in the center are hard stones which signify the strength of the warriors' hearts (Kabotie 1982:73–74). Other Hopi men call this a ceremony for the making or the blessing of arrows (Weslowski 1979:13–14).

119

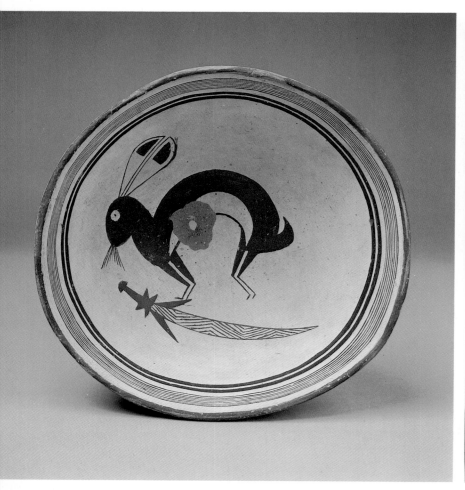

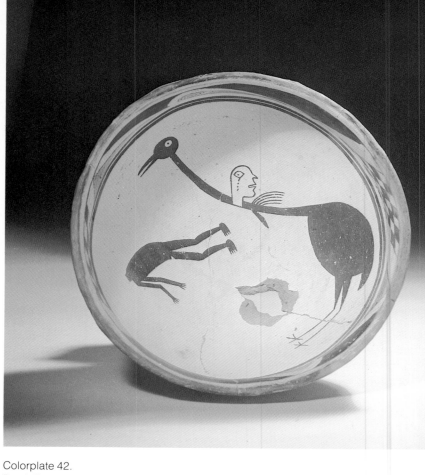

Colorplate 41.
Bowl. Rabbit with staff. Style III, Mimbres Classic
Black-on-white. Swarts Ruin.
H. 3½ in. (9 cm), diam. 8⅛ in. (20.7 cm).
Peabody Museum of Archaeology and Ethnology,
Harvard University, Cambridge, Mass.

Fred Kabotie called this painting *Jack Rabbit with
a Knife*. He thought it might represent the rabbit
clan, with the knife symbolizing that group's role
as guardians (Kabotie 1982:29). Other Hopi identi-
fied the object below the rabbit as a knife, a
sword, a boomerang, a stylized fish, a bird, a
reptile, or a dragonfly (Weslowski 1979:7).

Colorplate 42.
Bowl. Crane and decapitated man. Style III,
Mimbres Classic Black-on-white.
H. 4⅜ in. (11 cm), diam. 9 in. (23 cm).
Light restoration. Edwin I. Gregson, Santa
Monica, Calif.

120

behavior of humans and supernaturals could be closely parallel.

Over and again, images in Mimbres art that appear to suggest frivolous behavior are seen to be susceptible to double meanings that are more than frivolous when examined in light of only the slightest bits of ethnographic data; and on occasion ethnographic information allows us to select the most probable among possible interpretations. In the example seen in figure 125, the sex of the two painted figures is uncertain on pictorial evidence alone, and we cannot be sure whether they lie under a blanket or stand behind a shield. When informed by modern Pueblo people that their facial marks are like those placed on Hero Twin images, we may assume that they are men, and possibly warriors. It then follows logically that the rectangle is a shield behind which they stand. We are not only informed about the meaning of the painting, but we also learn to read Mimbres pictorial conventions with greater accuracy.

Rabbits are important to the Pueblos as food animals, and communal rabbit hunts still are important social and ritual events. But there is not much about rabbits in recorded Pueblo oral literature, leaving open any explanation of the great stress on rabbit imagery in Mimbres painting. If we return to Middle America, we find that rabbits there are associated with drunkenness, the moon, and Hero Twin mythology. Mimbres images of rabbits often have semilunate shapes that suggest a crescent moon (figure 126). A rabbit image that includes both a lunar shape and an elaborate staff reminiscent of those carried by long-distance traders from the Valley of Mexico in late pre-Columbian times suggests both similarity and connection to Middle America (colorplate 41). In a similar vein, Mimbres bat images resemble the death bats of the Maya Underworld who threaten the newly dead during their four-day journey to final rest, a concept shared with the Pueblos (colorplates 38, 39).

Most of the Mimbres paintings that we know were found on bowls that had holes deliberately punched in them before being buried with the Mimbres dead. Many such "killed" pots show no evidence of use except as mortuary offerings. The imagery on some of these pieces seems to refer to death and the Underworld, but in ambiguous terms that may also refer to life and this world. The ambiguity is repeated in other ways, and to judge by the paintings that we know, it is integral to their aesthetic system just as it is implicit in their burial of the dead below the floors of the living. Ambiguity and continuity, life and death, images of an Underworld that could be images of this one, black the color of death, and white the color of life, all are equivalents; all are integral to Mimbres art (colorplate 42, figure 123). The fundamental image of Mimbres painting is of a tense universe kept harmonious by the careful and rigid balancing of all conceivable oppositions, particularly those that refer to life and to death.

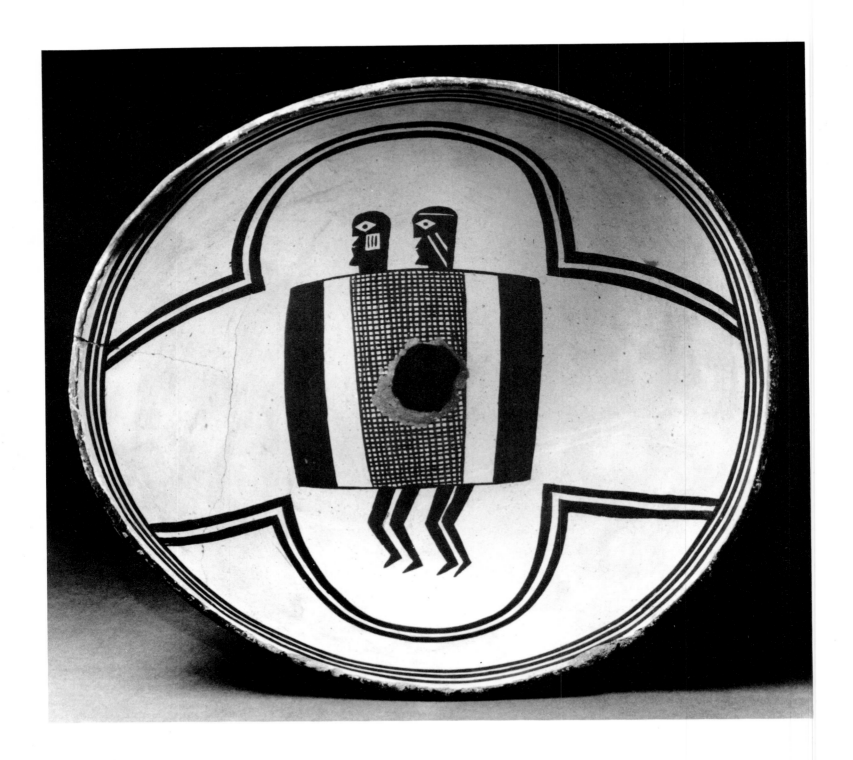

Despite all the suggested references to Middle America, Mimbres paintings were very much a southwestern expression. Their compositions and even some of their subjects were derived from Hohokam art, or perhaps from the art of other southern neighbors. Their technology, style, and some of their subjects were consistent with the art of the Four Corners Anasazi. But their compositions and their iconography were richer, tenser, more complex, and consistently more expressive than the compositions made by their neighbors and contemporaries.

In its own time, Mimbres painted pottery was not well known outside of Mimbres territory, at least in part because so much of it was buried with their dead. Knowledge of their paintings was lost when the Mimbreños moved out of their lovely valley to places that are still unknown to us. At that time, they apparently stopped making the art by which we know them. Their paintings identify them as a unique group with unique customs, attitudes, character, and vision. In a startlingly simple way, the Mimbreños have demonstrated that art can indeed be life. Their paintings are ethnic markers, we use them to distinguish Mimbreños from all other people.

Abandonment of the Mimbres Valley was one of many dislocations that occurred throughout the Southwest between the twelfth and fourteenth centuries. By about A.D. 1350, other representational painting systems were invented in the Southwest that were comparable to the painting of the Mimbreños. A robust pottery painting tradition practiced in the White Mountains of Arizona during the thirteenth and fourteenth centuries contributed to the invention at Hopi of the Sikyatki style of pottery painting in the fifteenth and sixteenth centuries. In their pottery and extraordinary wall paintings, Sikyatki-style artists dealt both with this world and the mythic world occupied by the supernaturals in dynamic, self-contained pictures that are richly imaginative. In many respects, these are far different from Mimbres paintings, but they represent the prehistoric painting tradition of the Pueblos that is most comparable to that of the Mimbres. Historic connections between the two traditions, however, are most tenuous.

Even though the awareness of Mimbres art spread slowly, after its rediscovery in 1913, Mimbres representational paintings fascinated prehistorians of the Southwest for they provided our world with its first good view of the intellectual life of a vanished southwestern native people. Even though our readings of these images are by no means clear, it is certain that we know more of the humanity, philosophy, and values of the Mimbreños than of any of their contemporaries.

While Mimbres paintings have fascinated southwesterners for decades, their impact on any mainstream contemporary art movement has been minimal. The art has influenced art and craft revival movements among contemporary Native Americans, particularly in the Pueblos of San Ildefonso and Ácoma in New Mexico. Fewkes'

Opposite:
Figure 125.
Bowl. The Hero Twins. Style III, Mimbres Classic Black-on-white. Swarts Ruin.
H. 4½ in. (11.5 cm), diam. 9 in. (23 cm).
Peabody Museum of Archaeology and Ethnology, Harvard University, Cambridge, Mass.

This painting is discussed on page 121 of the text. The figures are identified by Hopi men as the Twin War Gods (Little Warrior Gods, Hero Twins). The facial markings are noted as being different from those used to identify the Twins *Pookanghoya* (Echo) and *Palangaohoya* (Ash Boy) at Hopi. These heroes are the protectors of the earth who defend against misdeeds and bad happenings. They are the monster slayers, but they are also mischievous and disobedient and can bring trouble on themselves and on innocent bystanders by their carelessness. The border designs of this painting were thought by some Hopis to have meaning as symbols of the four world directions, the turning axis of the whole world, or the balancing of top and bottom (this world and the underworld). Some thought the center rectangle was a shield and others a woven blanket (Kabotie 1982:45–46, Weslowski 1979:11–12).

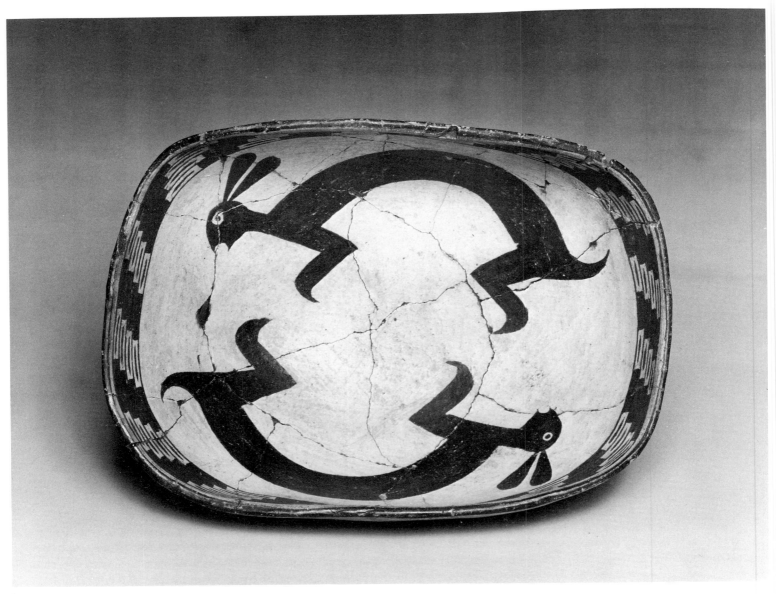

Figure 126.
Bowl. Pair of rabbits. Style III, Mimbreś Classic
Black-on-white. Galaz site.
H. 3½ in. (9 cm), w. 6¾ in. (17 cm), l. 9½ in.
(24 cm).
Mr. and Mrs. Edward Kitchen, Santa Monica,
Calif.

1923 publication of Mimbres paintings was hardly off the press before Julián Martínez of San Ildefonso Pueblo was inspired to modify the designs he saw there to fit the character and form of pottery made by his wife, María. Three generations later, his Mimbres innovations have become totally integrated with San Ildefonso tradition. More recently, potters at Ácoma have used Mimbres painted pottery in entirely different ways that are more compatible with traditional Ácoma pottery styles. In both instances, the art of the Mimbreños has been a catalyst for the invention of new, but entirely appropriate ethnic traditions.

As Mimbres paintings have become better known, more greatly admired, and more highly valued, they have inspired some less positive activities. They have become an art market commodity, and during the last fifteen years looters have plundered many Mimbres village sites in their search for specimens to feed that market. In the process, they have unwittingly destroyed many more paintings than they ever recovered. Ironically, the same market also engendered the manufacture of clever fakes, which may ultimately provide the best protection that we can give to the endangered Mimbres sites. There is nothing like a good fake to cast doubt on the authenticity of any undocumented painting.

Mimbres paintings can teach us much about greed; but above all, they teach us about art and the power that creative cultural expressions have to link together the past, present, and future. This was, surely, the objective of all Mimbres mortuary paintings.

J. J. Brody

Notes
1. Kubler, 1962.
2. Jernigan, 1978.
3. Schaafsma, 1980.
4. Kabotie, 1949.
5. Di Peso et al., 1974.
6. Brody, 1977.

Overleaf:
Figure 127.
View of the Gila River and Pinos Altos Mountains seen from the Woodrow site. The Woodrow site was the largest Mimbres settlement on the Gila River. (©1982, Dan Budnik)

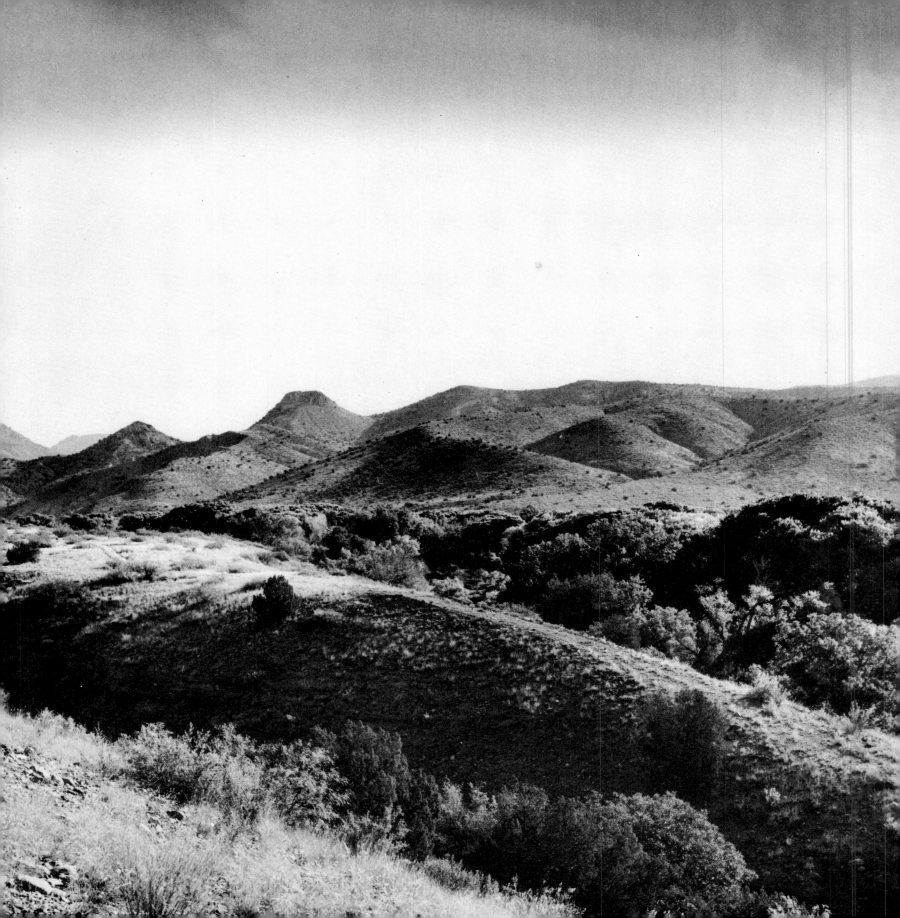

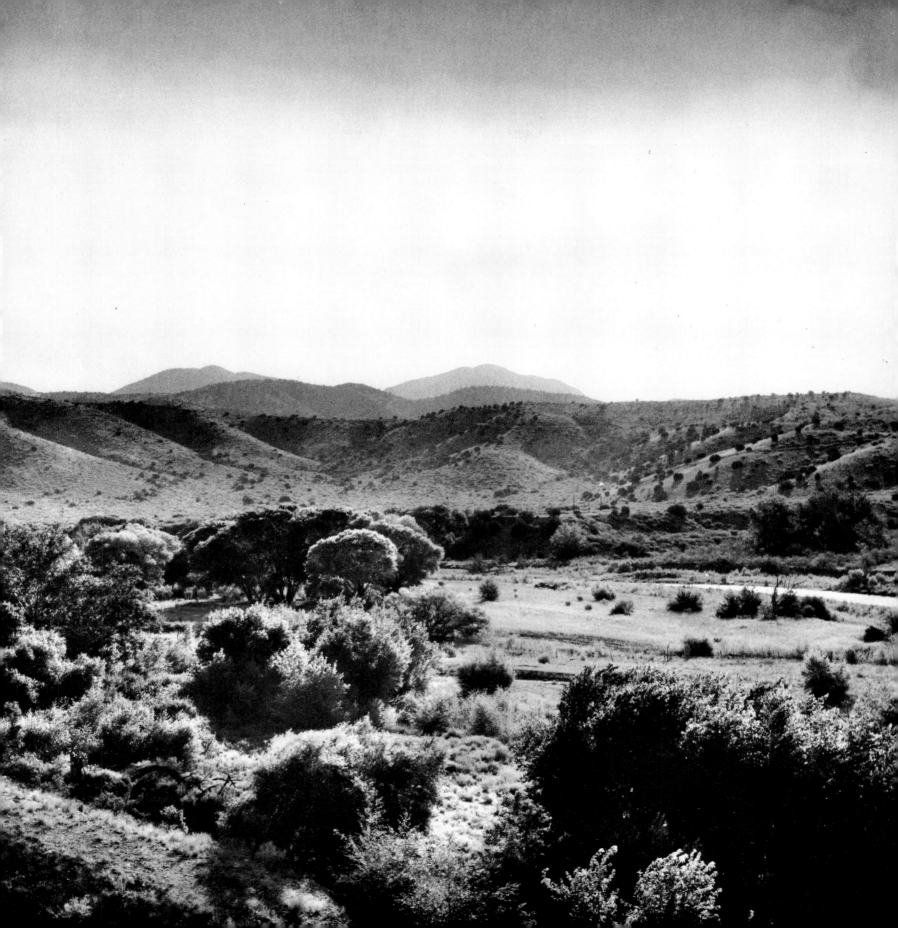

Bibliography

Anyon, Roger; Gilman, Patricia A.; and LeBlanc, Steven A. 1981. A Re-evaluation of the Mogollon-Mimbres Archaeological Sequence. *The Kiva* 46:209–25. Tucson.

Anyon, Roger, and LeBlanc, Steven A. In press. *The Galaz Ruin: A Mimbres Site in Southwestern New Mexico.* Albuquerque: University of New Mexico Press.

Bradfield, Wesley. 1931. *Cameron Creek Village: A Site in the Mimbres Area in Southwestern New Mexico.* School of American Research Monograph, no. 1. Sante Fe.

Brody, J. J. 1977. *Mimbres Painted Pottery.* Albuquerque: School of American Research, Santa Fe, and University of New Mexico Press.

Carr, Patricia. 1979. *Mimbres Mythology.* Southwestern Studies Monograph, no. 56. University of Texas, El Paso.

Cosgrove, Cornelius B. 1947. Caves of the Upper Gila and Hueco Areas in New Mexico and Texas. *Papers of the Peabody Museum of Archaeology and Ethnology,* vol. 24, no. 2. Cambridge, Mass.

Cosgrove, Harriet S., and Cosgrove, Cornelius B. 1932. The Swarts Ruin: A Typical Mimbres Site in Southwestern New Mexico. *Papers of the Peabody Museum of Archaeology and Ethnology,* vol. 15, no. 1. Cambridge, Mass.

Di Peso, Charles C.; Rinaldo, John B.; and Fenner, Gloria J. 1974. *Casas Grandes: A Fallen Trading Center of the Gran Chichimeca.* 3 vols. Amerind Foundation Publication, no. 9. Dragoon, Ariz.

Fewkes, J. Walter. 1914. Archaeology of the Lower Mimbres Valley. *Smithsonian Miscellaneous Collections,* vol. 78, no. 10. Washington, D.C.

Gladwin, W., and Gladwin, H. S. 1934. A Method for the Designation of Cultures and Their Variation. *Medallion Papers,* Series 4, no. 15. Gila Pueblo, Globe, Ariz.

Haury, Emil W. 1936a. The Mogollon Culture of Southwestern New Mexico. *Medallion Papers,* Series 4, no. 15. Gila Pueblo, Globe, Ariz.

———. 1936b. Some Southwestern Pottery Types. *Medallion Papers,* Series 4, no. 19. Gila Pueblo, Globe, Ariz.

Jernigan, E. Wesley. 1978. *Jewelry of the Prehistoric Southwest.* Albuquerque: School of American Research, Sante Fe, and University of New Mexico Press.

Kabotie, Fred. 1949. *Designs from the Ancient Mimbreños with a Hopi Interpretation.* San Francisco: Graborn Press.

———. 1982. *Designs from the Ancient Mimbreños with a Hopi Interpretation.* 2nd ed. Flagstaff, Ariz.: Northland Press.

Kubler, George. 1962. *The Shape of Time.* New Haven: Yale University Press.

LeBlanc, Steven A. 1975. *Mimbres Archaeological Center: Report of the First Season of Excavation, 1974.* Los Angeles: University of California Institute of Archaeology.

———. 1976. Mimbres Archaeological Center: Preliminary Report of the Second Season of Excavation, 1975. *Journal of New World Archaeology,* vol. 1, no. 6. Los Angeles.

———. 1983. *The Mimbres People: Ancient Pueblo Painters of the American Southwest.* London and New York: Thames and Hudson.

Nesbitt, Paul H. 1931. The Ancient Mimbreños. *Logan Museum Bulletin,* no. 4. Beloit College, Beloit, Wis.

Schaafsma, Polly. 1980. *Indian Rock Art of the Southwest.* Albuquerque: School of American Research, Santa Fe, and University of New Mexico Press.

Snodgrass, O. T. 1973. A Major Mimbres Collection by Camera: Life among the Mimbreños, as Depicted by Designs on Their Pottery. *The Artifact* 2:14–63. El Paso, Tex.

———. 1975. *Realistic Art and Times of the Mimbres Indians.* El Paso, Tex.: Privately printed.

Weslowski, Lois V. 1979. Preliminary Report of the Mimbres Iconography Study. Unpublished manuscript, on file at the Maxwell Museum of Anthropology, University of New Mexico, Albuquerque.

Photograph credits:

All photographs of objects were taken by Justin Kerr, New York, except:

Susan Einstein, Santa Monica, Calif. (colorplates 30, 31, figure 1)

Hillel Burger for The Peabody Museum of Archaeology and Ethnology,
 Harvard University, Cambridge, Mass. (colorplates 3, 11, 12, 24, 32, 41,
 figures 30, 48, 62, 63, 67, 72, 73, 78, 93, 94, 110, 111, 112, 118, 119, 125)

Richard B. Duane, New York (figure 4)

Rick Gardner, Houston, Tex. (figure 5)

Jerry Jacka, Phoenix, Ariz. (figures 6, 7)

Credit for field photographs is noted with each image.

The American Federation of Arts

The American Federation of Arts is a national, non-profit, educational organization, founded in 1909, to broaden the knowledge and appreciation of the arts of the past and present. Its primary activities are the organization of exhibitions that travel throughout the United States and abroad, and the fostering of a better understanding among nations by the international exchange of art.